6 *Victoria is someor*

makes high fashion relevant for

everyone. She has really brought

fashion into the mainstream and

brought awareness to designer fashion

that would not have been possible without

her. Not only does she love fashion, but

she really understands it and how it works

best for her. Victoria is not just a fashion

icon: she is an icon full stop. 9

ROLAND MOURET

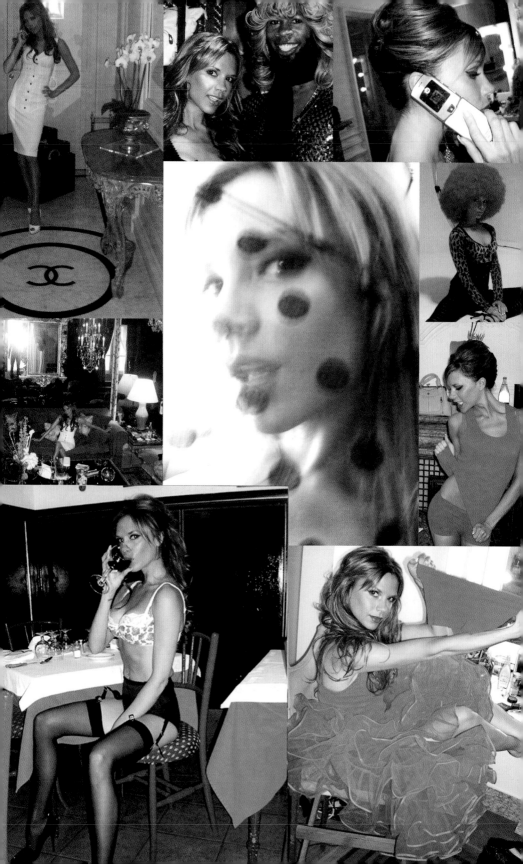

Victoria Beckham

that extra half an inch

with Hadley Freeman

PHOTOGRAPHY BY ELLEN VON UNWERTH

Still-life photography by Benoît Audureau

Illustrations by Cecilia Carlstedt

PENGUIN BOOKS

PENGUIN BOOKS

Published by the Penguin Group
Penguin Books Ltd, 80 Strand, London WC2R 0RL, England
Penguin Group (USA) Inc., 375 Hudson Street, New York, New York 10014,
USA
Penguin Group (Canada), 90 Eglinton Avenue East, Suite 700, Toronto,
Ontario, Canada M4P 2Y3 (a division of Pearson Penguin Canada Inc.)
Penguin Ireland, 25 St Stephen's Green, Dublin 2, Ireland (a division of
Penguin Books Ltd)
Penguin Group (Australia), 250 Camberwell Road, Camberwell, Victoria 3124,
Australia (a division of Pearson Australia Group Pty Ltd)
Penguin Books India Pvt Ltd, 11 Community Centre, Panchsheel Park, New
Delhi – 110 017, India
Penguin Group (NZ), 67 Apollo Drive, Mairangi Bay, Auckland 1310, New
Zealand (a division of Pearson New Zealand Ltd)
Penguin Books (South Africa) (Pty) Ltd, 24 Sturdee Avenue, Rosebank,
Johannesburg 2196, South Africa

Penguin Books Ltd, Registered Offices: 80 Strand, London WC2R 0RL, England

www.penguin.com

First published 2006
Reprinted with revisions 2007
1

Text copyright © Moody Productions, 2006, 2007
Portrait photography © Ellen Von Unwerth, 2006, 2007
Still-life photograph © Benoît Audureau, 2006, 2007
Illustrations © Cecilia Carlstedt, 2006

The credits on p.377 constitute an extension of this copyright page

Set in Bodini and FirminDidot
Art directed and designed by Nikki Dupin
Colour reproduction by Dot Gradations Ltd, UK
Printed and bound in Italy by Graphicom, srl

A CIP catalogue record for this book is available from the British Library

ISBN: 978-0-141-02920-7

TO MY MUM

My first fashion guru, who taught me to sew, showed me how clothes should fit and who told me never to eat beetroot because it stains. She also told me never to wear horizontal stripes – sorry, Mum, couldn't resist that gorgeous striped dress for the cover shoot!

Most importantly, she taught me to enjoy being a girl.

(P.S. Jacks may have brought me up but in actual fact I know that my real mother was Joan Collins – but that must always remain a secret. Mum's the word …)

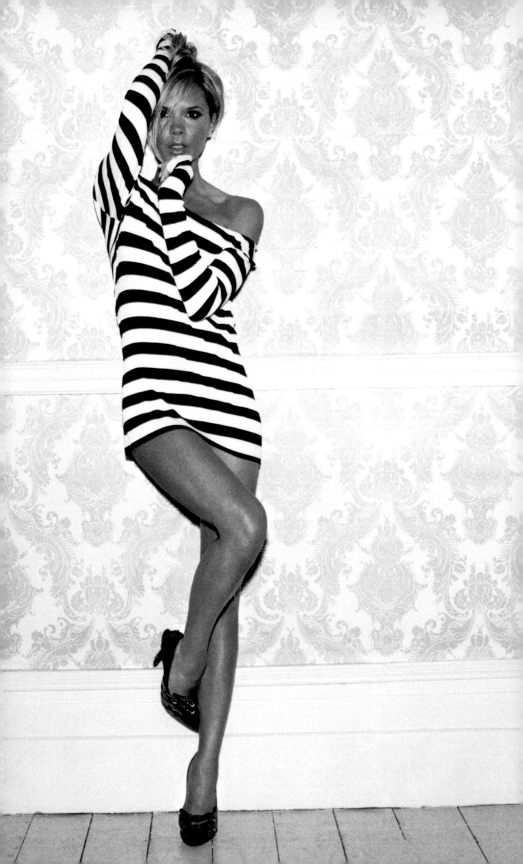

contents

introduction

There are people out there who only wear clothes 'because you have to' or 'because it's cold'. Be warned: this book is not for them!

IT'S FOR GIRLS WHO LOVE FASHION. Who love that magical transformation of material on a hanger into something that makes you want to twirl in front of a mirror, that gives you the confidence to think, You know what? I look great! Fashion is how we express our personalities. Our way of saying, 'This is who I am,' sometimes even, 'This is who I would like to be.' Most of all, fashion is about having fun and using your imagination.

I have no qualifications to write this book other than a lifelong passion which, combined with the extraordinary way in which my life has turned out, has given me the chance to wear some amazing clothes, meet some amazing people – and learn a hell of a lot along the way. And this is what I hope to share with you: the passion, the insight and the tips.

First, I'd like to knock a few things on the head. The idea that, once you have a bit of money, you start staggering around wearing couture and stilettos all day long is as mad as thinking you'll be living on caviar and champagne. The staples remain the same whatever happens in your life. Toast is still my favourite food and jeans are probably what I'm happiest wearing. (As proof, jeans were the first thing I set my sights on designing. If I were a cook I'd probably be perfecting the ultimate toaster.) Looking good isn't about money, it's about style. And style never goes out of fashion.

Designers borrow from the street, they borrow from the past, and there's no copyright on that; the genius of the greats – designers or individuals – lies in the way they put it together, and I feel incredibly privileged to talk to these people about their influences and their techniques. You'd be surprised to learn how many ideas come from history, whether it's a hundred years ago or thirty. Second-hand doesn't mean second class, as anyone who has discovered vintage shops will know.

My own inspiration comes from fashion icons of the last century: Grace Kelly, Jackie Onassis and my muse-for-all-seasons, Audrey Hepburn. *Breakfast at Tiffany's* must be my favourite movie of all time, and you could still wear anything from that today. And what do these women have in common? Simplicity. The understanding that it's all about shape – not just body shape, but the silhouette: the hat, the sunglasses, the bag, the shoes. Looks that have staying power.

MY OWN INSPIRATION COMES FROM FASHION ICONS OF THE LAST CENTURY: GRACE KELLY, JACKIE ONASSIS AND MY MUSE-FOR-ALL-SEASONS, AUDREY HEPBURN.

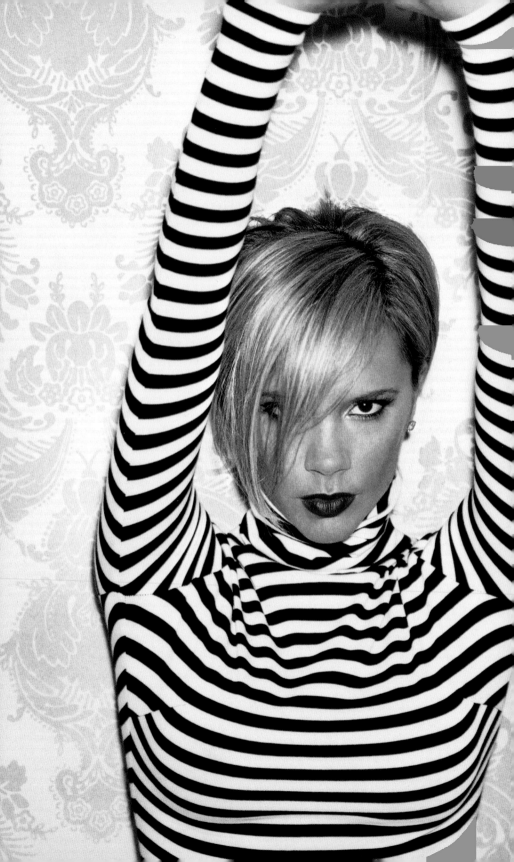

My image, if you like, began at my stage school, where it was drummed into us that grooming was everything: nails, hair, make-up, it all had to be perfect if you wanted to get that job. In those pre-Spice Girls days, I was simply Victoria Adams. 'Posh Spice' came about because of how I looked: the bob, the heels, the little black Gucci dress. Except that it wasn't Gucci. It was Miss Selfridge, and I've still got it, though it finally fell to bits from being worn to death. But other things from that time I can and do still wear. For example, a Dolce & Gabbana little tube dress in a beautiful narrow pinstripe with built-in corset – the first corset dress I ever bought. Buy cleverly and things will last. Remember: nothing is more expensive than the thing you only wear once.

Apart from when I'm doing fashion shoots for work (where the clothes are planned), I never use a stylist, never have and never will. Why let somebody else have all the fun? I decide what I'm going to wear and it's been that way since I was fourteen, when my mum let me loose in C&A. She, of course, was my first fashion guru, with a strict list of do's and don'ts. Geri of the Spice Girls had her own, one of which I will never forget: don't let it all hang out. If it's your legs that are on display – like in a miniskirt – put those boobs away. Whereas if you're wearing trousers, then you can get away with something a bit plunging. Fashion is about feeling sexy, not inciting a riot.

A lesson that anyone can learn from just walking down the street is to know your limitations. Other people's mistakes are easy to spot. So if your thighs aren't your best feature, then choose your jeans carefully: different cuts flatter different shapes, and there are loads of styles out there. I know; I've investigated them. If the idea of wearing a size 14 freaks you out, don't try to squeeze into a 12; buy the size that fits and cut out the label. Life's challenging enough, why be challenged by your clothes? Not that I haven't made mistakes. The most cringe-making was when David and I turned up wearing identical leather outfits (Gucci) at a Versace party … Not clever from any perspective. Keep your eyes open and your instincts intact – and those old enough to remember should never forget Dorian of *Birds of a Feather* …

From as far back as I can remember, I was always on the fashion road. At school I studied textiles for GCSE and my great claim to fame was starting the trend of wearing one pair of socks pushed down on top of

I DECIDE WHAT I'M GOING TO WEAR AND IT'S BEEN THAT WAY SINCE I WAS FOURTEEN, WHEN MY MUM LET ME LOOSE IN C&A. SHE, OF COURSE, WAS MY FIRST FASHION GURU.

I'M NOT A SIX-FOOT-TALL MODEL, NOR AM I A PIN-UP FOR MEN, AND, FOR THIS BOOK, THAT'S MY STRENGTH, BECAUSE I'M A GIRLS' GIRL.

another! But when I met the girls, my life took a bit of a detour. Now, with my various design projects up and running, I'm doing something I'd probably have ended up doing anyway, fulfilling a dream which I now realize that I have had for ever.

I'm not a six-foot-tall model, nor am I a pin-up for men, and, for this book, that's my strength, because I'm a girls' girl. In most respects I am very ordinary: smaller-boned than average, perhaps, but normal height, normal face, normal hair: the girl-next-door who got lucky. However, nowadays it's hard for me to shop like I used to – popping in every week to see what was new on the rails – though the high street is still my first choice for basics. What's been great for me in writing this book is that it's given me the opportunity of getting back into that groove; my sister, Louise, being my chief scout, has brought me armfuls of stuff from all my favourite shops in the UK; plus I've investigated a whole raft of new shopping options, including supermarkets. And these days, even when you live abroad as I do, you can always buy online. But wherever it comes from, every single thing I mention in this book has been chosen for the simple reason that it works; and if something doesn't work, then I'll say that too.

Victoria clearly loves fashion, and her style is watched and copied by many. It's interesting to me to look at how her personal style has evolved over the years.

MATTHEW WILLIAMSON

I have never lost that excitement of trying on new clothes, the bedroom looking like a jumble sale, remembering a pair of shoes in the back of the wardrobe that will pull a look together, finding a new top that will reinvent something I've had for years. I meet people who are so cool they could freeze your hand, whereas I still get excited when I'm lucky enough to be sent amazing pieces – like the Prada bag which I have used virtually every day since it arrived, doubling as everything from hand luggage to a pillow. But, if I'm being honest, the buzz is no different when I come across a great little find in the market or a vintage piece.

I've come a long way, but this book is not my attempt to tell you what or what not to do, it's just to share some of what I have learned, from tips from the best make-up artists and hairdressers, to the difficult (but not impossible) task of cramming nappies and baby bottles into a little Fendi bag. The advice in this handbag-sized edition has also been updated – we all know that the world of fashion is forever changing.

As for the title, I'm actually talking about high heels. OK, so it's a bit tongue-in-cheek – but that's what it's all about. And as every woman knows, that extra half an inch makes all the difference …

AS FOR THE TITLE, I'M ACTUALLY TALKING ABOUT HIGH HEELS. OK, SO IT'S A BIT TONGUE-IN-CHEEK – BUT THAT'S WHAT IT'S ALL ABOUT.

jeans

&

trousers

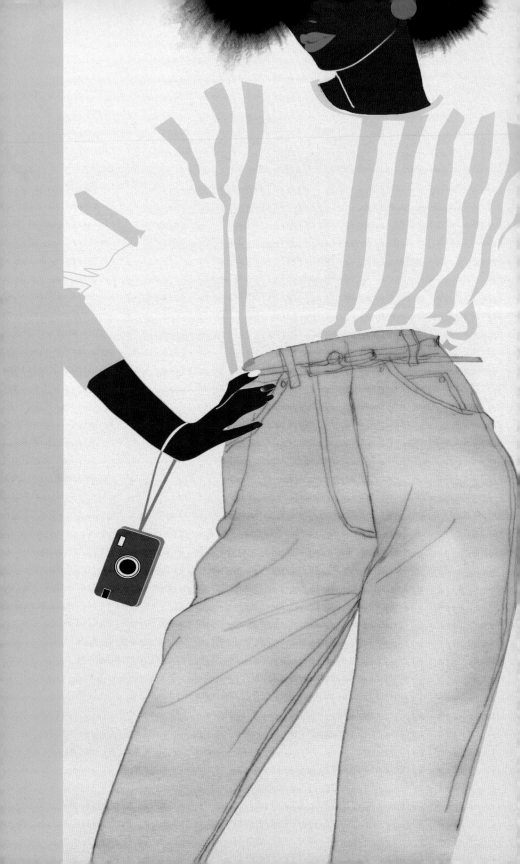

Jeans are the obvious place to start. They have become not just the backbone but spinal cord, ribcage and, for some of us, the whole skeleton of a woman's wardrobe.

SO IT'S A REAL JOLT TO THINK THAT THIS HAS REALLY ONLY BECOME THE CASE IN THE PAST DECADE OR SO. Remember how bad they used to be in the 80s and 90s? Unflattering, and almost always with that hideous tapered cut that makes everyone look like they have drumsticks for legs. Definitely the less-cool element of 80s fashion.

But, in the past decade, jeans have become hugely important in women's wardrobes and it's hard to think back to how we coped without them. I mean, what would we wear when going straight from work to a cool bar in the evening? Or when playing with the kids in the park without having to worry about looking frumpy or getting our clothes dirty but still wanting to look half-good? I honestly can't remember. No other piece of clothing can be worn in so many different situations and always look good.

MORE THAN ANY OTHER PIECE OF CLOTHING, JEANS CAN SHOW OFF YOUR FIGURE TO ITS BEST.

Jeans have always had a chequered history in the cool stakes. When they were invented, they were just there to provide sturdy clothes for hard-working cowboys out on the plains. It was really in the 50s that they became cool – when James Dean hooked his finger through his denim belt loop, instantly making them the symbol for sexy teenage rebellion – and original Levi's Red Tab are now real collectors' items. Nowadays they are made to complement a woman's figure and it's hard to imagine they'll ever fall out of fashion's favour again.

And even though I love getting dressed up, everyday clothes do have to be practical. I pretty much live in jeans and T-shirts – jeans are flattering but easy to just throw in the washing machine, and T-shirts, as every mum knows, are great for mopping your children's noses.

Best of all, there is no age limit on jeans. A sixty-five-year-old granny could wear jeans and she'd look good, as long as it was a pair that suited her shape. That is something to bear in mind: we all change shape as we get older and so you'll almost certainly need to change the style of jeans you wear every few years instead of automatically still buying the same sort you were wearing when you were twenty-one. That's not depressing, it's just doing something that will make you look better.

It is only through years of wearing jeans that I discovered what really works for me. It was through this experience that I decided to design my very own collection of denim under my own label, dVb. The range itself offers different styles, cuts, fits and colours to suit the varying demands of the discerning denim-lover. Whether you love straight legs, boot-cuts,

drainpipes or even shorts, there is definitely something to suit most shapes and sizes. I wanted to create a collection of denim that essentially combined both style and comfort whilst looking desirably gorgeous and glamorous. It gave me the competitive edge to produce something equally good as the other top designer denim brands but with my very own signature style and I must admit I'm really pleased with the whole range.

Just because jeans have improved in style and quality in recent years doesn't mean that they are fail-safe. To be honest, it's actually become trickier because there are so many possible jeans styles around, and magazines that tell you everybody should wear this style or that style, when the truth is – obviously – no one style is going to suit everyone. More than any other piece of clothing, jeans can show off your figure to its best, but if you get the wrong cut or style they will do you absolutely no favours at all.

If you have the time and money, it's worth buying your jeans from a specific denim store or a knowledgeable boutique. Matches, Harvey Nichols and Selfridges all have excellent denim collections. One way of telling whether a jeans shop is any good is by the mirrors in the changing rooms: any denim shop with a bit of nous will have multi-way mirrors so you can see every possible view of yourself, particularly your bottom. Actually, all changing rooms should have these but getting the full perspective is especially important when it comes to denim.

I WANTED TO CREATE A COLLECTION OF DENIM THAT ESSENTIALLY COMBINED BOTH STYLE AND COMFORT WHILST LOOKING DESIRABLY GORGEOUS AND GLAMOROUS.

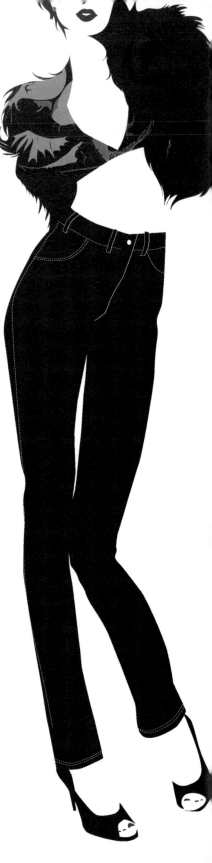

jeans

ALTHOUGH IT IS DEFINITELY A
GOOD INVESTMENT TO BUY A
PAIR OF WELL-CUT JEANS, it's
surprising how few there are out there.
I will not spend my money on something
that doesn't make me look good, and
nor should you.

CHECK THE WAISTBAND

A common problem is that if the jeans are tight enough around the leg then they're too tight at the waist. And speaking of the waist, the waistband shouldn't be too thick and heavy because it will dig painfully into your hips and that gives everyone the hated muffin-top look. Check that the waistband doesn't do that annoying gaping thing at the back, either, as you'll end up with a weird wind-tunnel effect. Look for jeans that are cut higher at the back so not only do they not gape but also they don't give you builder's bottom every time you sit down.

LOOK FOR JEANS THAT ARE CUT HIGHER AT THE BACK SO NOT ONLY DO THEY NOT GAPE BUT ALSO THEY DON'T GIVE YOU BUILDER'S BOTTOM EVERY TIME YOU SIT DOWN.

PLEASE – NO BAGGING

Jeans that bag around the knees or bottom are another fashion disaster and it's amazing how many designers don't pay attention to this, considering a major point of jeans is to make those parts of your body look good. For instance, I really like skinny-fit jeans, but some can start bagging around the knees after a couple of wears, and can flatten my bottom as opposed to acting like a Wonderbra on it, as a pair of jeans should.

I always make sure my jeans have just a bit of stretch to them (but not too much that they bag), are narrow around the leg and give shape to the bottom instead of squashing it down.

GET THE LENGTH RIGHT

It is crucial to make sure the jeans are long enough, unless you particularly fancy looking like Charlie Chaplin paddling about. When trying them on, stand in front of the mirror on your tiptoes and then with flat feet, as you are likely to be wearing them with heels and trainers and you need to see how they look with both. With heels, the bottom of your jeans should just skim your toes, as that will give a good couple of inches of length to your legs without making you look like a child playing in her mother's dressing-up box. Obviously, if your jeans are long enough for heels, they're going to drag a bit with flats but that really doesn't matter. If you can afford it, though, it's good to have one pair for heels and one for trainers, but don't make the mistake of getting your 'trainers jeans' too short. Like your 'heels jeans', they should end almost at the tip of the shoe, maybe even just graze the ground, and break almost at your toes. Being a seasoned jeans lover helped me to make my collection comfortable, stylish and well-fitting – the last thing you want is to feel imprisoned by your jeans. I am very fussy about getting the length right on my jeans which is why dVb offers both varying lengths *and* a fabulous fit, elements which are essential in finding the perfect pair of jeans.

THE HIGH-WAISTER

Ever since low-slung jeans came on the market a lot of people have thought that they should be the automatic choice, but that actually isn't so. True, low-slung is more flattering on short-waisted girls, but flat-fronted, high-waisted jeans actually look really fashion-forward now – welcome to the cyclical fashion world! And if you're a bit self-conscious about the length of your legs, high-waisted jeans are great for elongating them. Remember to team high-waisted jeans with very high heels or platforms to really lengthen your legs. I was a little wary about high-waisted jeans myself at first and thought they'd make me look completely out of proportion. But you know, they weren't bad at all. Admittedly, they do really squeeze you in round the waist and by the end of the day I was beginning to have mental images of my epitaph: 'Victoria Beckham – done in by denim'. So I generally stick with my skinny-fit low-slungs.

COLOUR ME BEAUTIFUL

As for colour, white looks fresh and funky for summer, but be wary as sometimes white jeans can make your thighs look larger than they actually are. Subtle shades of powder blue and pale grey are interesting too and look best in skinny drainpipe or high-waisted styles. Black jeans are great as long as you get them in a good cut – slim styles are best, remember: skinny black is sexy rock 'n' roll; baggy black tends to be a bit roadie and quite unflattering.

SIZING

Yes, you want a pair of jeans that is good and slim on the legs, but that does not mean you should try to squeeze yourself into a pair that is just too small because you can't face the idea of going up a size. Wearing something that is obviously too small is never a good look, whatever the size on the label. Plus, it is just depressing wearing something all day that is digging into you, making you feel miserable and uncomfortable. There are some denim lines now that offer different shaped 'cup' sizes for your bottom! Notify do them, and there is even a Tummy Tuck jean by NYDJ that aims to flatten your tum. Whatever your size, it's important to firstly try your jeans on to make sure they fit, and secondly buy the right size regardless of the number. You can always cut out the label at home, and you'll pretty soon forget whatever that number was because you'll be too busy admiring how fantastic you look. Or you can be like my mum, who always says, 'I am a size 10 but a size 12 is so much more comfortable!'

BOOT-CUT, STRAIGHT OR SKINNY

The ideal pair of jeans is flattering, comfy and sexy and that tends to mean blue, slim and well cut. Boot-cut jeans can be very versatile, as you can wear them with heels, sexy boots and flats. I know a lot of women never deviate from wearing boot-cut jeans as they really lengthen your legs and can be very flattering around the hips for

curvier shaped figures. There is also the argument for the simple straight leg too, which I think should be in every woman's denim wardrobe. The most flattering jeans outfit for a woman can simply be a pair of well-cut straight-leg jeans, heels and a simple top or fitted jacket. It's no-fuss, no-frills dressing and looks understatedly smart. There is of course the whole skinny jean phenomenon that is an undeniable trend. I do think they look very cool and I particularly love skinny drainpipe styles, which look super-flattering with cute vests and T-shirts.

For me, the most essential accompaniment to my jeans is a sexy high heel. Kate Moss famously sports the skinny jeans and flats look so stylishly, but that's because she's Kate Moss! Just because something looks good on someone else does not mean it will look good on you. It's important to experiment and find your own style. Kate Moss has great personal style when it comes to fashion and has designed her own range for Topshop, including some great skinny jeans.

One exception to the Kate rule, though, is tucking jeans into boots. As far as I can tell, she made this fashionable again and it is the most fantastically useful look as it is easy, looks a bit cooler than just boots under jeans, and keeps your jeans dry and clean on rainy days – a crucial consideration if jeans are part of your almost daily wardrobe and you live in Britain. Couple of things to remember: first, make sure the jeans are tucked in nice and

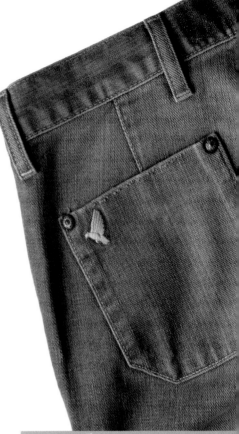

style no-no

One thing I cannot bear on jeans are those bleached-out faded patches under the bottom and on the front of thighs. In some cases you can end up looking like you've been sitting with a puppy that hasn't been house-trained on your lap.

snug and don't, as often happens, bag around the knee, or you will look like you're playing Billy Bunter in some Christmas panto. I have to admit, skinny jeans are best for this as then you won't look like you've got some weird growth inside your boots around your ankles, which can happen with boot-cut jeans because there is much more excess fabric swishing about at the ankles.

But if you don't have any skinny jeans, you can tuck the ends of your straight-leg jeans into tight long socks. This can squeeze your legs a bit, so maybe it's the perfect outfit to wear on long-haul flights to ward off deep-vein thrombosis! And you thought I was just here for fashion tips …

As for the boots, they should end right below your knee and not, as too many boots do, midway up your calf, since this cuts off your leg at the widest point. Skinny jeans tucked into an ankle boot is more of a fashion thing than a style thing, by which I mean it isn't a classic look, but one that only looks good if it's currently going through a moment.

MONEY TALKS – FROM HIGH ST TO HIGH FASHION

As for how many pairs of jeans you should own, well, it obviously depends on how often you wear them. As you can tell, I wear denim almost every day, so I have quite a few pairs and I try to get them in as many different styles as possible. It makes more sense to me to spend that little bit more on something that my bottom will be relying on so

I RECOMMEND BUYING ONE PAIR OF STRAIGHT-LEG OR BOOT-CUT JEANS AND ONE PAIR OF SKINNY.

style no-no

The absolute worst thing anyone can do with their jeans is to pull their G-string over the waistband. There was a period a few years ago when it seemed that everybody and their dog was being photographed falling out of Chinawhite with their G-string hoiked above their jeans. I don't mind a bit of lingerie showing, like a pretty bra strap under a vest top, or maybe even a peek underneath a dress or shirt (very Dolce & Gabbana), but that is very different from bending over in Piccadilly Circus and showing your thong.

much. But the high street, as it almost always does, has risen to the challenge quite commendably and you can get great jeans there. As a general guideline I recommend buying one pair of straight-leg or boot-cut jeans and one pair of skinny. If you can stretch to a few more, get a pair that slip very flatteringly around the hip and are loose in the legs – boyfriend style, as they're called, because they look like you borrowed them from your boyfriend; these look really cute with trainers, or glammed up with a pair of platforms.

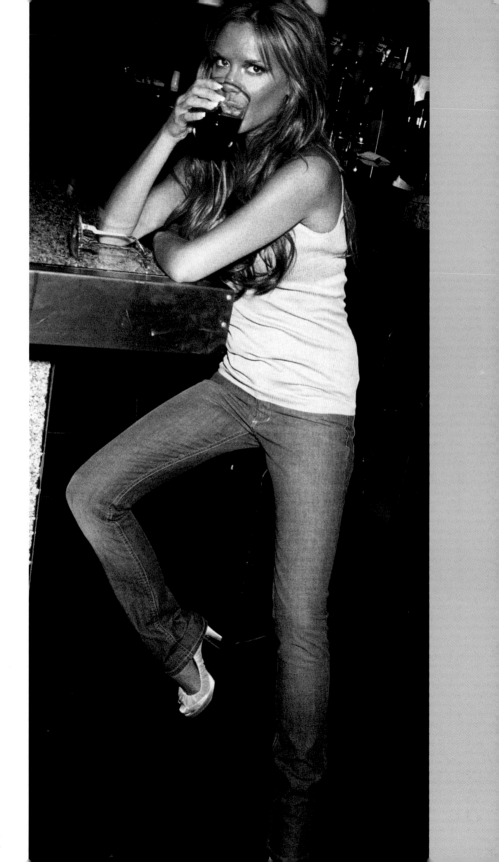

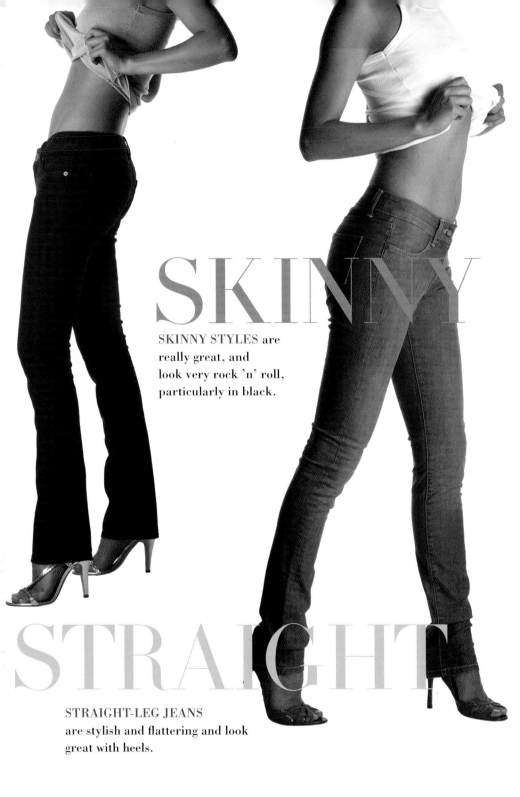

SKINNY

SKINNY STYLES are really great, and look very rock 'n' roll, particularly in black.

STRAIGHT

STRAIGHT-LEG JEANS are stylish and flattering and look great with heels.

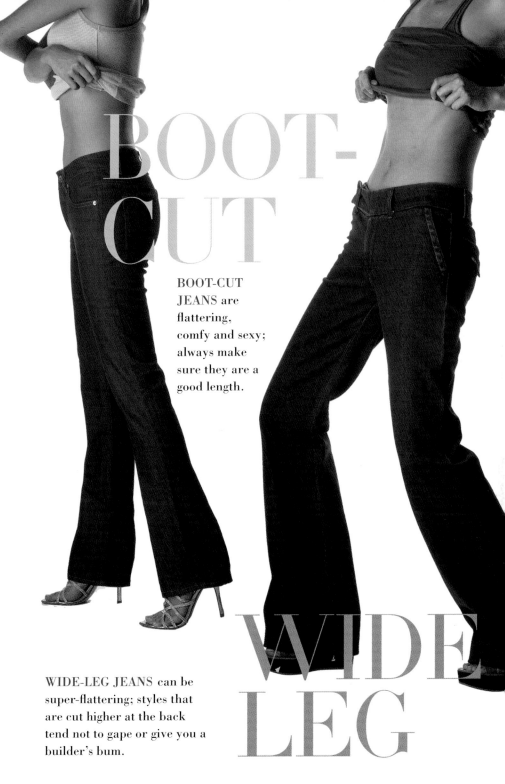

BOOT-CUT

BOOT-CUT JEANS are flattering, comfy and sexy; always make sure they are a good length.

WIDE LEG

WIDE-LEG JEANS can be super-flattering; styles that are cut higher at the back tend not to gape or give you a builder's bum.

JEANS *what to buy*

1. GREAT BUY
Cheap Monday, Florence and Fred, H&M,
Kate Moss for Topshop, Lee, New Look

2. HOT LABEL
Acne, Diesel, Fornarina, Miss Sixty, Notify,
Serfontaine

3. SUPER LUXE
Chloé, dVb, McQ, Sass & Bide, Stella McCartney,
Superfine

trousers

MOVING ON FROM DENIM, TROUSERS IN GENERAL ARE
TRICKY TO BUY BECAUSE YOU ARE SO DEPENDENT ON THE
CUT. Generally speaking, you want a slim pair that skims your figure,
is loose at the ankle (in other words, NOT tapered), and in a good,
heavyish fabric like a wool/cotton mix. This will fall better and be less
likely to give you VPL – something you should always, ALWAYS check
for before leaving the house. As with jeans, you can go high-waisted
or low-waisted, depending on which part of your body you feel more
confident about emphasizing – the hips or the waist – and the proportion
of your legs to your torso. And, again, as with jeans, boot-cut trousers
generally tend to be the most flattering and versatile, so they are my
usual choice, although I do have a very flared pair which I really love
as they make me feel very 70s David Bowie, in a rather fabulous sort of
way. But wearing them is definitely a look, meaning I then have to think
about what I wear them with and where to, as opposed to something I
can just throw on.

The trousers I wear most frequently are black and boot-cut. I know
people complain that women wear black trousers too often, but why
not if they look great? Wearing a totally black outfit can be sexy in an
understated way and make you feel confident, as you know everything
matches. For example, the other day when I went out for lunch I wore
some black cord trousers, a black polo neck and big black sunglasses.
Black can work wonders, but only if you don't begin to rely on it too
much, like a crutch. Then you will start to feel a bit dreary and that will
reflect in how you look.

GENERALLY SPEAKING, YOU WANT A SLIM PAIR THAT SKIMS YOUR FIGURE, IS LOOSE AT THE ANKLE, AND IN A GOOD, HEAVYISH FABRIC.

It can be quite daunting finding a good pair of flattering and stylish trousers, but here are a few basic guidelines that will help you.

SHAPE IS EVERYTHING

Make sure that the trousers have good length in the leg for your high heels and that they give your bottom a bit of a lift instead of flattening it or just bagging around it shapelessly.

Always check when you're buying trousers that they really are working for your figure. In other words, if you're not a pear, there's no need to buy pear-shaped trousers. Square peg, round hole, to put it simply.

PRIVATE ISSUES

Make sure your trousers are not too tight in the front of the crotch (if you see what I mean). You don't want to give people more than an eyeful in that area. I'm always amazed how many women seem to leave the house without checking for this very obvious and highly embarrassing issue. The trick is simply to buy trousers that are flat-fronted and sufficiently roomy in the crotch, even going a size up, if necessary, and then getting them taken in around the waist and legs by a good dry-cleaner or tailor.

For me, the ultimate trousers are by Balenciaga: the shapes and cuts are so fantastic. It is a label that has always specialized in superb tailoring. Even though the original Cristóbal Balenciaga died over thirty years ago, the brand, led by Creative Director Nicolas Ghesquière, still makes some of the most perfect and expensive trousers and jackets in the world. I'm also a fan of Stella McCartney's tailored trousers and jackets. As investment pieces they will last you for years, although you can get great tailored pieces on the high street now.

CORDUROY CUTE

I love corduroy trousers as they have that casual – but sexy – look of jeans, but are a little more original, with a 70s kick to them too. This is particularly true of ones with that very 70s Farrah cut to them – flat-fronted with a narrow then lightly flared leg. Most corduroy trousers today take a similar inspiration.

THE CROP

I really love cropped trousers and they can be worn in almost every season. They have a classic Audrey Hepburn-style charm about them and can look effortlessly chic.

Whatever material you get yours in – denim, tweed, cotton or wool – and whether you're going for a formal or casual look, make sure they end about three-quarters of the way down your calf, just at the point where it starts to narrow towards your ankle. This is the most flattering cut-off point on your leg: any higher and it ends at the widest part of your calf and your legs will look like sausages; any lower and it will just look like you shrunk your trousers in the wash.

CROPPED TROUSERS HAVE A CLASSIC AUDREY HEPBURN-STYLE CHARM ABOUT THEM AND CAN LOOK EFFORTLESSLY CHIC.

As for what shoes to wear with cut-off trousers, this is where a lot of women make mistakes and think, well, last time cut-offs were in I wore white stilettos so I'll wear white stilettos again. When something from your past comes back into fashion – cut-off trousers, flared trousers or long skirts – this does not mean you should wear them exactly as you did ten years ago. The whole point of certain looks coming back into fashion is to show us how we can do it differently this time round, usually even better. So last summer, for example, I wore my

❝ When buying cords avoid the chunky variety – not only do wide ribs actually make your legs look bigger, they also look outdated and remind me of the kind of thing my mum used to wear to the Starlight Rooms in the 80s. Cool then, maybe, definitely not now. Incidentally, the rule about wide ribs applies to all ribbed clothing, from vest tops to wool tights, for exactly the same reasons as corduroy. ❞

cut-offs with a pair of chunky-heeled round-toed shoes, which looked far more current than a pair of white stilettos! Always watch out that you don't get stuck in a fashion time warp: it's very easy to be complacent and to dress exactly the same as you've been doing for the past however many years, but not only will that style probably not suit you any more, you'll look hopelessly out of date. You needn't be scared about updating your style as it really isn't difficult: it's just a matter of doing something as simple as switching from pointed-toe shoes to round toes, or from stilettos to chunky heels. This is not a matter of blindly following trends that don't suit you, but rather it's about updating your look.

top tip

With cut-off trousers, I recommend wearing high heels to make your legs look longer. However, flats with slim, cigarette trousers (in other words, not gripping the leg but closely fitting around it) is very Audrey Hepburn in *Funny Face*, or Jean Seberg in *A Bout de Souffle* – two very good looks to go for. Flip-flops with cropped trousers are, of course, a summer staple.

LAST SUMMER, I WORE MY CUT-OFFS WITH A PAIR OF CHUNKY-HEELED ROUND-TOED SHOES, WHICH LOOKED FAR MORE CURRENT THAN A PAIR OF WHITE STILETTOS!

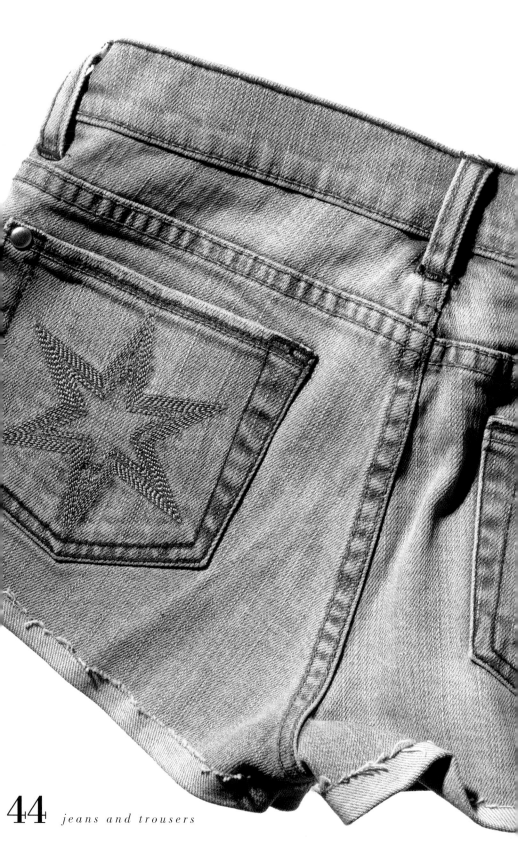

jeans and trousers

'When I wear shorts in the summer, I tend to pair them with a simple T-shirt and thick-heeled boots to make the look a bit more grown-up instead of looking too cutesy cute. '

SHORTS STUFF

Shorts are a fantastic wardrobe staple. They can be worn with heels or delicate flats – never trainers, unless you're off for a round of golf. Layered over dark opaque tights they look great in the winter with a tailored jacket, and in summer wear them with a cute racer-back vest.

Home-made cut-off denim shorts are always useful and you can totally control how you want them to look as you're the one making them! But longer, neater versions are also available on the high street that are called 'city shorts'. They can be a great alternative to trousers, but, in general, this can be a pretty hard look to pull off – they don't have the simplicity of jeans or the cuteness of shorts, and they put the emphasis on your knees in a way normal shorts just don't.

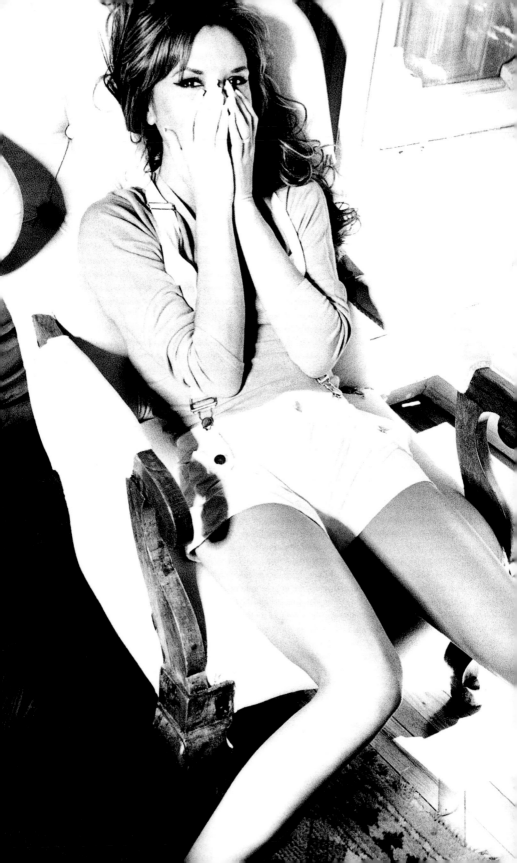

For me, when I'm buying jeans, trousers or shorts all the rules are the same: check the cut; check how they look from every angle; check the crotch area; and don't buy anything too small for your figure. The basic rule is if you try something on and it makes you feel good and look good, then buy it.

WHERE TO BUY

1. BOYFRIEND JEANS: Abercrombie & Fitch, Edun, French Connection, Gap, Lee, Levi's, Marc by Marc Jacobs, Moto at Topshop, Paul & Joe, Pepe Jeans, Rag & Bone, Rogan, Tommy Hilfiger Denim, Tsubi

2. STRAIGHT-LEG JEANS: 7 for all Mankind, Abercrombie & Fitch, Acne, Chip & Pepper, CK Calvin Klein, dVb, Frankie B, Gas, Habitual, James Jeans, Levi's, Notify, Pepe Jeans, See by Chloé, Serfontaine, Vanessa Bruno, Wrangler

3. BOOT-CUT JEANS: 7 for all Mankind, Abercrombie & Fitch, Citizens of Humanity, dVb, Earnest Sewn, Fornarina, Gap, Joe's Jeans, Made in Heaven, Miss Sixty, Paper Denim Cloth, Pepe Jeans, Radcliffe, Replay, True Religion

4. SKINNY JEANS: 3.1 Phillip Lim, 18th Amendment, Acne, Cheap Monday, Diesel, dVb, H&M, J Brand, Kate Moss for Topshop, Lee, McQ, New Look, Sass & Bide, Siwy, Stella McCartney, Superfine, Thomas Wylde, True Religion

5. HIGH-WAISTED JEANS: Acne, Cheap Monday, Diesel, Evisu, Guess, Karen Walker, Lee, Levi's, Miss Sixty, Moto at Topshop, Paul & Joe, Superfine

48 *jeans & trousers*

6. DESIGNER TROUSERS: Alexander McQueen, Balenciaga, Burberry Prorsum, Chloé, Gucci, Joseph, Junya Watanabe, Marc by Marc Jacobs, Martin Margiela, Paul & Joe, Stella McCartney, Vanessa Bruno, Viktor & Rolf

7. HIGH-STREET TROUSERS: Agnes B, French Connection, Gap, Jigsaw, La Redoute, Mango, Oasis, Reiss, Warehouse, Zara

8. CORDUROYS: 7 for all Mankind, French Connection, Juicy Couture, Lee, Mango, Miss Sixty, Moto at Topshop, See by Chloé

9. CROPPED TROUSERS & JEANS: Agnes B, dVb, Fornarina, French Connection, Gap, La Redoute, Mango, Paul & Joe, Reiss, True Religion

10. SHORTS: Abercrombie & Fitch, Chloé, dVb, Miss Selfridge, New Look, Paul & Joe, Reiss, Topshop, Zara

NOTES

tops

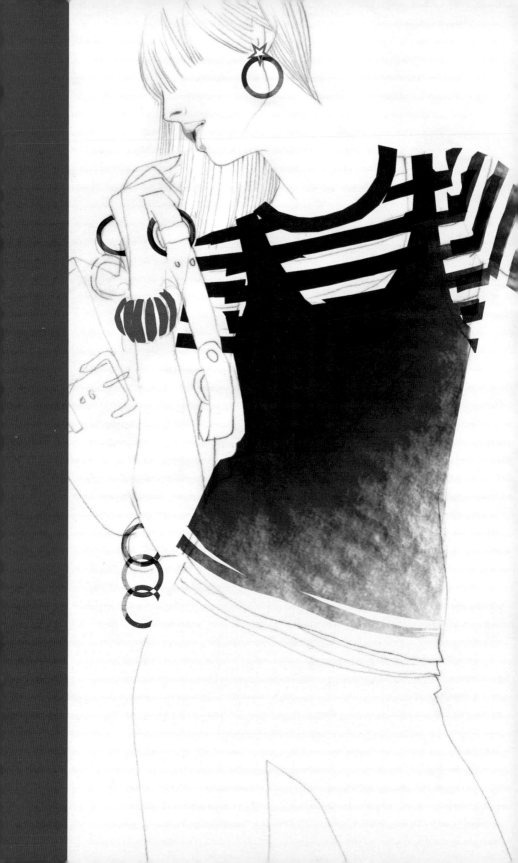

When you're getting dressed first thing in the morning, the trick is not to pull out just any old garments and pile them on without thinking about it.

– think about the end product, if you like, figuring out what bag would go with the dress, what you should then do with your hair, and so on, so you know the look you're going for from the start. Gordon Ramsay told me he does the same thing when cooking, visualizing the whole meal in advance and then pulling the ingredients together. Funnily enough, David said he applies the same thing to football, so perhaps it's a lesson you can apply to all walks of life!

It's often with tops that it all starts to go wrong. You may decide to wear something because it's on the top of the pile in your drawer, or because it will keep you warm enough, or just because it will do and you're in a hurry, whether or not it goes with the rest of your outfit. As a mother of three, I'm always rushing around in the mornings and don't have much time to fiddle about in my wardrobe, so I often work out my outfit the night before, thinking which tops would go with which trousers or skirts. For example, recently I wore a long multicoloured skirt I bought from a vintage shop, a Zara vest and an Alexander McQueen bolero – in other words, clothes from very different parts of the fashion spectrum, but I felt they worked together. It's through mixing and matching, but careful planning, that you make the outfit your own.

T-SHIRTS & VESTS

GOOD QUALITY T-SHIRTS AND VESTS CAN FORM THE BASIS
OF A GREAT OUTFIT. I often take inspiration from the West Coast of
America where the uniform of choice for most girls and women are
well-cut cotton T's. The American West Coast generally makes the best
T-shirts, cut long in the body and made from super-fine cotton. It's for
the same reason that so many of the best jeans labels come from the West
Coast: California specializes in that laid-back but pulled-together look.
So it's not surprising they do the informal basics so well.

THE CUT

However, you don't need to look across the Atlantic for a decent T-shirt.
The UK high street has plenty of affordable basics on offer and it's
always a good idea to stock up on simple vests and T's. I get mine from
Topshop all the time. In terms of cuts, scoop necks and V-necks look
lovely on most women as they elongate the neck. Obviously, any cut that
plunges is going to make your neck look longer, whereas one that ends
right under your throat can truncate it and can be less sexy. Basically,
just letting your collarbones show is very sexy – actually, almost more
sexy than showing off your cleavage because you give a hint of bareness
without being clichéd and obvious. Because square-necked tops look a

THE BRITISH HIGH STREET IS
MAKING GREAT VESTS THESE
DAYS – LONG, COMFORTABLE,
FLATTERING, IN COOL COLOURS
AND WITHOUT TOO MUCH
STRETCHY FABRIC IN THEM.

My favourite cut is thin-ribbed, long and with a sports back, which is much more flattering than the conventional cut as it gives a nice shape to your shoulders and back.

bit more formal than V-necks and scoop necks, they go best with a more formal outfit, such as smart trousers or a pencil skirt, both of which balance out the broadening effect of the square neck on top as they are narrower on your bottom half. Scoop necks, on the other hand, are very casual and can be worn just with a simple denim mini or denim cut-offs.

With vests, it's often a good idea to get them a size bigger than you need just to make sure that they're long enough, and it doesn't matter so much if they're a bit loose on the sides as you can layer them to keep your modesty intact. Some vests even have built-in support for your boobs so you don't have to worry about getting a bra that won't show through your vest, a look that can be hard to carry off. The British high street is making great vests these days – long, comfortable, flattering, in cool colours and without too much stretchy fabric in them. Lycra always seems to have the miraculous ability of making the vest cling to your body in precisely the places you'd rather it didn't, so always opt for pure cotton. Length, too, is key as this will give you a much nicer shape and will make you look far more pulled together than having a flash of skin poking out.

style
no-no

Lots of people think that wearing a bra that is the same colour as their top will stop it showing through, but this just isn't true. The material of the top will be thinner than that of your bra, so two quite noticeable triangles will be staring everyone in the face every time they look at you. You see this so often with white T-shirts in particular. Instead, wear a flesh-coloured bra underneath because what you really should be trying to match is your skin colour. That will look far more natural. The exception to this rule is if you are obviously letting your bra show through deliberately.

WHAT COLOUR?

The classic colours I recommend for T-shirts and vests are plain navy blue, black, slate grey and white – the most useful colours when it comes to tops as they go with almost everything. Once you find a T-shirt and vest make that you like, buy as many as you can afford because a well-fitting T-shirt is a precious find and stores have an evil habit of discontinuing your perfect style soon after you find it. But even though you might bulk-buy the same style, make sure you get it in different shades to suit different outfits and occasions.

LONG OR SHORT?

I'm not a fan of cropped T-shirts. A simple T-shirt, a vintage belt and a good pair of jeans is a much cooler look. Cap sleeves are particularly popular with high-street stores but they can be tricky. Often they are cut so narrowly they practically cut off your blood supply, which looks as unflattering and uncomfortable as a waistband that's too tight. They also rub into your armpit badly, meaning you'll probably get massive sweat patches; most definitely not a good look either.

WHAT YOU SHOULD BE AIMING FOR IS A NICE SIMPLE LINE, NOT TRYING TO HOIK YOUR BOOBS UP YOUR NOSTRILS.

With long-sleeved shirts, make sure the sleeves are actually long enough, i.e. not ending halfway down your wrist, otherwise your top will look like it's shrunk in the wash. If you're wearing a T-shirt, wear a smooth T-shirt bra beneath it, not a frilly lace one as the lace will poke through the T-shirt and make it look as though you have bumpy breasts. So just go for a plain, underwired T-shirt bra. Lastly, don't wear a push-up bra under a tight T-shirt as that really is too obvious. What you should be aiming for is a nice simple line, not trying to hoik your boobs up your nostrils.

Patterned T-shirts are OK – I've got some really pretty vintage ones – but I do find plain ones more useful. Big prints can look good but I think it's best just to limit them to your accessories because they can be a little gimmicky on clothes and it's really noticeable if you wear them too often. In my opinion, patterns can be more challenging and are the equivalent of someone jumping up and down and shouting, 'Look at my outfit! Hey! Over here! Check it out!' Plain colours, however, are subtler and you can recycle them as much as you like and no one ever notices. They're easier to layer and just go with more of the clothes in your wardrobe.

Some T-shirts with slogans are OK – some are even fashion classics. Katharine Hamnett's T-shirts from the 80s, with oversized political statements, remain one of the defining looks from that decade. Interestingly her T-shirts have had a hip revival of late. It's impossible to talk about 70s fashion without mentioning the Sex Pistols' T-shirts and Vivienne Westwood's punk pieces, and the impact they had on popularizing the punk movement.

I do, however, like vintage rock 'n' roll T-shirts. Shrunken Michael Jackson's *Bad* tour T-shirts? Madonna 'Material Girl' pieces? How can anyone not enjoy those? Wear them with good jeans and heels and you look cool, casual and show you have a sense of humour, which is always attractive. You can find these in any half-decent second-hand vintage shop and, unless they're really rare, they are dead cheap. Urban Outfitters does them too, and you can find mocked-up ones all over the high street. I have found brilliant Rolling Stones and rock T's by a label called Amplified; they even have some with diamanté on, which are great

KATHARINE HAMNETT'S T-SHIRTS FROM THE 80s REMAIN ONE OF THE DEFINING LOOKS OF THE DECADE. HER T-SHIRTS HAVE HAD A HIP REVIVAL OF LATE.

CLEAN UP
OR DIE

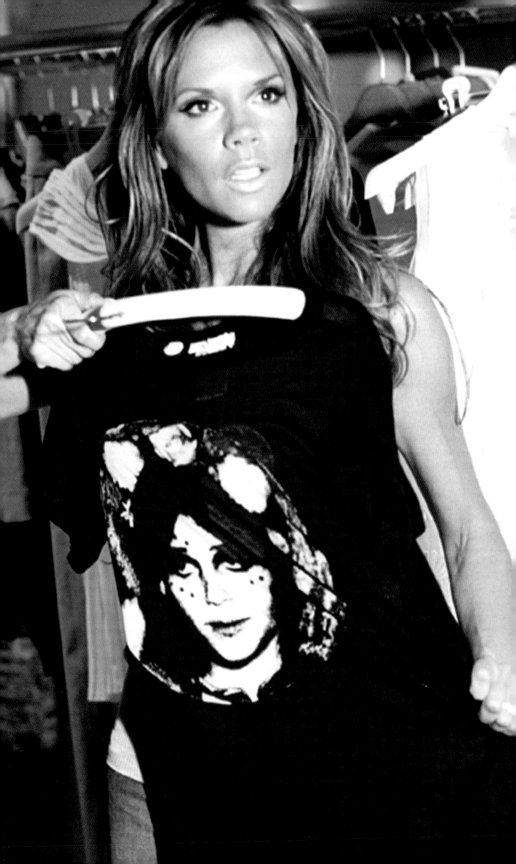

I DO LIKE VINTAGE ROCK 'N' ROLL T-SHIRTS. WEAR THEM WITH GOOD JEANS AND HEELS AND YOU LOOK COOL, CASUAL AND SHOW YOU HAVE A SENSE OF HUMOUR, WHICH IS ALWAYS ATTRACTIVE.

for going out, and they have a great men's range too. On a trip to New York recently, I went to one of my favourite vintage shops, What Goes Around Comes Around, and picked up T-shirts for David from tours by the Beatles, U2 and Abba, which looked just fantastic on him. But no, David is not a secret Abba fan, so let's stop that rumour now.

A word about vintage, though: it's easy to get confused about the difference between vintage and second-hand and that's because they're basically the same. But when I say vintage, I mean something that is relatively old, looks unique and has been checked by an expert to make sure it's good quality. You don't necessarily have to go to a specialist vintage store to get good pieces since you can find them in second-hand charity shops, like Oxfam. Actually, I've given away some pieces to charity shops myself, so you never know, you might walk out with something from my wardrobe for a fiver! In vintage shops, though, they'll generally know more about the history of the clothes and the pieces will have been chosen because there's something special about them, as opposed to being stocked just because people donated them.

In the last edition of this book I said that I was wary of tops with horizontal stripes. One of my mother's style rules when I was a child was never to wear horizontal stripes, and that always stayed with me … until recently, that is. Sorry, Mum, I just had to break a few rules here and there. I have found that a slinky striped sweater dress or fitted T can actually look very stylish. My mum's other style tip, incidentally, is don't eat beetroot because it stains, and I never have to this day.

IN THE LAST EDITION OF THIS BOOK, I SAID THAT I WAS WARY OF TOPS WITH HORIZONTAL STRIPES … UNTIL RECENTLY, THAT IS.

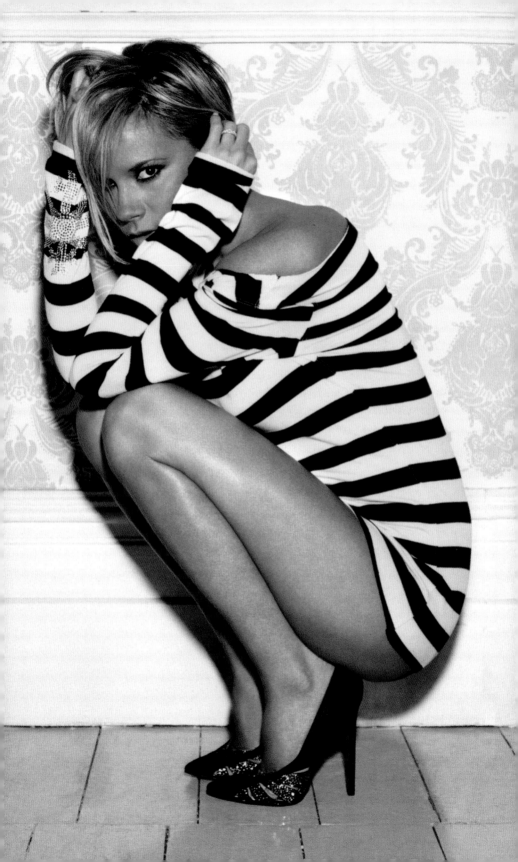

BLOUSES

BLOUSES HAVE HAD A REVIVAL RECENTLY AS MANY
DESIGNERS HAVE RETURNED TO A MORE FEMININE
APPROACH TO FASHION. Worn in the right way, blouses can actually
be very youthful, very cool and very, if subtly, sexy. The best way to
wear them is just with a pair of jeans, a vintage-looking belt and boots;
with a miniskirt they can look a bit finicky and overly girlish, whereas
jeans balance out the blouse's overtly feminine style. The high street has
done this blouse thing really well, with very pretty, well-made ones that
have taken clever cues from designers, particularly, of course, Chloé
and Chanel.

For long-sleeved blouses, the best sleeve style is the classic bellsleeve,
slightly billowing and then cinched in at the cuff, giving your arm a
willowy, elegant appearance. It's one of those looks that girls love and
boys just wonder why we're trying to look like milkmaids.

An easy way to make your blouse stand out a little more is to replace the
plastic buttons that blouses often have with some pretty vintage buttons,
or just unusual-looking ones. There are lots of great button shops in
London, such as the Button Queen in Marylebone and the Button Shop
in east London, but equally you can just go to your local haberdashery
department or even your neighbourhood market stall for some unique
button finds. Replacing shop-bought buttons for unique vintage ones
is a handy tip for all items of clothing, particularly coats, and can
individualize a basic high-street piece to make it look much more striking.

top tip

**Make sure your blouse is not too see-through and, if
it is, slip on a white vest or something similarly simple
underneath, but check that the vest is as long as the
blouse or you'll have that inch or two of tummy visible
through your blouse, which can look a bit fussy no matter
how good your tummy is, or how ladylike your blouse.**

style
no-no

If your blouse is relatively flouncy, with a frilled neck – although you shouldn't go too frilly, especially if you're busty – keep your hair off your neck otherwise you'll look like you're drowning and it all gets a bit Krystle Carrington.

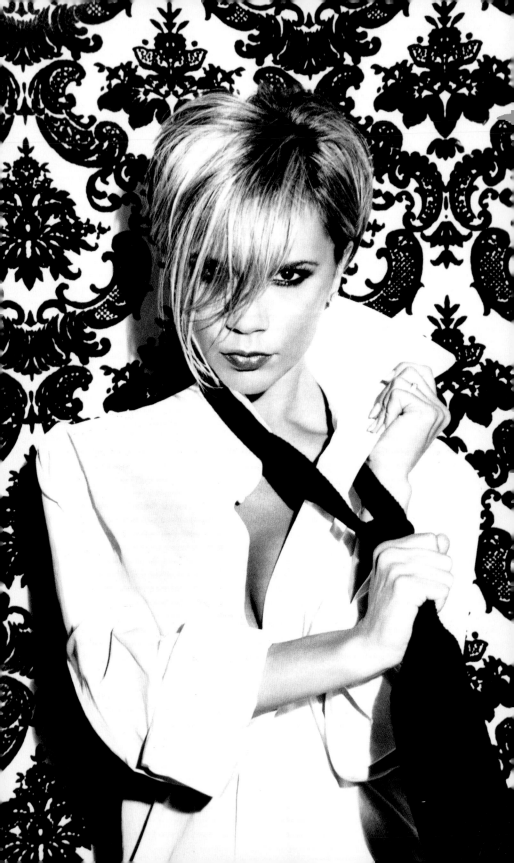

MAKE SURE THE SHIRT IS CRISP, WELL TAILORED, FITTED ALL THE WAY UP TO UNDER YOUR ARMS AND WITH A GOOD, STARCHY COLLAR.

To be honest, I usually find blouses a little too frilly for my taste and instead I prefer to go for men's white shirts cut for women. I really love this look because it's sexy but clean and sharp. Dolce & Gabbana pretty much invented this sexy masculine look back in the 80s and showed how it can be very alluring, for example with a few buttons undone and a good pencil skirt or pair of trousers, and the look, impressively, has never dated. Just make sure the shirt is crisp, well tailored, fitted all the way up to under your arms and with a good, starchy collar. Of course, one must not forget that we have Yves Saint Laurent to thank for designing the most fabulous tailoring for women. In 1966 he created the legendary 'Le Smoking' – the sharp, sexy tuxedo suit that revolutionized the way modern women dress. The look comprises a fitted mannish jacket, tailored trousers, heels and crisp shirt and remains sleek and sexy to this day. Just think of Bianca Jagger in her white trouser suit when she married Mick Jagger and you get the picture.

Shirts cut for women can still sometimes hang in a bit of a shapeless way, so nip them in with a wide belt that sits right above your trousers or skirt, almost like a cummerbund, to give them a feminine shape. Then just wear the shirt either tucked in or over your waistband.

To shop cleverly means buying the simple basics from the high street and maybe spending a little more on tailored pieces where the cut really does matter.

HALTERNECKS

WHILST I'M NOT A FAN MYSELF, a halterneck top is another alternative to wear with your jeans on a night out and some are very pretty. Look for sexy ones from high-street stores like Karen Millen and Whistles. Make sure you wear a bra with them (Marks & Spencer and La Senza do good halterneck ones) as if you don't, and if it's a bit chilly that night, well, everyone will be able to tell just by looking at your top. After all, you don't want to look like you could tune yourself into Radio 1!

WAISTCOATS

SPEAKING OF MEN'S CLOTHES, waistcoats have always been a great way to sex up a pair of jeans. I have bought a lot of vintage men's waistcoats from second-hand stores and had them taken in at the back to fit. The high street has picked up on them in a big way, making sharp ones specifically for women so you don't even need to bother with altering them. Kate Moss created one for her debut collection for Topshop as it was such a staple piece in her own wardrobe.

SWEATERS

I HATE FEELING COLD, like a lot of women, but bundling up under loads of layers isn't my style. Instead, in the winter I rely on polo necks and cashmere V-neck jumpers and I almost always buy these from the high street, particularly Topshop, whose jumpers are often cut brilliantly.

Just remember, if you do wear a polo neck, to keep your hair simple and your neck as clear as possible. A skinny-fit polo neck and a fitted skirt is a great smart-casual uniform for work or play, but steer clear of fussy or excessive jewellery that can overcomplicate matters. I remember wearing a necklace over a polo neck in pictures the day after my engagement to David, but generally I think keeping things as clean as possible is what works best. Polo necks, like all jumpers, should be either super-fitted or deliberately thick and baggy; everything in between just looks sloppy. I would recommend buying slim-fitting knits as they look ultra flattering worn with a pencil skirt or skinny jeans. Super-fine knits are perfect for layering under short-sleeved dresses.

A useful tip is to keep an eye out for designer knitwear in charity shops and vintage stores as you never know what people might give away.

Jumpers can be tricky; if you get a well-cut, well-knit one, you can look fabulous. Designers such as Missoni, Sonia Rykiel, Donna Karan and Bella Freud who specialize in knitwear do

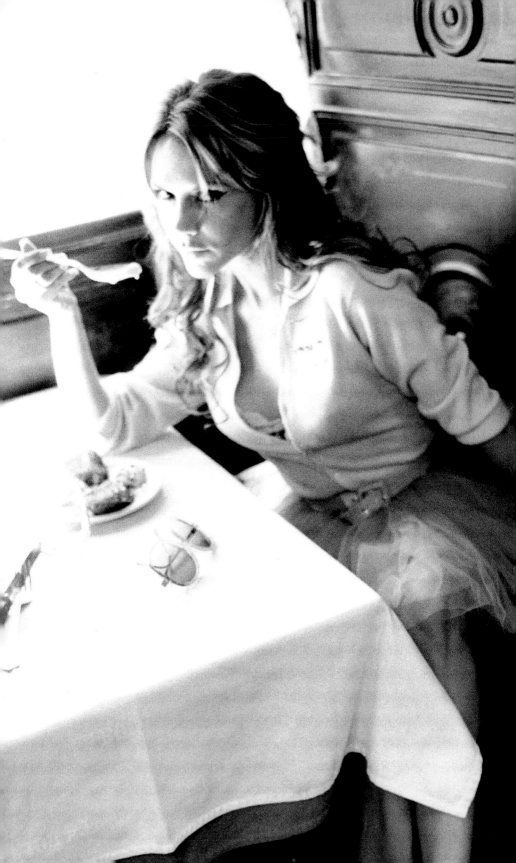

superb sweaters which are very sexy and fashionable. Marc Jacobs became famed for his 3-ply waffle-knit cashmere sweaters that actually looked like thermal vests. Speaking of which, Pringle rose from humble beginnings making woollen underwear (because of the harsh Scottish winters) to the outerwear for which they have become famous: luxury cashmere twinsets and distinctive argyle knit sweaters. If you really want to blow the budget, Chanel does the most amazing twinsets, complete with pearl buttons and silk ribbon trims. The Chanel twinset is a classic, originally designed in the 1920s by Coco Chanel herself, and still looks chic today.

CARDIGANS

CARDIGANS HAVE HAD A LOT OF BAD PRESS IN THE PAST BUT, WORN CORRECTLY, THEY CAN BE VERY STYLISH. I love wearing the really thick, long ones, either from Topshop or by Stella McCartney: you can snuggle down in them, and maybe even belt them up and wear them like a dress with some high-heeled boots. The very cropped cardigans, which end halfway up your back and are almost boleros, look great and are far sexier than a baggy old V-neck jumper. They look a bit *Flashdance* in a good way. Embellished cropped cardigans have become very popular, and it's not surprising as they are just so useful. They can totally make an outfit, even if you are only wearing jeans and a vest, and are perfect to wear with a strappy party dress for a night out. You can find very pretty ones on the high street or in vintage stores.

top tip

The great thing about cropped cardies is that they give you layering and warmth but still show off the shape of your body instead of hiding it beneath huge swathes of material.

NO SWEAT

SWEATSHIRTS AND HOODED TOPS CAN LOOK QUITE CUTE AND SPORTY, as long as you get well-fitting, almost shrunken ones. Those from American Apparel fit beautifully. Marc by Marc Jacobs also does sweet little hooded tops and long-sleeved T-shirts, often in kitschy prints.

One outfit people often ask me about is the tracksuit, and my response is always the same: for non-photographic occasions only. They're great for slobbing around the house in on Sunday mornings and for long-haul flights, but it is hard to find ones that look good, so everyone ends up wearing the same one label. Generally, I am more of a jeans person anyway, but I do love Juicy Couture tracksuits and sweatpants from Abercrombie & Fitch – they are cosy, come in such great colours and have the sexiest cut. So I do wear them while hanging out at home with David and the kids. But you can't have another footballer's wife out and about being photographed in a Juicy Couture tracksuit!

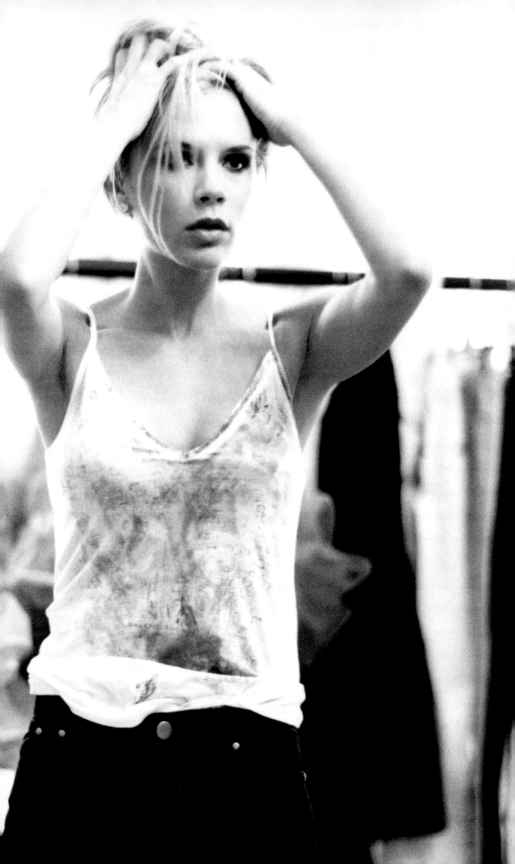

BLOUSE

Blouses have had a comeback in a big way, particularly those with billowing sleeves and ruffles. The best way to wear them is with a pair of good jeans, a vintage-looking belt and boots.

My favourite *vest* make is Abercrombie & Fitch, which is an American label, and their vests are really fantastic – thin-ribbed, long and with a sports back, which is much more flattering than the conventional cut as it gives a nice shape to your shoulders and back.

VEST

CARDIGAN

I really like *cardigans*, and, worn correctly, they can look
totally sexy. They either have to be super slim or long and chunky.
Anything in between just looks dull and frumpy. I love wearing the thick,
long ones that you can snuggle down into or maybe even belt up.

In the winter I rely on polo necks and cashmere *V-necks*. I always
get these from the high street. I think a V-neck jumper, scarf and jeans is
a perfect winter date outfit.

V-NECK

WHERE TO BUY

1. T-SHIRTS: Abercrombie & Fitch, American Apparel, Amplified, APC, C&C California, Cherokee, H&M, Mango, New Look, Splendid, Topshop, Vanessa Bruno

2. LONG-SLEEVED TOPS: Abercrombie & Fitch, Benetton, C&C California, Cherokee, H&M, Mango, Marks & Spencer, Topshop, Uniqlo, Urban Outfitters, Whistles

3. VESTS: Abercrombie & Fitch, Anonymous by Ross & Bute, C&C California, CK Calvin Klein, Ella Moss, Gap, H&M, James Perse, Mango, Petit Bateau, Topshop, Uniqlo, Vanessa Bruno, Zara

4. BLOUSES: 3.1 Phillip Lim, Chloé, Coast, Diane von Furstenberg, H&M, Miu Miu, Paul & Joe, Principles, Reiss, Sara Berman, Sass & Bide, See by Chloé, Topshop, Whistles, Zara

5. CLASSIC SHIRTS: Alexander McQueen, APC, Bottega Veneta, Florence & Fred, Gucci, Hobbs, La Redoute, Margaret Howell, Paul Smith, Ralph Lauren, Thomas Pink

6. HALTERNECK TOPS: Dolce & Gabbana, Fornarina, H&M, Karen Millen, Mango, Miss Selfridge, Miss Sixty, Morgan, Topshop, Warehouse, Whistles

7. WAISTCOATS: Dolce & Gabbana, Karen Millen, Mango, Principles, Reiss, second-hand stores, Stella McCartney, Topshop, Urban Outfitters, Zara

8. SWEATERS: Bella Freud, Benetton, Brora, Chanel, Donna Karan, Florence & Fred, John Smedley, Marc by Marc Jacobs, Missoni, Pringle, Pure Cashmere, Sonia Rykiel, Stella McCartney, Toast, Topshop, vintage stores, Whistles

9. CARDIGANS: Benetton, Chanel, Day Birger et Mikkelsen, Dorothy Perkins, H&M, Jigsaw, John Smedley, Joseph, Kookaï, LK Bennett, Marc by Marc Jacobs, Monsoon, Oasis, Paul & Joe, Principles, Topshop, vintage stores, Whistles, Zara

10. SWEATSHIRTS AND HOODED TOPS: Abercrombie & Fitch, Adidas, American Apparel, Gas, H&M, Hummel, Juicy Couture, Miss Selfridge, Pepe Jeans, Puma, Topshop

NOTES

skirts

&

day

dresses

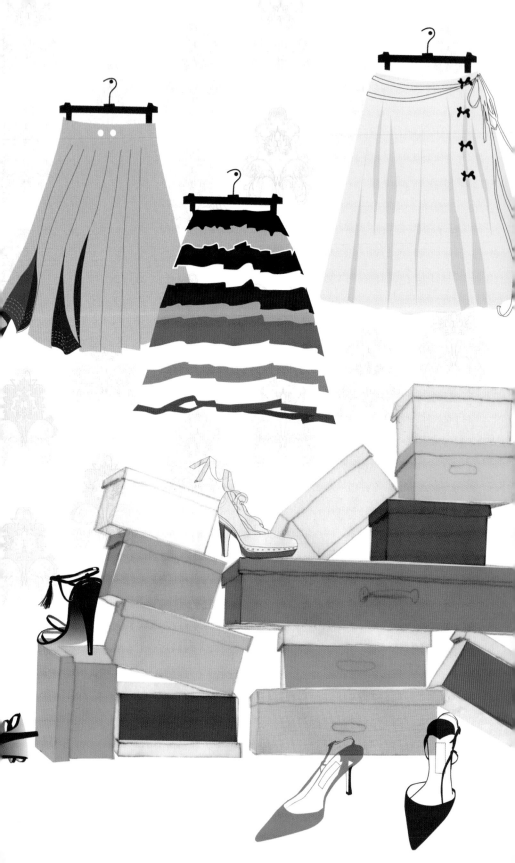

The question of whether to wear a miniskirt or a longer skirt tends to settle itself as you get older.

I USED TO WEAR MINISKIRTS ALL THE TIME IN MY TEENS AND TWENTIES, but these days, as much as I still like them, I increasingly find myself leaning more to A-line and pencil skirts that end just on or below the knee. They're elegant, but still sexy. A-line skirts are often much more flattering in proportion to your leg than miniskirts and you can wear them with some really fabulous shoes or boots; flats work for a ballerina-type look, but I prefer heels to give myself a bit of a lift.

THE A-LINE SKIRT

A few basics to share with you:
1. Pair an A-line skirt with a V-neck top or a cardigan and you've got a really pretty outfit that you'll feel both comfortable and sexy in.

2. Be careful when you wear A-line skirts with shoes with ankle straps as this will interrupt the relatively short leg line you already get with a knee-length skirt, making your legs look stumpy.

3. Look for skirts that hug neatly around the hips before flaring out in an A-line, as opposed to falling into pleats from the hips. The latter can give you an unfortunate tent shape, expanding the shape of your bottom.

4. Have fun with patterns and prints. A printed skirt is a good way to wear colour (just team it with a plain-coloured top). If your skirt is A-line it won't cling to the body and make you look like you've been mummified in a test pattern – stick to florals or delicate prints for extra wearability.

One style that I really love is a starchy tulle skirt. They can really prettify an outfit in a *Sex and the City* manner and, like A-line skirts, are very flattering on the legs. You can always find them in vintage shops such as Patricia Field's shop in New York, and they are almost always very cheap. Wear it with a narrow, body-skimming top, maybe even a plain leotard, to balance out the volume on your bottom half. And don't forget: you can always wear your tulle skirt underneath a plainer one, acting like an old-fashioned hoop skirt for extra volume!

ONE STYLE I REALLY LOVE IS THE STARCHY TULLE SKIRT ... WEAR IT WITH A NARROW, BODY-SKIMMING TOP TO BALANCE OUT THE VOLUME ON YOUR BOTTOM HALF.

THE MINISKIRT

Of course, I'm not dismissing miniskirts. Anyone who has ever seen photos of Naomi Campbell, Cindy Crawford, Christy Turlington and Linda Evangelista working the miniskirt on the Versace catwalk back in the 80s knows that they can look undeniably fantastic. I still love to wear them in the summer and there are endless options on the high street. You just need to bear in mind how to balance the look:

1. If you're wearing quite a short miniskirt, counteract it with a modest cardigan over a non-cleavage-tastic top, tone down your make-up and keep your hair simple.

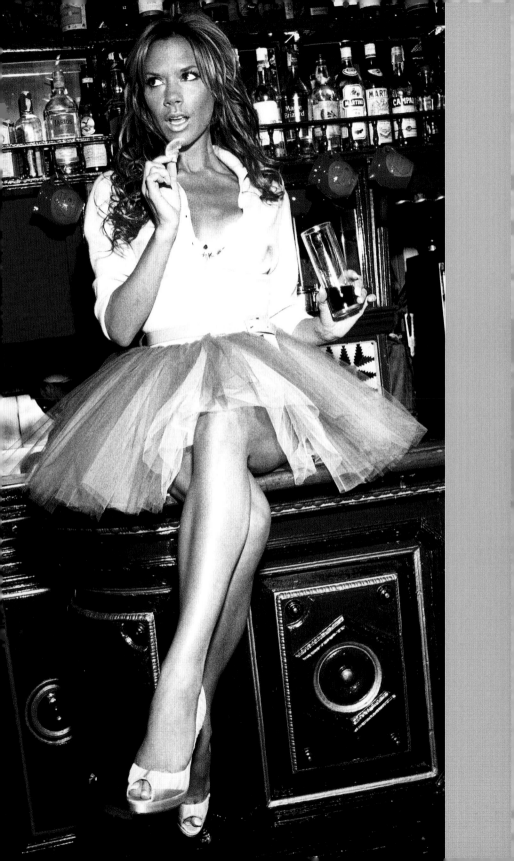

2. Make sure that the skirt is not so short that everyone can see your knickers whenever you bend over or get out of a car. For that matter, make sure you're wearing knickers – which may seem like an obvious point but I've seen people getting out of cars with no knickers on!

3. Look for clever underwear tricks when wearing miniskirts; you can find miniskirts with built-in knickers to really protect your modesty, which is a genius idea. Boy-shorts are a safer bet than G-strings, but failing that, it's Bridget Jones-style knickers underneath!

4. Be careful when wearing denim skirts as they have an unfortunate habit of slipping upwards all too easily whenever you sit down. A little too 'ride 'em cowboy', if you know what I mean!

5. Denim skirts are also prone to sagging a little at the front of your waistband after too many wears, giving you a funny bulge around the tummy, or making it look like your skirt is straining to hold in a pot belly. Avoid this by looking after them properly: wash them frequently at a cool temperature, lay them out flat to dry and finish with a quick once-over under a hot iron.

6. Always check your back view before you buy any kind of miniskirt. So often you see people in the street wearing minis that are just WAY too short at the back. Some designers have rather cleverly cut their miniskirts to hang longer in the back to avoid this 'shortfall'.

BE MINDFUL OF THE RULE THAT IF YOU GET YOUR BOOBS OUT, PUT YOUR LEGS AWAY AND VICE-VERSA. YOU WILL LOOK BETTER AND FEEL MORE CONFIDENT AND COMFORTABLE.

THE LONG SKIRT

Long skirts can look elegant, but wear them with a structured or even quite sexy top to balance out the proportions. Keep your top half clean and uncluttered: wear just a vest, for example, and, instead of a cardigan, go for a bolero or even a shrug so you don't have anything loose around your torso at all. Of course, you can reverse the proportions and wear a plain short skirt with a really ruffly top, but if you have a bust and long hair this can make you end up looking strangely top-heavy and a bit stifled.

And finally, be mindful of the rule that if you get your boobs out, put your legs away and vice-versa. You will look better and feel a lot more confident and comfortable, which will then really come across in your whole attitude.

THE PENCIL SKIRT

The pencil skirt is a shape that is going to flatter a woman. It holds everything in, doesn't add volume and gives a gorgeous hourglass shape. I love that 50s silhouette because it's seductive but ladylike – far subtler than G-strings falling out of jeans. And it really is a timeless shape – after all, it's flattered women for the past fifty years! My favourite way to wear it is to make a whole look out of it, kind of sexy secretary, with a fitted masculine shirt, a good bra and some beloved high heels or boots. It's a look that really suits my shape as it gives me some curves, but it also really works on curvier women. Roland Mouret, who probably makes the best pencil skirts, once told me that he designs all of his clothes with a size 14 figure in mind and I've seen his clothes work on size 16s as well as size 8 models, proving that it's not just a style for skinny minnies. The fact that he has got to be one of the best-looking designers in no way compromises my incorruptible fashion judgement, I promise! Alexander McQueen also designs amazing pencil skirts – all Hitchcock heroine, very feminine and beautifully made. In his new diffusion line, McQ, McQueen has made some great, affordable ones in denim, giving them a bit more of a youthful kick but still using that classic, slender yet curvy McQueen cut. Otherwise, go to high-street stores that are aimed at the older end of the market as opposed to the more youthful, as it is a more mature style. A well-cut sexy skirt should be able to take you from desk to date instantly.

top tip

I sometimes make my own skirts out of long, tasselled vintage shawls, which are brilliant when you're on holiday as they can double up as evening cover-ups, meaning you get two uses out of one garment. As a skirt, I just pin it up on my hip with a big vintage brooch and it makes a really lovely individualized outfit, perfect with flip-flops on the beach during the day or with a vest and pretty sandals for cocktails in the evening.

A little black dress is an essential every woman should have in her wardrobe. A simple black pencil dress is probably one of the most useful things you can own because you can dress it up in so many different ways and no one will realize you're wearing the same thing over and over – you can wear it with flats for coffee with your girlfriends, you can wear it with heels and pearls. It is worth considering spending a little more if you can afford to on classic dresses – your LBD and perhaps a tweed shift – as they should last for years and they'll always be in style. Dresses on the high street are great, but they are often more trendy than classic, perfect for just one season but not really long-term prospects. Having said that, as previously mentioned, my little one from Miss Selfridge served me pretty well all those years back in the Spice Girls.

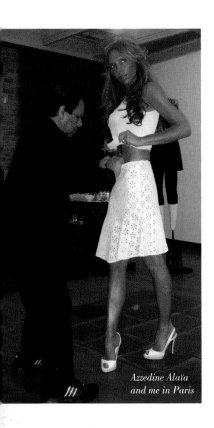

Azzedine Alaïa and me in Paris

When it comes to the little black dress, no one can surpass the master dressmaker Azzedine Alaïa in my opinion. I really do think that he is probably the best when it comes to cutting clothes properly so that they suit a woman's shape. David recently took me on a surprise trip to Paris, which was so exciting. The icing on the cake was when he took me to Azzedine Alaïa's showroom because he knows just how much I love that label and, amazingly, Mr Alaïa himself was there! I was so nervous but he turned out to be such a kind man, as well as being a genius. Anyway, he really took me through how he cuts his clothes and how they should fit and make you feel. And if you're going to learn these things from anyone, I have to say that Mr Alaïa is a pretty good place to start: it's hard to think of a better teacher than someone who himself was once taught by Christian Dior.

THE PROM DRESS

Prom dresses have become popular in the past few years and they can look adorable. The best kind to get are ones with 50s prints – mini poodles, for instance – taking the look to the tongue-in-cheek extreme. Great for parties and special occasions, prom dresses are available all over the high street now, from Ted Baker to Monsoon to House of Fraser. Topshop often have some really cute ones in their vintage Peekaboo range. For extra fun you can always plump up the skirt by putting an extra net petticoat underneath. The beauty of prom dresses is that they look fantastic at any time of year – they're a timeless classic with a nod to 1950s retro chic. But on a more practical note, I will always keep a large space in my wardrobe for simpler shapes: slip dresses and pencil dresses.

THE WRAP

You'll be surprised at how versatile some dresses are: wrap dresses, of course, are the obvious example and I am so pleased they've come back into fashion again. They are the ultimate proof of how the best fashion usually comes from the simplest formula. Because the cut is so clean, you can have a lot more fun with the patterns and colours.

Another advantage of the simplicity of wrap dresses is that the high street has been able to do its own really good versions of this Diane von Furstenberg classic. Honestly, once you have a wrap dress you really will, as they say, wonder how you managed without. They are the perfect thing for work with a pair of boots, for summer holidays with some flip-flops, and for dates with a fabulous pair of heels. Plain colours work well for the office, whilst wrap dresses in graphic prints or even leopard print can look ultra-sexy – perfect for dinner dates and parties. When von Furstenberg first created the wrap dress back in the 70s, it was seen as almost a feminist garment because it gave women such freedom, and, thirty years on, I can't think of a more stylish or practical fashion nod to feminism.

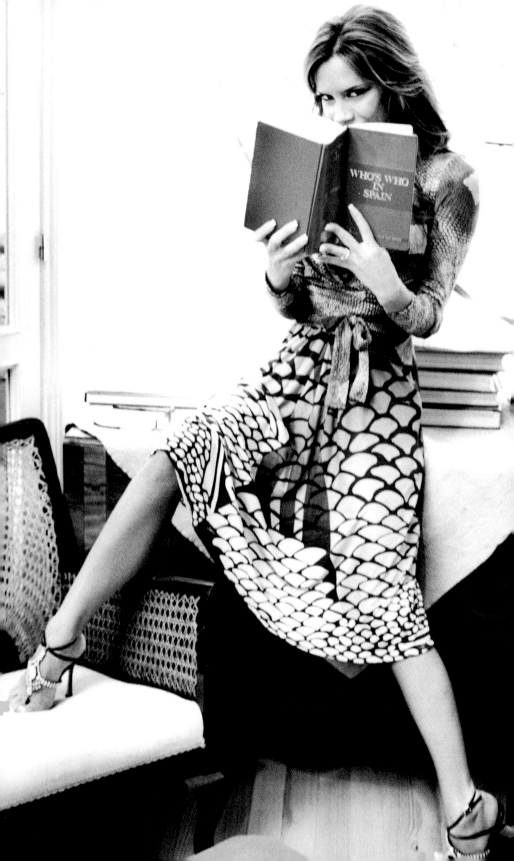

Shirt dresses are also very simple. Although they're not something I wear very often, when I do, I like to sex them up a little, giving them a bit of a shape, for example with a belt and a fabulous pair of heels. A flirtier variation you can try is an extra-long thin knit (but not too thin!) jumper belted around your hips, but just make sure it really is long enough to be decent. I often do this with David's jumpers for summer evenings. Stella McCartney makes some seriously sexy sweater dresses and they look great worn with opaque tights and ankle boots. Extra long boys-style cardigans belted at the waist can also do a similar job; the key is to wear them with confidence.

Vest tops that have been lengthened into little summer cotton dresses are also great, and can be worn on the beach (they are the perfect thing to slip on when you come out of the sea as they dry so quickly) or back at home. Cotton tunics or short smock dresses look great in the summer with tanned legs and flat sandals.

STELLA MCCARTNEY MAKES SOME SERIOUSLY SEXY SWEATER DRESSES.

HOW TO WEAR IT

Dresses in general are amazingly useful, mainly because you can wear the same one in many different ways by just changing your shoes.

1. LITTLE COTTON DRESSES are one example: with high-heeled sandals they're great for a dinner date, with simple flats they're perfect for weekend lunches with friends, and these really are the easiest thing in the world to find on the high street.

2. A JUMPER DRESS works in so many situations as it looks smart enough for going out for a nice meal, but not too formal that you couldn't wear it to go shopping with your girlfriends. Wear it with boots and you've got an outfit that is cool without looking like you're trying too hard. They keep you warm – a rare quality in a dress! – and are the perfect thing if you're having a bit of a bloated day before your time of the month.

3. A ONE-SHOULDERED DRESS always looks sexy. Look for one that doesn't have sleeves and is maybe even belted, so as not to look bulky – it's good to give a sense of your real shape beneath.

4. EMPIRE-LINE DRESSES are also good for those bloated days, but that's not to say it is a fail-safe style. For a start, a badly cut one – when it doesn't really follow the shape of your body – can easily make you look pregnant, and while there's nothing wrong with this if you actually are pregnant (as a mother of three I should hope not!), it might not be a look you are going for otherwise. It's also incredibly difficult to pull off if you have any kind of bust whatsoever; the fabric juts out over your boobs and then falls straight down, giving you a really weird cliff-like appearance. Empire-line dresses work best on women who are relatively flat-chested.

5. BABY-DOLL DRESSES can look really cute and sexy – dress them up with high-heeled sandals. Make sure this style of dress fits you properly around the bust and doesn't splay out too much around your midriff, otherwise you'll spend all day having people ask you when it's due!

The perfect date dress is one that gives a hint of sexiness – but just a hint – and shows off the best of your body shape, but is also comfortable so you don't spend the whole evening fidgeting with it and you can concentrate on being sparkly, witty and fabulous. On one of my first dates with David I wore a brown suede dress from Oasis with a round neck and a belt at the waist. I picked it because it was flattering and comfortable and fulfilled my dress criteria – covering my top half but getting my legs out. David still talks today about how much he liked that dress. I always think Kate Moss does date outfits very well: a simple vintage dress and scruffy hair, and it looks easy and fabulous.

I think one of the best date outfits that I've ever worn was a silk full skirt that puffed out a little, a plain V-neck Joseph jumper, pointy court shoes and smooth glossy hair – trying to go for a bit of a ladylike look. Simple, flattering and really pretty without looking like I'd given it too much thought, whereas in reality, of course, I'd planned it all well in advance! Looking effortless is actually fashion code for 'this involved lots of thought' and it is a tragic truth that this generally is the best strategy. But it's only through careful planning that you can achieve that look. Ironic, don't you think?

I ALWAYS THINK KATE MOSS DOES DATE OUTFITS VERY WELL.

But this does not mean you should spend every waking hour thinking about your clothes. Being a mother has taught me how not to waste so much time faffing about in the wardrobe every morning, simply because I don't have a spare minute. Necessity is the mother of invention and all that, and so I multitask, planning outfits while I'm doing something else: getting ready for bed or taking a bath. You can get massively stressed as a mum and often feel you never have any time to yourself, but you do learn how to get things done more quickly and often you do them just as well as when you used to spend ages thinking about them.

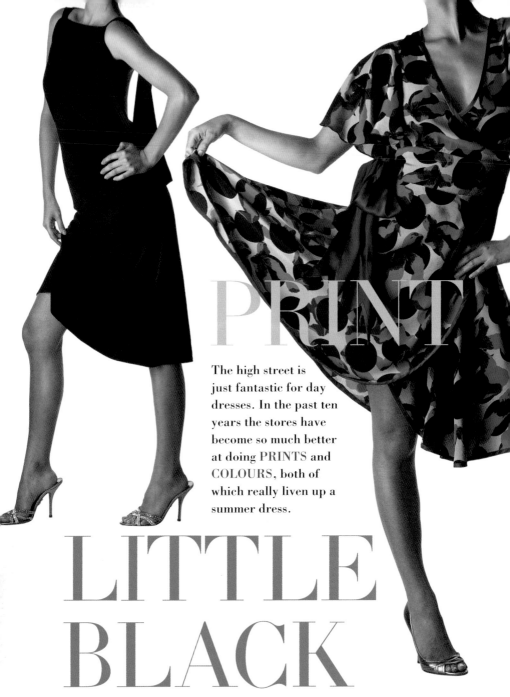

PRINT

The high street is just fantastic for day dresses. In the past ten years the stores have become so much better at doing PRINTS and COLOURS, both of which really liven up a summer dress.

LITTLE BLACK

It's worth spending a little more on your LITTLE BLACK DRESS as this is a dress that should last for years and it'll always be in style.

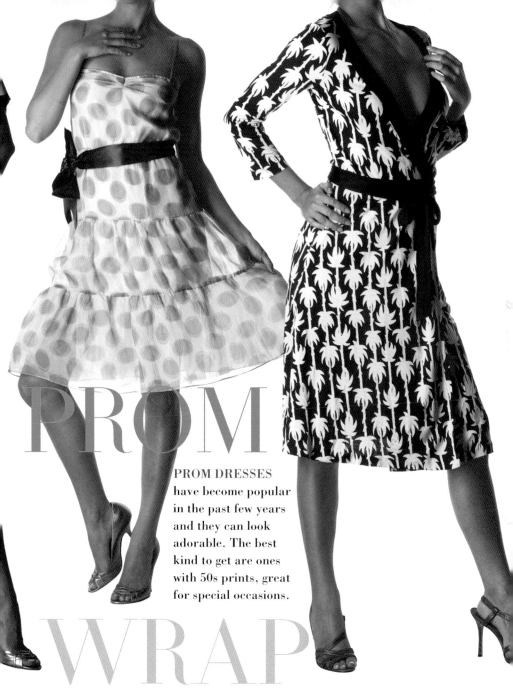

PROM

PROM DRESSES have become popular in the past few years and they can look adorable. The best kind to get are ones with 50s prints, great for special occasions.

WRAP

WRAP DRESSES are the ultimate proof of how the best fashion usually comes from the simplest formula. Because the cut is so clean, you can have more fun with patterns and colours.

I adore one-piece dressing and a *well-cut designer dress* can make you feel like a million dollars. One of my favourite designers of late is Giambattista Valli, who previously designed for Emanuel Ungaro. He designs very simple, beautifully feminine and body-conscious dresses in gorgeous fabrics but with a pretty bow here and there to break up the simplicity of the line. I love his warm Italian passion which is fused with a classic French style of dressing. Other dress designers that have caught my eye are British boys, Christopher Kane, Giles Deacon and Marios Schwab. Christopher Kane's youthful energy combined with a talent for creating über-sexy evening dresses caught the attention of Donatella Versace herself, and he became her protégé. Kane was fortunate enough to have Donatella's support for his debut collection at London Fashion Week, and all his models were supplied with brand-new Versace shoes! Giles is another contender on the London scene, and has a loyal celebrity following, including Linda Evangelista and Naomi Campbell. His glamorous eveningwear has a 1990s twist to it, yet his dresses are uniquely modern and sexy. Marios Schwab cuts some of the best little black dresses, and I admire his style. Both designers create sexy, body-hugging dresses in black jersey – a staple in any woman's wardrobe.

With persistence and a keen eye you can often get lucky in scoring a drop-dead gorgeous dress on the high street. The high street is just fantastic for day dresses. In the past ten years the stores have become so much better at doing prints and colours, both of which really liven up a summer dress. Designers on the high street are looking more and more to vintage clothes for inspiration. H&M and New Look in particular have started doing really fantastic dresses in delicate, unusual prints that look almost vintage. H&M is a key player in joining forces with designers such as Karl Lagerfeld, Stella McCartney and Viktor & Rolf, creating sell-out one-off collections of stunning designer dresses and clothes available at high-street prices. The success of these collections is phenomenal and Brit designer Giles Deacon's Gold label for New Look has had equal success. There really are some fantastic gems on the high street, so keep your eyes peeled for the next designer collaborations to hit the stores. Topshop is famous for fostering talent with new designers: Preen, Peter Jensen and Marios Schwab, young gems on the London Fashion Week circuit, have all successfully designed capsule collections

for the high-street mecca. Their designer dresses are some of the stongest items in the collections.

As for the rest of the high street, Reiss has some gorgeous occasion dresses, but at a slightly higher price point – great for weddings and parties though. Monsoon does lovely prom-style dresses, perfect for special occasions, in addition to pretty, long, summery dresses, which are great to take on holiday. Primark and, even more recently, Peacocks have improved lately by an enormous extent, producing pretty summer smock dresses, mini-dresses and shifts in gorgeous prints and fabrics at unbelievably good prices.

As well as the high street improving, *supermarkets* have wisely stepped up their game on the fashion front, competing with each other to produce the most fashion-forward collections. You can pick up some famously good bargains here, and day dresses form the staple of most collections. Tu at Sainsbury's and George at ASDA are both good, but the best is probably F&F (Florence & Fred at Tesco), which takes very clever tips from the shows each season. The best thing is that you can afford to indulge in a little flirty dress here and there and it won't cost you the earth.

106 *skirts & day dresses*

SUPERMARKETS HAVE STEPPED UP THEIR GAME ON THE FASHION FRONT, COMPETING WITH EACH OTHER TO PRODUCE THE MOST FASHION-FORWARD COLLECTIONS.

Some designers have also started making really good-value lines for *catalogues*, which is obviously extremely convenient if you just don't have the time to trawl the shops. La Redoute, a French mail-order catalogue, is both the best-known and the best in that respect. Designers like Karl Lagerfeld, Jean Paul Gaultier and Emanuel Ungaro have all designed ranges for the catalogue. They have even done a range of pretty dresses by Paul & Joe Sister, one of my favourite French designers, and a heritage line of Courrèges dresses. Another good catalogue is Additions, which has an amazing collection of Amanda Wakeley dresses. Freemans is excellent too and offers many brand names at competitive prices.

top tip

'A simple day dress that skims the legs and hips, has a defined waist and good support for your boobs is the perfect thing for a weekend lunch out with your husband.'

WHERE TO BUY

1. A-LINE SKIRTS: Azzedine Alaïa, Cacharel, Celine, Chloé, Day Birger et Mikkelsen, French Connection, Jigsaw, Joseph, Marc by Marc Jacobs, Miu Miu, Nanette Lepore, Prada, Principles, Vanessa Bruno

2. TULLE SKIRTS: Blackout II, Cornucopia, Peekaboo Vintage at Topshop, Rokit, Steinberg & Tolkien, second-hand stores and vintage shops

3. MINISKIRTS: D&G, Gucci, Guess, Karen Millen, Kookaï, Luella, Mango, Morgan, Reiss, Roberto Cavalli, Topshop, Versace

4. DENIM MINISKIRTS: Abercrombie & Fitch, Chip & Pepper, CK Calvin Klein, dVb, Earnest Sewn, Fornarina, Levi's, Pepe Jeans, Topshop, True Religion, Urban Outfitters

5. LONG SKIRTS: Benetton, Coast, Day Birger et Mikkelsen, Diane von Furstenberg, DKNY, Ghost, Hobbs, MaxMara, Principles, Reiss, Topshop, Whistles

6. PENCIL SKIRTS: Alexander McQueen, Burberry Prorsum, Celine, Dorothy Perkins, George at ASDA, Giambattista Valli, Gucci, Joseph, Karen Millen, La Redoute, Mango, Next, Paul & Joe, Prada, Zara

7. OFFICE SKIRTS: Coast,
Diane von Furstenberg, Episode, Florence & Fred,
H&M, Hobbs, Jaeger, Joseph, Mango, Marks & Spencer,
Principles, Reiss, The West Village, Wallis, Whistles, Zara

8. THE LBD: Alexander McQueen, Azzedine Alaïa, Calvin
Klein, Chanel, D&G, Donna Karan, Giambattista Valli, Gucci, Karen
Millen, Kookaï, Marios Schwab, Miss Selfridge, Morgan, Next, Oasis,
Reiss, Roberto Cavalli, Topshop, Warehouse, Whistles

9. SUMMER DRESSES: Cacharel, Chloé, Day Birger
et Mikkelsen, Diane von Furstenberg, Florence & Fred, H&M, Issa,
Joseph, Marc by Marc Jacobs, Miss Selfridge, Miu Miu, Monsoon,
New Look, Nicole Farhi, Paul & Joe, Peacocks, Primark, Reiss, Sara
Berman, Tocca, Topshop

10. WRAP DRESSES: Diane von Furstenberg, Dorothy
Perkins, French Connection, Hobbs, Issa, La Redoute, LK Bennett,
Marks & Spencer, Next, Oasis, Principles, Reiss, The West Village,
Zara

11. EVENING DRESSES: Alexander McQueen,
Azzedine Alaïa, Calvin Klein, Chanel, Christopher Kane, Coast,
D&G, Donna Karan, Giambattista Valli, Giles, Gucci, Karen Millen,
Oasis, Reiss, Roberto Cavalli, Topshop, Warehouse, Whistles

12. SWEATER DRESSES: All Saints, French
Connection, Joseph, La Redoute, Miss Selfridge, Sonia Rykiel, Stella
McCartney, Topshop, Warehouse

NOTES

accessories

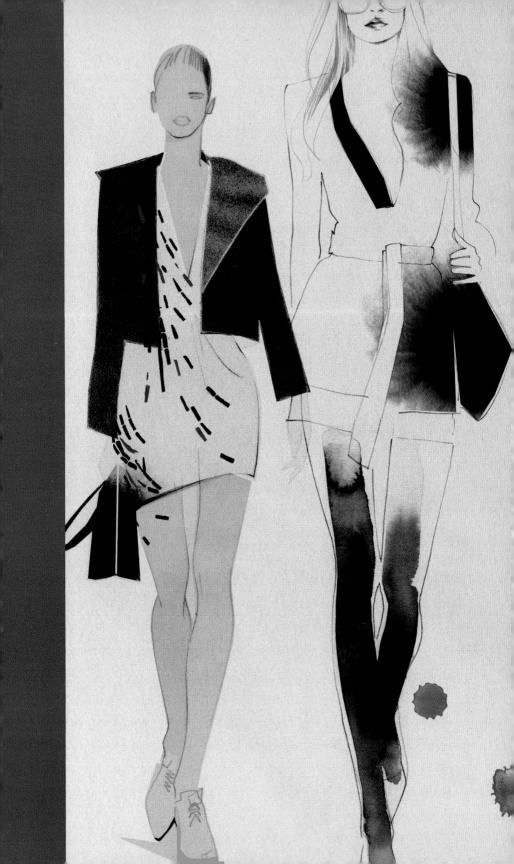

Find me a woman who doesn't love accessories! They are like toys for grown-ups, aren't they?

THEY PERSONALIZE AN OUTFIT, THEY OFTEN LAST A LOT LONGER THAN CLOTHES AND THEY CAN BE A GOOD, QUICK AND NOT TOO EXPENSIVE TREAT ON DAYS WHEN YOU REALLY NEED ONE. Good shoes and bags, for example, should last you decades, if not longer. I always think it's so cool when you see young women carrying around their grandmother's old Hermès bag: not only are those bags obviously beautiful, but it's as if they're carrying a piece of their family history with them.

top tip

It's smart to spend more on things that rely on cut and quality and that you'll use a lot – like jeans, little black dresses, good quality shoes and handbags – and then save on the simpler, more trend-led pieces that won't last as long.

It's worth spending more on your accessories as you'll tend to use them more than most of your clothes: after all, you'll carry your bag every day, whereas you probably won't wear the same dress nearly so often.

I've always been an accessories junkie. When I was a kid, a friend of my mum's gave me a Gucci carrier bag after she bought some shoes there. I loved that bag and carried all my school books round in it for ages until the bottom of the bloody thing fell out completely. But it just goes to show how you can personalize your look with some of the most unexpected accessories and I can't think of anything that says more about me when I was that age than a Gucci carrier bag instead of a school satchel. It also reflects how accessories can be a cheaper and more sensible way of giving you that designer-name fix, and in those days I certainly didn't have much spare cash. Anyway, I guess it isn't all that surprising that the first designer handbag I ever bought was from, yes, Gucci.

WHEN I WAS A KID, A FRIEND OF MY MUM'S GAVE ME A GUCCI CARRIER BAG AFTER SHE BOUGHT SOME SHOES THERE. I LOVED THAT BAG AND CARRIED ALL MY SCHOOL BOOKS ROUND IN IT.

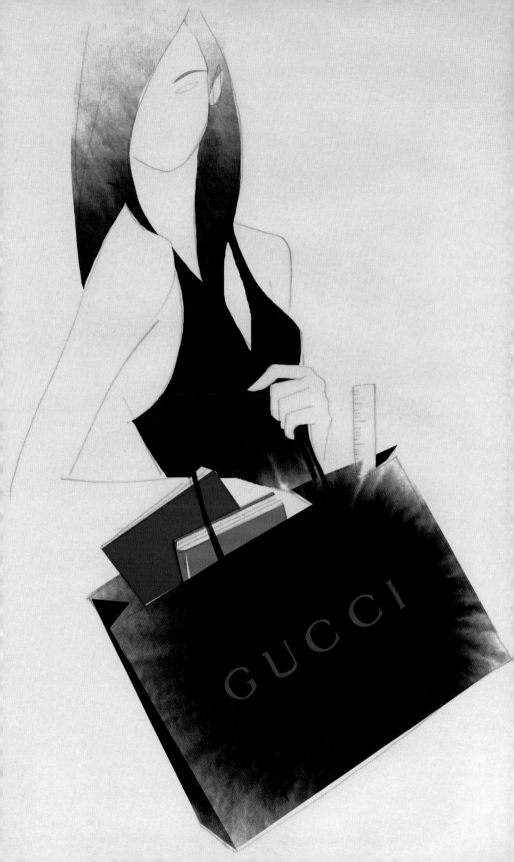

TO VICTORIA
YOU LOOK AMAZING
IN MY DRESS
XXXX??!
ROLAND

Love
Richard

I remember that when I got my first pay cheque from appearing in the musical show *Bertie*, my sister, Louise, and I rushed down to Patrick Cox first thing on a Saturday morning and queued up to buy a pair of Wannabes, which were very much the thing to have then. I didn't have enough to buy two pairs so we bought one pair, some white slingbacks, to share. I was so proud of those shoes I just wanted to wear them every single day. I probably did, actually, whenever Louise wasn't wearing them herself, of course! And funnily enough, just to show that you can never guess what life's going to bring you, Patrick is now one of my friends. When I met him a few years after the Wannabe triumph, that story was one of the first things I told him and he just loved it, proving that designers get as excited about you loving something they've made as you do about buying it.

That, I have to say, has been one of the nicest discoveries I've made since I've started meeting more designers. At a big fashion party recently, I wore a beautiful Roland Mouret dress that just worked so well with my body shape, with a tight top half and a ballerina-style skirt. Then who do I bump into there but Roland himself! I loved that dress and felt fantastic to be wearing it – it's a real fairy-tale dress.

AT A BIG FASHION PARTY RECENTLY, I WORE A BEAUTIFUL ROLAND MOURET DRESS THAT JUST WORKED SO WELL WITH MY BODY SHAPE, WITH A TIGHT TOP HALF AND A BALLERINA-STYLE SKIRT ... IT'S A REAL FAIRY-TALE DRESS.

shoes

SHOES ARE PROBABLY EVERY WOMAN'S NUMBER-ONE
ACCESSORY. Maybe it's a Cinderella complex, but there is just such
pleasure to be had in looking down at your feet and seeing something
fabulous. Even if you have to wear a sensible suit to the office, you can
slip on a pair of really cool or pretty shoes and, during a particularly
dull meeting, just tug up your trouser legs, look at them and reassure
yourself that you're not turning into some office clone.

top tip

❝The most useful kind you can possibly own is a pair of tan
high-heeled shoes, with either pointed or open toe.
Not only do they elongate your leg, because it looks as if
you're not wearing shoes at all, but because they are a
neutral colour they will go with pretty much any outfit and
dress it up. ❞

"Open-toed shoes can elongate your legs as they can give the illusion that the line of your leg goes on for ever ... Of course, you have to be practical sometimes: a woman wearing open shoes in the rain in winter can look ridiculous, especially with muddy puddles gathering between her cold little toes."

POINTED OR ROUND?

There are some lovely round-toed shoes about nowadays – Chloé and Marc Jacobs make pretty patent ones and they've been copied on the high street, with Kurt Geiger in particular doing really fabulous ones.

Round-toed shoes do look good with full knee-length skirts, and they can make your feet look smaller too. But I find I just get more wear out of pointy-toed shoes. I also know that pointed shoes give me more of an illusion of height, so I instinctively reach for them in my closet.

So, as is often the case, there is no real right or wrong decision – it just comes down to what pair makes you feel better and more confident when you wear them.

SHOE SIZING

Never, ever, buy a pair of shoes that are too small, no matter how much you love them. Remember: if they pinch just a little when you try them on in the shop, imagine what they'll feel like at the end of a working day. You'll just end up never wearing them and feeling very cross with yourself when you see them in the closet every morning. If you have fallen in love with a pair of shoes but the shop doesn't have your size, and if the shoes are closed-toe, go up a size; you can then take them to a

cobbler, like Timpsons, and have a pad put in. This won't work, however, if the shoes have ankle straps, as these will just bag around your leg.

When trying on new shoes, do it towards the end of the day when your feet have had a chance to expand. That way you won't end up buying a pair too small for you.

If you're self-conscious about your ankles, particularly if they tend to swell up during that time of the month, then ankle straps are definitely best avoided because they do draw attention to water retention. T-strap shoes are similarly tricky as they also shorten your legs and can make your feet look wider by splitting them down the middle. Basically, as you now know, I tend to go for the simpler, cleaner option and a basic court or sandal is, in my opinion, just the most flattering style. Less fuss is always the best way, in all areas of life, really.

WHEN TRYING ON NEW SHOES, DO IT TOWARDS THE END OF THE DAY WHEN YOUR FEET HAVE HAD A CHANCE TO EXPAND.

BOOTILICIOUS

I personally struggle with flat boots. I know, I know, people seem to love them these days, and I've seen a lot of girls wearing them over jeans, but I have yet to be convinced. Karl Lagerfeld makes some fantastically cool ones for Chanel, but they just don't work on me. And is it just me or do all these women wearing narrow flat boots over trousers look like they're off to war? If you want boots but can't do high heels, why not get a pair with a low, chunky (not kitten, though – we'll discuss this in a minute) heel: they are just as comfortable, and that bit of a heel really does make enough of a difference.

As for Ugg boots, I wouldn't wear them outside – and I can say that because, as I write this, I am wearing a pair myself! But, well, I am indoors!

1. Good boots with a thick stacked wooden heel are a smart buy as you can wear them with jeans, shorts or summer dresses and skirts, giving them a bit of a tougher edge. I really like them with bare legs as they then look very cool but also quite sexy. Now that they are becoming so popular they have become a bit of a high-street staple too.

2. Aim to invest in a decent pair of boots, that way they'll last for several seasons. Check the quality carefully before you buy them because boots can look cheap if made badly.

3. Make sure you get them in leather, not suede, as that just turns to mulch in the rain and it's ridiculous to buy a pair of boots that wilt whenever they get near water. And leather boots look better as they get older because they take on a worn-in, vintage look.

4. Avoid boots with too many buckles flying about as they look pretty gimmicky now. I'd recommend giving those pirate-style boots a little rest because they really have been copied to death.

top tip

❝Platform wedges can be very heavy, so watch that you don't end up dragging your feet and doing that hunched-over walk. ❞

WEDGE APPEAL

I do like wedges, but it can be hard to make them look sexy as they are so clunky, so you need to get them super-high. And speaking of clunky, there has been a real trend recently for platform wedges after Chloé did some whopping great enormous ones which looked fantastic with shorts and long, wafting dresses. You've got to be careful with platforms as they can make you look like you've got cement blocks around your ankles and have been captured by the Mafia and are being sent to sleep with the fishes. When I was in the Spice Girls, all the rest of the girls wore those Buffalo boots but I just completely refused. One day, though, I tried on a pair out of curiosity, and to this day I'm amazed the girls were able to dance in them. I was a little wary about this platform-wedge thing, but I've discovered that if you wear a good pair underneath a super-long pair of jeans or trousers, you won't believe how long your legs look: the platform wedges basically work like a pair of stilts, just a little more sturdy. Recently, I was persuaded to wear a pair of really beautiful ones and I was completely converted. My legs looked about ten feet long, which doesn't happen every day. I don't think I took them off the whole weekend.

One shoe style I have little love for is the kitten heel. I think a lot of women see them as the wearable compromise to high heels, but in fact they have none of the benefits of high heels yet also none of the casual ease of flats. High heels elongate your leg because they pull up your calf muscles; kitten heels make your muscles tense and swell up; high heels hoist you up; kitten heels make you slump. But most of all, they make your feet look bigger: they emphasize the feet by having them point downwards. There is nothing wrong with big feet but in this case they will look out of proportion to the rest of your body.

But then, I am a real high-heels girl. Some people can do the whole dressed-up flats look really well – Elle Macpherson, for instance, always looks amazing in flats. The fact that she's a six-foot goddess may have something to do with it. But if you do love pretty flats, French brand Repetto makes very pretty ones in metallic leathers and bright coloured patents. Kate Moss is often pictured wearing them and you can find them in one of my favourite boutiques, Paul & Joe. Zara and Topshop also do great inexpensive flats, whilst you can get classic ballet pumps from French Sole, and from Pretty Ballerinas online at www.prettyballerinas.com.

If I do wear flats, they tend to be trainers, sandals or flip-flops, and I am quite picky about all of them. Trainers have to be crisp and white Adidas Y3, white Nike Airmax or Bathing Ape, but never dirty ones of any variety. You can also find some really good collectible trainers from Japan. But whatever trainers you have, be careful about wearing them with miniskirts. That whole fly girl look very rarely does anyone any favours.

HIGH HEELS ELONGATE YOUR LEG BECAUSE THEY PULL UP YOUR CALF MUSCLES; KITTEN HEELS MAKE YOU SLUMP.

top tip

“There is no doubt that the price of wearing high heels is a painful one. But you can now buy Party Feet by Scholl, which act like invisible pillows beneath the balls of your feet. They won't make heels completely pain-free, but they are a definite improvement and will give you at least an extra hour or so on the dance floor. ”

SUMMER FLATS

With sandals, just a pretty, thin-soled pair is perfect for nice summer evenings. Metallic shades of silver and gold always work well for summer, be it for day flats or evening sandals. The key is to get something comfortable as your feet will undoubtedly swell in the summer heat.

WHAT TO LOOK FOR WHEN BUYING SUMMER FLATS

1. For evenings go for sandals with perhaps rhinestones or some gold detailing on the strap over your foot.

2. Thin soles are always more elegant-looking than heavy, thick ones, though they are more delicate.

3. Prolong the life of your sandals by getting a thin waterproof sole fitted to your favourite flats.

4. Buy sandals in a neutral colour like black, white, silver or, best of all, sand. Summer clothes tend to be more brightly coloured than winter ones so it's just smart to keep your summer shoes subtle. Plus you can then have a little more fun (and I stress, LITTLE) with the decoration on the shoes themselves, like a smattering of diamanté.

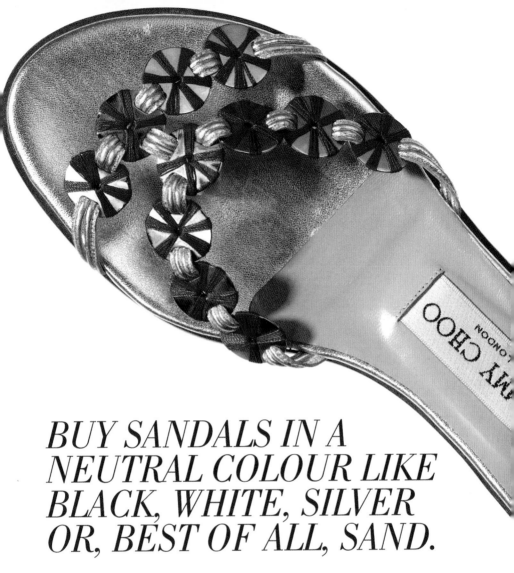

BUY SANDALS IN A NEUTRAL COLOUR LIKE BLACK, WHITE, SILVER OR, BEST OF ALL, SAND.

5. When buying flip-flops, the brand of choice has to be Havaianas. They come in great colours and are probably the first flip-flops ever not to rub painfully between your toes, thanks to their satin-soft rubber.

6. Flip-flops are one summer shoe on which you can splash out and indulge in bright colours all you like because they're such an easy basic.

7. A pair of white flip-flops will accentuate your summer tan most effectively (a pedicure will work wonders too).

HIGH HEELS

For me, it's really all about high heels. I like to wear heels up to eleven centimetres high, but that's a bit tricky for every day if I'm running around, even I must admit.

As for chunky or thin heels, I tend to go for the latter, just because I think they look daintier and more feminine. But there has been quite a trend for chunkiness recently and they do look pretty cool and can be flattering on your leg, so I have branched out a bit.

The ultimate shoes, as every stylish woman knows, are a pair of high-heeled Manolo Blahniks. I actually happened to meet Mr Blahnik recently at a big fashion event in New York and I was completely star-struck.

If you're willing and able to spend more on special-occasion shoes, aside from Manolo, I really recommend Christian Louboutin, who makes probably the sexiest heels you can find, and I love the way the soles of the shoes are always red, giving a little flash of scarlet as you walk. Roberto Cavalli, Jimmy Choo, Fendi and Gucci shoes are always pretty and feminine, and Prada ones last for years. I'm loving the sexy but classic shoes of Giambattista Valli and also Roger Vivier, a classic French shoe designer who has been given a new lease of life recently with his gorgeous buckle-detail pumps. Lulu Guinness has started making really cute ones that are as pretty and detailed as her bags. I particularly like how she has written inside some of them 'You have to suffer to be beautiful', which gives them a touch of the Ronseal advert, doing exactly what they say on their tins.

On the high street, **TOPSHOP** really stands out. It has high heels that look very much like designer and vintage versions, with interesting detailing, such as satin bows and delicate buckles. Its boots, too, are usually brilliant, sometimes made with almost vintage-looking leather so it looks like you got them from the coolest vintage shop around, but make sure you waterproof them as soon as you buy them. It has also started doing pretty, thin-soled flats with piping and other details, which are very cheap and so great with miniskirts or under jeans.

SHELLYS is another high-street shoe store that has come on in leaps and bounds, making some very beautiful two-tone party shoes in jewel-coloured velvet, and adorable little flats which are very Bottega Veneta, one of my favourite labels for accessories. Sadly they cost an arm, a leg and all the rest of your body too – unlike Shellys, thankfully.

KURT GEIGER is another really, really good store, especially its new Fashionistas range, which is a little pricier than its usual selection but does look so much like some of the best stuff you can get from designers. Its boots and heels really last for years, and the assistants who work in its shops are always, I've found, very knowledgeable and helpful.

BERTIE does some fun and quirky party shoes as well as great flats and wedges. **ZARA** does great high-heel basics and often does more glamorous styles like sexy leopard prints too. **NEW LOOK** has some great shoes at unbeatable prices; Giles Deacon's Gold collection is full of rock 'n' roll studs and shiny patent sandals.

KAREN MILLEN can make some great high-heeled party shoes that are strikingly similar to the ones on the catwalks. It does occasionally go over the top with dangly bits and enormous ankle ties, but sometimes they are genuinely very pretty and look like they ought to cost five times more. Best of all, they last for ever. **FAITH**, too, is a good hunting ground for party shoes; they have even created a special party collection designed by Olivia Morris, which is very colourful and fashion-forward.

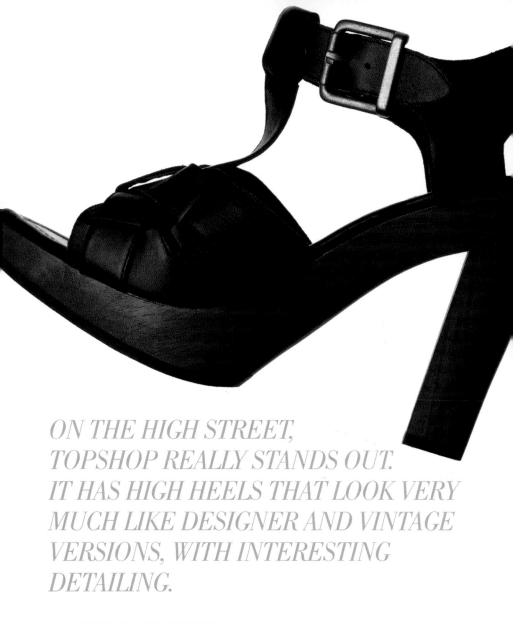

*ON THE HIGH STREET,
TOPSHOP REALLY STANDS OUT.
IT HAS HIGH HEELS THAT LOOK VERY
MUCH LIKE DESIGNER AND VINTAGE
VERSIONS, WITH INTERESTING
DETAILING.*

MARKS & SPENCER's shoes are a real fashion editor's secret. You can find really pretty little heels that are perfect for work or nights out at extremely reasonable prices.

PIED A TERRE really picked up on the chunky-heel trend and has been making very Chloé-esque sandals and heels for, obviously, about a fifth of the price.

bags

I DON'T KNOW ANY WOMAN WHO ISN'T A BIT OF A BAG LADY,
IN THE FASHION SENSE, OF COURSE … But women started using
bags only in the nineteenth century; before that they just kept all their
bits and bobs dangling from their waist or tucked in pockets, an idea
that would seem pretty impossible to most of us girls now, considering
the amount we cart about these days. After many hours of practice, I've
mastered the art of fitting baby wipes, a nappy and a credit card into
a little Fendi bag (it's all about careful rolling techniques, you see, just
tucking things inside each other and then rolling it all up in the nappy),
and maybe a lipstick if I'm being particularly clever. I then pack David
out with all of my make-up and extra bits, as if he's some undercover
spy, and I'm good to go. I may be a mummy but I still want to look
nice! After all, just because you have kids doesn't mean that you have
to be all mumsy and frumpy and carry big plastic-coated bags covered
with little bunnies everywhere you go. You don't suddenly lose your
personality and all taste as soon as you leave the hospital delivery room,
you know! Keeping your sense of style does not negate your abilities as a
mother. If anything, it can actually be a help because feeling good about
how you look will make you a happier, more confident person, two very
important qualities for a mother to pass on to her children.

For an everyday bag, I tend to use quite a big bag, mainly because I
have all the kids' stuff to cart about, so if I just have some tiny, dinky
little thing I inevitably end up carrying multiple bags to cope with the
overspill.

POCKET TIPS

A good everyday bag should have a separate pocket inside in which you
can keep your keys, phone, iPod and a little mirror for emergency
make-up and post-lunch, spinach-in-the-teeth moments. In fact, I got so
fed up with not being able to find a decent bag in which I could carry all
the kids' stuff and still look good that I designed one myself for a
Japanese company – Samantha Thavasa.

There's been a real trend recently for having the pockets sit on the outside of the bag, thanks to Mulberry's amazingly popular Roxy bag, which has its chunky pockets on the bag's exterior. Alternatively, there are some very suave-looking bags around that allow you to access the pockets from the outside, but instead of looking chunky and sitting on top of the bag the pockets themselves are hidden on the inside, with only their zipper on the bag's front, if you see what I mean, so it's still easy to find your essentials, but the bag's shape is kept simple and sleek.

KEEP IT SECURE

Another thing you must look for in a bag is that it closes properly. So many bags just flap open, making it far too easy for pickpockets. One that zips properly or has various buckles criss-crossing the top will work. Just don't get one of those sloppy shopper bags as they are the thief's best friend.

SATCHEL SAVVY

Satchel bags can be a little tricky. On the plus side, satchels can give certain people a really cool urban or boho kind of look, and they do leave your arms free, which is always a relief. Designers like Roberto Cavalli make beautiful ones and you can get cute ones on the high street that look almost vintage. Mulberry do good ones too. However, they can also look a little too casual, so you really have to make sure it goes with what you're wearing. If you're going to a formal event, or are wearing anything A-line, the satchel really won't work because, in the case of the A-line, it will totally crush down the line of your skirt or dress. You also have to be reasonably small-busted to carry off the satchel as the strap cuts right across your front, squashing you down and giving you three boobs. This is why I actually think they best suit men (the ones without boobs, that is): David, for example, looks great with a satchel bag, better than most of us women, really. APC, Martin Margiela, Louis Vuitton and Gucci all do great leather ones for men.

YOU HAVE TO BE REASONABLY SMALL–BUSTED TO CARRY OFF THE SATCHEL AS THE STRAP CUTS RIGHT ACROSS YOUR FRONT, SQUASHING YOU DOWN AND GIVING YOU THREE BOOBS.

SHOULDER HAPPY

If you truly love your shoulder bags, and they're just more practical for your everyday life, the best sort to get are the big ones with short straps that hang right under your armpit. They give a cool 70s, almost *Avengers* kind of look to your outfit, and they work with jeans and skirts, plus they are better at keeping your belongings safe. But the problem with these, like most shoulder bags, is that they can be difficult to wear with a winter coat, which is just too bulky for the strap. They also aren't totally secure as people often tuck them behind their back to keep them out of the way. Instead, I almost always opt for handbags which, like a lot of women, I just jam up to my elbow to free up my hands, like the Queen.

HANDBAGS

Structured handbags look more formal and proper and are generally more timeless, whereas soft ones – the famous 'Paddington' by Chloé, for example – tend to be a bit cooler, younger and fashion-y. So it just depends on the look you're going for as both have their advantages. Structured handbags have been popular style status symbols since the 50s when Grace Kelly was photographed for the cover of *Life* magazine with a Hermès bag, which was quickly named the Kelly bag (and are now really sought after and collectible). One of the first presents David ever bought me was a gorgeous black Prada handbag, delivered to my parents' home with a massive bouquet of roses. A fabulous bag, of course, but there are other reasons why that one will always be one of my favourites.

When buying satchels, structured bags and softer ones, particularly ones in beautiful leather, you can find a fantastic selection in vintage markets, especially Portobello, Spitalfields and in Brighton, and often they are much cheaper than you get on the high street, so it's always worth checking out your local vintage market or even searching in car-boot sales for some great bag finds.

THE CLUTCH

For dressier events, I'll always go for a clutch bag; they aren't practical at all but are just so beautiful, and for parties I do let myself choose beauty over practicality. They were particularly popular in the 30s and 40s and their prettiness has kept them in fashion ever since. You can get some gorgeous, cheaper ones in vintage stores. The high street sometimes has some excellent ones, but if you want to spend more, Lulu Guinness does some of the most beautiful ones ever, notably her famous fan one that really does look like a fan until you see the little zipper at the top.

CLUTCH BAGS AREN'T PRACTICAL AT ALL BUT ARE JUST SO BEAUTIFUL.

140 *accessories*

CANVAS

Canvas is a good alternative to leather for bags: it's classic but a little bit different, and is great for summer as you can get bags in bright colours and prints. Canvas bags are great to pile all your extra bits in whilst keeping your handbag uncluttered. Anya Hindmarch does some great ones every summer.

Designers such as Miu Miu and Hermès use canvas, often mixing it with other materials, like wood and leather respectively. The problem is, though, that canvas stains very easily, and if, for example, you have a leaky bottle of baby milk inside your bag, within two seconds it will have a great big milk stain sitting on the front, so look out for the potential leakage factor of anything you put in your canvas bag.

LOGO OR NO GO

With the exception of Louis Vuitton or Fendi, I can't say I'm really a fan of logoed bags. I have given them a go in my time, but they never really work for me, I find. At least Louis Vuitton's monogrammed look is traditional in its original brown and burnished-orange tones, but most others just seem over the top and get tired very quickly, and also look a bit designer-designer. So try not to go for anything too flashy as it becomes too much of a statement. Invest in classic buys that won't date. If you really want to

put down a lot of money for a bag, go for something more classic and of good quality that you can use repeatedly and with lots of different outfits. As I've got older I've noticed I've started thinking more and more about what I can wear with what, and in a thoroughly good way it has begun to affect the choices I make when I shop, pushing me towards the classic pieces and straight past the kitschy ones.

As I'm always travelling, I really appreciate bags that have special pockets and compartments for keeping precious things safe. Louis Vuitton do gorgeous little travel cases that hold jewellery and are specially padded. Smythson also do beautiful brightly coloured jewellery boxes suitable for travelling with your favourite adornments.

HIDE-OUT

I'll often go for leather, ideally brown and a little bit vintage- or worn-looking. But as soon as you get your leather bag, make sure you spray it properly with a good, non-staining leather protector, like Collonil's Waterstop, which you can get in any decent leather-goods shop, as otherwise a sudden downpour of rain will ruin your beautiful bag, making it pucker and change colour. Quilted leather always looks good. The obvious designer reference is Chanel, whose quilted leather handbags have become iconic. Marc Jacobs now quilts some of his bags too, as does Balenciaga, giving this classic look a bit of a younger kick, and high-street stores such as New Look, Topshop and Principles have followed their lead well.

sunglasses

AS YOU ALL KNOW, THE CRUCIAL ACCESSORY FOR ME IS A
GOOD PAIR OF SUNGLASSES. If you've ever wondered why I'm
always wearing them it's very simple: as a mum, I often don't get that
much sleep, I don't always have time to put on the Touche Éclat in the
mornings, and who can be bothered putting on eyeshadow first thing
in the day anyway? So, instead, I just throw on the Chanel sunglasses,
which really do, as the fashion magazines say, hide a multitude of sins.
There's nothing that ruins the effect of a good outfit faster than puffy,
bleary eyes. This is why I often tend to go for sunglasses with dark or
mirrored lenses.

VINTAGE FINDS

Whenever I go to vintage shops with my friends Ben and Maria
Louise, we all have such a laugh trying on amazing pairs. Seriously, I
have pulled some impressive 70s rock-star looks in my time in some of
those shops.

But, as long as you don't let yourself get carried away, you can find
some great sunglasses in vintage shops and from vintage makes like
Linda Farrow. Linda Farrow first designed glasses back in the 70s and
consulted for major brands like Balenciaga and Pucci. The company
was only recently relaunched when her son discovered loads of original
70s and 80s sunglasses in the company's warehouse. I've also designed
a range of sunglasses under my own label, dVb – well, it makes sense

top tip

"Try lots of different styles to find one that suits your face. I
tend to go with bigger frames as I find smaller ones can give
me racoon eyes. But set aside some proper time to try on as
many pairs as possible in the shop."

" Vintage stores and even car-boot sales are great for finding a unique pair of sunglasses in pretty much any size ever imagined and they're often cheaper than those in the shops and better quality. Plus, because they're vintage, and therefore by definition at least a few years old, you know they must be of pretty good quality and should last. "

seeing how sunglasses and I have become synonymous! It's been so interesting learning how to design sunglasses properly. For example, frames should be fabulous but also wearable, and you have to get the balance right between oversized and practical. I love my decorated frames but you have to keep the embellishment subtle. It's been so much fun designing my glasses, which are inspired by icons such as Jackie O, Diana Rigg and, of course, Audrey Hepburn.

People sometimes feel timid about experimenting with frames, but wearing something slightly different from your basic black can actually be really successful. You can get so many different combinations of coloured, graduated lenses and anything from large to small frames, you just have to find which style works for you. Make sure they are a good quality lens with UV to protect your eyes.

hats

HATS ARE ANOTHER ACCESSORY
I OFTEN USE TO HIDE ANY LESS-
THAN-PERFECT FEATURES ON A
BAD DAY. Hats are widely used by
designers to accessorize their catwalk
collections, from Marc Jacobs's little
cloche caps to Hermès' classic leather flat
caps – hats are rarely out of fashion and
can be worn at any time of year to create
an individual look.

BASEBALL HATS, which you can find all
over the place in England these days, are a
particular favourite of mine as they're so
useful if you can't be bothered to do your
hair and you just want to bung it up, out
of sight. They tend to work best on heart-
shaped faces as they can elongate long
faces and make them look a little horsey,
but they generally suit most people. Be
careful to get a good shape – not one that
looks like it's been run over. Slogans on
caps are OK, and I know I have worn
some in my time, but plain ones usually
work best as then you can just wear them
with anything and not worry about it.

Through years of travelling, I've discovered
that a baseball cap on a long-haul flight is
invaluable. I can disappear and go to sleep
beneath it without anyone noticing, plus it
hides me from the paparazzi once I get off
the flight. Abercrombie & Fitch do great
vintage-looking ones.

PHILIP TREACY DESIGNS THE MOST INNOVATIVE AND EXCITING OCCASION HATS. SCULPTURAL IN THEIR DESIGN, SOME OF THEM ARE ALMOST ACROBATIC IN THAT THEY SEEM TO DEFY GRAVITY, SPIRALLING UP FROM YOUR SCALP.

COWBOY HATS are also useful and I have worn them instead of beach hats, which can be pretty naff. If you do prefer a traditional beach hat, go for a plain straw one with an extra-big floppy rim for a dramatic Hollywood diva look. You can find these quite easily on the high street. Recently, I got some great cowboy hats from a vintage shop, although they didn't smell too hot on the inside, I have to say – very eau de sweaty cowboy. But, potential odours aside, they are great for covering up sweaty hair, and also protect your hair from getting bleached out by the sun and going all frizzy.

For smart occasions, OCCASION HATS can really make an outfit. Just think of all those great photos from the 40s in *Vogue* and *Harper's Bazaar*, with models posing in fabulous full-length gowns and incredible sculptured hats. For inspiration, just look at any shoots in old *Vogue* magazines – particularly those by Norman Parkinson – which you can often find in second-hand bookstores and vintage shops. Today, milliner Stephen Jones creates the most amazing hats and headpieces for John Galliano's catwalk and couture shows. Also, Philip Treacy designs the most innovative and exciting occasion hats. Sculptural in their design, some of them are almost acrobatic in that they seem to defy gravity, spiralling up from your scalp. He made the hat I wore to Buckingham Palace when David received his OBE and although I might not be able to compete with the Queen in terms of regal headwear, I did feel I was pulling my weight in that department.

Probably the prettiest way to disguise a bad-hair day is with a HEADSCARF tied over your head and then at the back of your neck. You could go for a vintage Pucci one (or a Pucci-esque one, as the high street has started to do them). This is one of the few times when I think patterns really work, mainly because it's such a small accessory and therefore the pattern doesn't seem too overwhelming. It makes sense to get your pattern fix by relegating it to a headscarf. Alternatively, really thick headbands are great for the sporty outdoors look.

As for HAIR ACCESSORIES, you can find really cute ones on the high street now, like feathered combs, hair sticks (those things that look like chopsticks that you stick through a bun) and pretty little hair clips. You can also find little hats and headpieces with netting and beading on, which really help to glamorize an evening dress. Topshop, Accessorize and vintage stores always have a good selection. Things like these not only help to tidy up your hair but distract onlookers from noticing if your hair is looking a bit on the greasy side that day.

Designers also do really fun little hair accessories and, although they are undeniably more expensive, they not only look amazing but really do last for ever. I adore Louis Vuitton's plastic hair bobbles and Luella has some great ones too. Cherry Chau does fabulously over-the-top feathered hairpieces that are great for special occasions. Miu Miu and Prada make some really pretty Alice bands which give a fabulous 20s look to any outfit, however cheap or old the dress. You can find Alice bands on the high street and even a simple plastic one in just a solid bright colour, like red or blue, can really spark up a look.

The truth is, everybody has a BAD-HAIR DAY once in a while and that's why I think wearing your hair up can be the safer option, particularly in the summer when everyone's hair can look flat and greasy by the end of the day. Putting your hair up into a high, sleek ponytail with a simple black band just looks more pulled together than having it fly about your face.

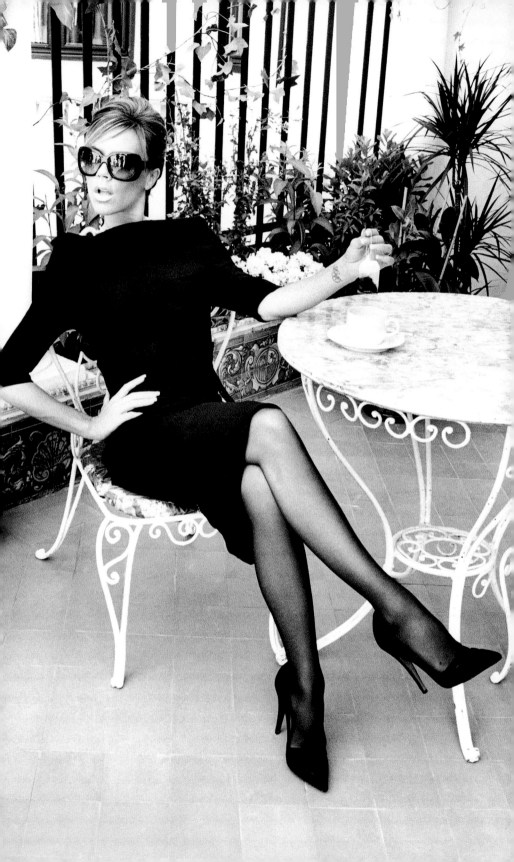

jewellery

GENERALLY, I'M NOT REALLY ONE FOR WEARING LOTS OF JEWELLERY EVERY DAY – usually I'll just wear a ring that David gave me and that is enough. How much or how little jewellery you wear is really up to you.

WHAT TO LOOK FOR WHEN BUYING JEWELLERY

1. Take a look at *Breakfast at Tiffany's* to see how beautiful it can be to have multi-strands of pearls draped around your wrist and on a choker. Buy inexpensive strands of pearls on the high street to achieve this look.

2. You can get some fantastic costume jewellery on the high street now. Marks & Spencer has great rings and earrings, and labels like Freedom at Topshop and Mikey make fun fashion pieces that last for ages and are reasonably priced. Mikey's diamanté pieces are perfect for special parties as they look so expensive. New Look always has colourful pieces, like plastic bangles and necklaces, which are great to pile up. Mail-order company Johnny Loves Rosie offers truly excellent vintage-style brooches and hairpieces, and I've found some great little decorative combs and dramatic earrings and chokers there too. Erickson Beamon is a must-have stop for the true fashion jewellery aficionado. This duo's designs are so dramatic and creative and are often photographed for *Vogue* magazine. I love their beaded chokers and jewel-encrusted rings, earrings and bangles.

3. Big chunky beads are good for a dramatic look, but wear them sparingly; just one strand will do. Accessorize and Freedom at Topshop always have great coloured ones. You can often find inexpensive strands of beads at your local department store; John Lewis has a good selection. Second-hand stores and charity shops will usually have them for next to nothing, too.

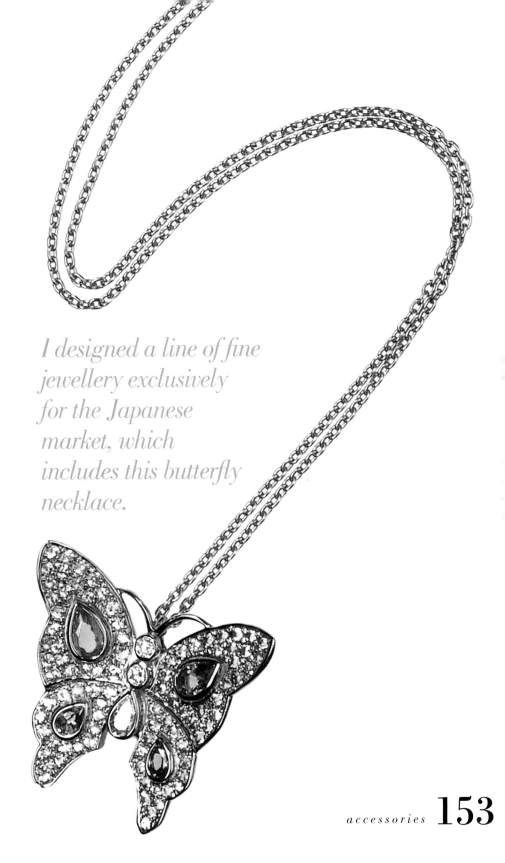

I designed a line of fine jewellery exclusively for the Japanese market, which includes this butterfly necklace.

For really special jewellery pieces, my favourites are Roberto Cavalli, Asprey and Chopard. Vivienne Westwood also does some amazing jewellery in her signature rock 'n' roll style. She has produced a line of special diamond pieces made from skulls and daggers which is totally decadent. A good high-street shop for inexpensive jewellery is Agatha, which has some beautiful vintage-style earrings and pretty little things. You don't have to spend a fortune to create a fabulous look. My favourite piece of jewellery in the world is a necklace the kids made me as a present out of bits of foam, which I doubt very much I'll ever actually wear but I know I'll always treasure. Similarly, it's the pieces of jewellery from David that will always mean so much more than anything anyone else could ever give me. Jewellery is very pretty, but I find that it's only really exciting if it has a special person or story behind it.

One piece of jewellery I do wear almost every day is a watch. Get either a good man-sized one, or a really pretty delicate one for dressing up. For the former, I really love Jacob & Co, De Grisogono or vintage Rolexes. As a special gift you could select a vintage watch made in the same year as that person's birthday. For elegant bracelet watches, Tiffany & Co is the ultimate, although the high street has started to make its own beautiful versions. I do think it's best to get one either from the high street or a proper watchmaker.

style no-no

If you wear jewellery, just watch out that you're not going OTT. It's almost never a good look to pile it on. Pearls are an exception to this rule.

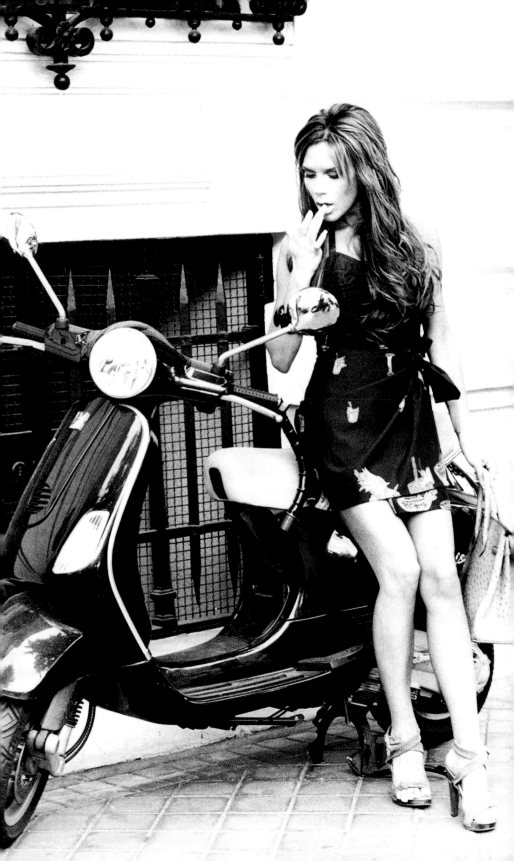

hosiery

MOVING ON TO HOSIERY, A LOT OF PEOPLE HAVE GOT INTO THE WHOLE PRADA-ESQUE CASHMERE RIBBED-STOCKINGS TREND, AND THEY CAN LOOK GOOD ON SOME PEOPLE. The best tights labels are Wolford, Falke, Fogal, Jonathan Aston and Jonelle, all of which last for ever; both John Lewis and Selfridges have a really wide selection. A pair of thick black opaque tights is a great investment and they look so chic and modern with some shiny patent shoes.

I do love fishnet stockings, though, and you can either wear them in a seductive, burlesque way, or give them more of a demure but still sexy look with a pencil skirt. The best are probably from Agent Provocateur. They tend to last that little bit longer and come in great shades. You can also get them from Marks & Spencer or Topshop. I like both wide and narrow mesh fishnets, but I recommend sticking with either black or flesh-coloured.

Flesh-coloured stockings with fake seams going up the back, which you can often get from Jonathan Aston, are very alluring. They really are quite fabulous as that seam looks so seductive disappearing up your skirt!

style no-no

Avoid tights that bag around the knees – they look hideous in the worst Nora Batty kind of way. This usually happens with woollen tights so always ensure your hosiery contains a good amount of nylon or Lycra to keep your pins looking sleek.

tattoos

CONSIDERING THAT I TEND TO ADVISE ERRING ON THE
MINIMAL SIDE when it comes to accessories and general personal
decoration, it might seem a bit surprising that I have tattoos – four, to
be precise: on my back, on my neck and on my wrists. I would urge you
to really think carefully if you're even considering getting one done.
Getting them removed is a painful process and often leaves a scar. But I
love all of my tattoos because each of them means something very special
to me, and if something has an emotional value then you'll never regret
it. David and I got tattooed with the same inscription of love in Hebrew,
on my neck and on his arm, which was so romantic, though I have to say
it was bloody painful. The five stars on my back represent me and David
and each of the kids. They also mean I can survive three months in a
freezer, which is handy. And one of the tattoos on my wrist is DB, for
David Beckham – or maybe David Blaine, or possibly David Blunkett.
I'll leave it up to the tabloids to decide.

*I LOVE ALL OF
MY TATTOOS
BECAUSE EACH
OF THEM MEANS
SOMETHING VERY
SPECIAL TO ME,
AND IF SOMETHING
HAS AN EMOTIONAL
VALUE THEN
YOU'LL NEVER
REGRET IT.*

WHERE TO BUY

1. COURT SHOES: Christian Louboutin, Dolce & Gabbana, Faith, Giambattista Valli, Jimmy Choo, Kurt Geiger, Manolo Blahnik, Marks & Spencer, Pied A Terre, Prada, Ravel, Roberto Cavalli, Roger Vivier, Russell & Bromley, Yves Saint Laurent

2. ROUND-TOED SHOES: Bally, Chanel, Chloé, Christian Louboutin, DSquared2, Faith, Fendi, Jimmy Choo, Kurt Geiger, Manolo Blahnik, Marc by Marc Jacobs, New Look, Peacocks, Primark, Rupert Sanderson, Shellys, Topshop, Zara

3. POINTY-TOED SHOES: Anya Hindmarch, Christian Louboutin, D&G, Dolce & Gabbana, Dune, Faith, Gucci, Jimmy Choo, LK Bennett, Manolo Blahnik, Office, Pied A Terre, Ravel, Roberto Cavalli, Sergio Rossi, Shellys

4. KNEE-HIGH BOOTS: Aldo, Anna Sui, Chanel, Chloé, Faith, Frye, Giambattista Valli, Gucci, Jimmy Choo, Marc Jacobs, Marni, Nicole Farhi, Office, Prada, Shellys, Topshop, Urban Outfitters, Vivienne Westwood

5. WEDGES AND PLATFORMS: Chloé, Christian Louboutin, D&G, Dune, Faith, Guess, Kurt Geiger, LK Bennett,

Marc by Marc Jacobs, Marni, Office, Pierre Hardy, Russell & Bromley, Sergio Rossi, Yves Saint Laurent

6. TRAINERS: Adidas Y3, Bathing Ape, Converse, DKNY, Keds, Kitson, Lacoste, Nike, Onitsuka Tiger, Puma

7. SUMMER SANDALS: Anya Hindmarch, Chanel, Christian Louboutin, Dune, Faith, Hermès, Jimmy Choo, Kurt Geiger, Lanvin, LK Bennett, Manolo Blahnik, Miu Miu, Office, Peacocks, Prada, Zara

8. FLIP-FLOPS: Accessorize, Debenhams, French Connection, Gap, Havaianas from Office, H&M, Marks & Spencer, Quiksilver, Topshop, Zara

9. PARTY SHOES: Bertie, Christian Louboutin, Designers at Debenhams, Dune, Faith, Fendi, Gina, Jimmy Choo, Karen Millen, Kurt Geiger, LK Bennett, Manolo Blahnik, Miu Miu, Moschino, New Look, Office, Patrick Cox, Pied A Terre, Prada, Roberto Cavalli, Roger Vivier, Sergio Rossi, Shellys

10. DAY BAGS: 3.1 Phillip Lim, Accessorize, Aldo, Alexander McQueen, Anya Hindmarch, Balenciaga, Bottega Veneta, Burberry,

Chanel, Chloé, Christian Louboutin, Fendi, Gap, Hermès, Luella, Marc Jacobs, Miu Miu, Moschino, Mulberry, New Look, Orla Kiely, Paula Thomas for Thomas Wylde, Pierre Hardy, Prada, River Island, Topshop, Urban Outfitters, vintage markets, Vivienne Westwood, www.net-a-porter.com

11. SATCHEL BAGS: Ally Capellino, APC, Billy Bag, Burberry, Gucci, Louis Vuitton, Mulberry, Paul Smith, Roberto Cavalli, Shellys, Topshop, vintage markets

12. HANDBAGS: Accessorize, Anya Hindmarch, Asprey, Burberry, Chanel, Chloé, Christian Louboutin, Coast, Designers at Debenhams, Fendi, George at ASDA, Hermès, Jimmy Choo, J&M Davidson, Karen Millen, LK Bennett, Louis Vuitton, Luella, Lulu Guinness, Mango, Marc Jacobs, Marks & Spencer, Miu Miu, Mulberry, Next, Oasis, Prada, Principles, Ravel, Reiss, Roberto Cavalli, Roger Vivier, Russell & Bromley, Sonia Rykiel, Topshop, Wallis, Warehouse, Yves Saint Laurent

13. CLUTCH BAGS: Accessorize, Anya Hindmarch, Coast, Designers at Debenhams, D&G, Dune, Fendi, Gucci, Jimmy Choo, LK Bennett, Lulu Guinness, Oasis, Primark, Roberto Cavalli, vintage markets, Virginia, Warehouse

14. SUNGLASSES: Accessorize, Bottega Veneta, Calvin Klein, Chanel, Cutler & Gross, Diesel, Dolce & Gabbana, dVb, Fabris Lane, Fendi, Gucci, H&M, Linda Farrow Vintage, Marks & Spencer, Miss Sixty, M:UK, New Look, Oliver Peoples, Ray-Ban, River Island, Stella McCartney, Topshop, Urban Outfitters, vintage Yves Saint Laurent

15. COWBOY HATS: Accessorize, Dune, H&M, Miss Selfridge, R. Soles (on the Kings Road), Topshop, vintage stores (or pick one up when you visit the States)

16. BEACH HATS: Accessorize, Anya Hindmarch, Benetton, Designers at Debenhams, Gap, Heidi Klein, H&M, Jigsaw, LK Bennett, Marks & Spencer, Miss Selfridge, Oasis, Tommy Hilfiger Sport, Topshop, Whistles

17. HAIR ACCESSORIES: Accessorize, Boots, Cherry
Chau, Debenhams, Dorothy Perkins, H&M, Johnny Loves Rosie,
Louis Vuitton, Miss Selfridge, Miu Miu, Oasis, Prada, Reiss, Tatty
Devine, Topshop

18. JEWELLERY: Accessorize, Agatha, Asprey, Boucheron,
Butler & Wilson, Chanel Fine Jewellery, Chopard, De Grisogono, Dior
Fine Jewellery, Diva at Miss Selfridge, EC One, Erickson Beamon,
Fiona Knapp, Freedom at Topshop, Georg Jensen, Johnny Loves Rosie,
Mikey, Mood at Debenhams, New Look, Oasis, Pebble, Roberto Cavalli,
Solange Azagury-Partridge, Stephen Webster, Vivienne Westwood
TRAVEL CASES FOR JEWELLERY: Asprey, Hermès, Louis Vuitton,
Smythson

19. HOSIERY: Agent Provocateur, Aristoc, Falke, Fogal,
H&M, Jonathan Aston, Jonelle at John Lewis, Marks & Spencer,
Pamela Mann, Pretty Polly, Topshop, Wolford, www.mytights.com,
www.tightsplease.co.uk

20. BELTS: Bottega Veneta, Burberry, Cornelia James, D&G,
Fendi, Gucci, Hermès, Jigsaw, J&M Davidson, Miu Miu, Mulberry,
Prada, River Island, Stephen Collins, Topshop, Warehouse, Yves
Saint Laurent

NOTES

parties

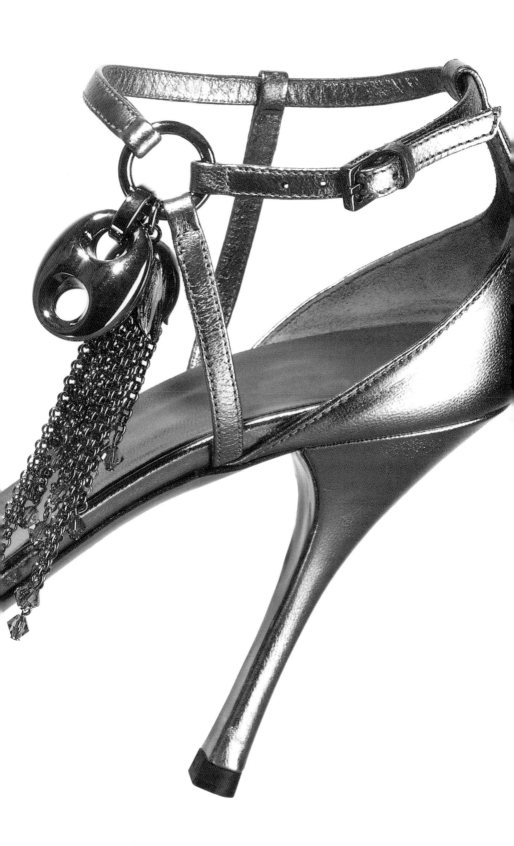

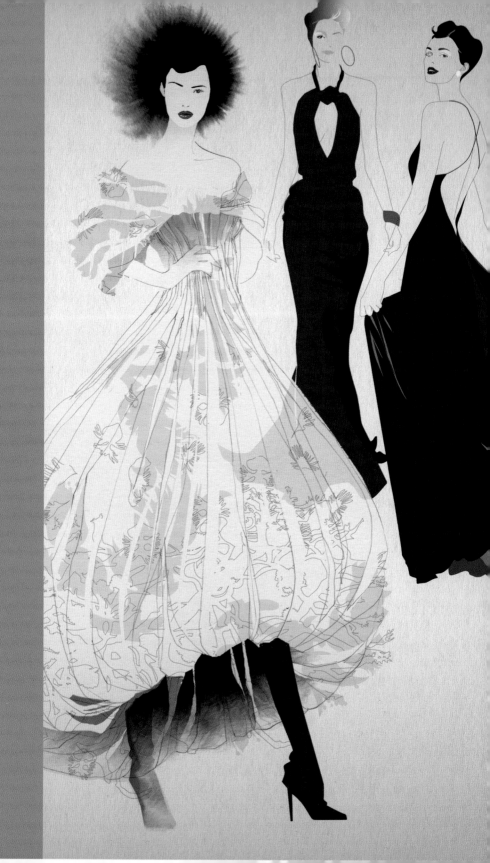

Getting dressed for a red-carpet event can be a perilous affair ...

GENERALLY, I RECOMMEND CHOOSING A CLASSIC DRESS IN A SIMPLE SHAPE, and that's a good formula to bear in mind for any formal party, particularly one where you know you'll be photographed. If I'm going to a red-carpet event I'll always go direct to the designers to find the dress myself. Also, I am in the incredibly privileged position of being friends with Roberto Cavalli and I'll ring him and explain exactly the sort of dress I want, describing the shape, the colour and the back, as that way it always has my individual stamp on it. For example, Roberto and I worked very closely together on the dress I wore to Elton John's wedding as I wanted something special for that. I loved that dress and still do when I look at the photos.

As I've said before, I don't have a stylist outside of professional fashion shoots because I really enjoy creating the look myself. I remember when I was young I'd go round to a friend's house before a party and we'd be running around, make-up brushes flying about everywhere, and I still try to recreate that today when I can.

If it's a big night out, I'll get my hair professionally blow-dried, and that usually takes about forty minutes. Otherwise, I'll just wash my hair myself and dry it at home. My sister once bought me a pair of travel hair straighteners, which you can use en route to the party if you're very strapped for time. Be careful as they can really damage your hair, leaving you with charred split ends, which is only a good party look on Halloween.

I'll spend about ten minutes on my make-up – by now I have it down to a well-practised art. Having a bit of music on in the background always helps to get you in the mood after a long day.

As for the outfit, I always plan it the night before to save more time and also because I hate making rushed decisions as that's when mistakes tend to happen. But I've found that, as you get older, you do know yourself better, and know what really suits you, so you tend not to make silly choices quite so often.

Regarding your outfit, get the opinion of someone you trust. I almost always ask my sister, Louise, and my mum what they think of my outfit. You have to ask the opinion of someone who's close to you, because you can ask loads of people what they think and they'll say, 'Oh, it's wonderful, it's wonderful,' when in actual fact you look rubbish but they either don't want to be rude or just don't know how to tell you. No one will be more honest with you than your mum or your sister, and they won't let you go out looking ridiculous. Men are pretty good at giving opinions on clothes, but I do think it's important to get a woman's point of view too because they're often the ones who will understand what you're trying to do with an outfit; men will usually tell you that you look fine just to make you hurry up.

My kids are always happy to offer opinions when I get dressed and, as I'm the only woman in the house, they find it really exciting. They're also really good at noticing things like a new haircut or a new dress, so sometimes you can find advice in the most unexpected of places. But be warned: kids can be brutally honest too, so brace yourself before soliciting their opinions …

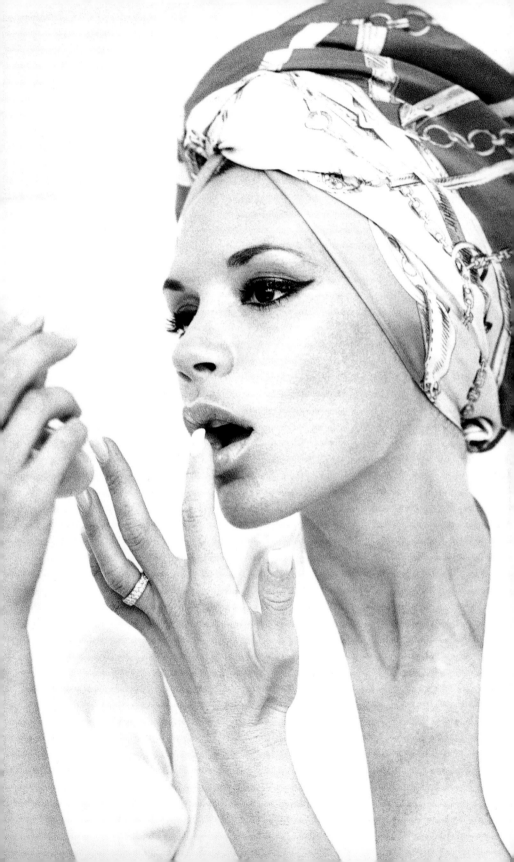

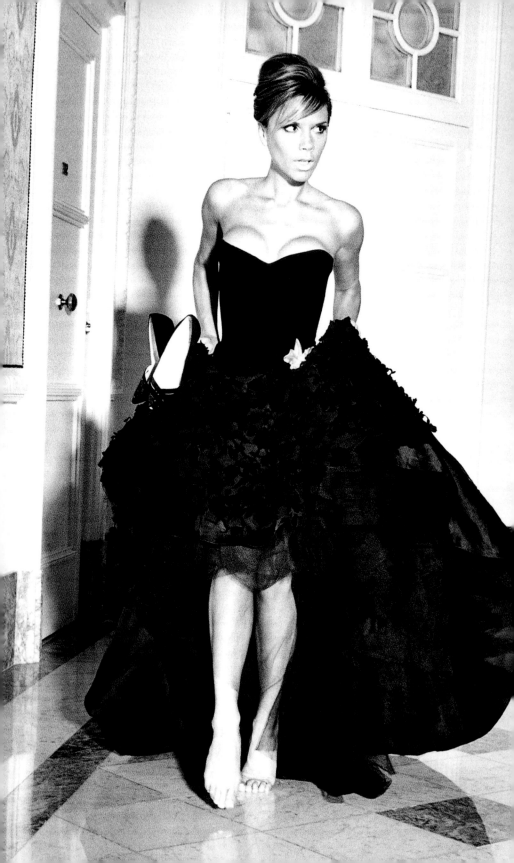

I do love wearing long dresses. There are so few occasions when you can really dress up, so if one comes along I think it's a wasted opportunity to pass it up. I also think it's more respectful to the person who's throwing the party – I've never been one of those people who tries to make a statement by looking really scruffy and I find it very disappointing if I'm at a big party and some people just look as if they haven't even bothered to make an effort.

Of all the party dresses I've worn so far, my favourite was the Roberto Cavalli Ming Vase print dress that I wore to one of Elton's parties a few years ago. David picked it out and I'd never worn anything like it before. I wanted it to give me a real hourglass shape, so when I was getting it fitted I kept asking the seamstresses to pull it tighter, tighter, and they were all saying to me in their Italian accents, 'If we make it any tighter, you won't be able to sit down!' I said, 'I don't care, I'll go in a horsebox standing up if I have to – I want it tighter!' As you can see, party clothes are the one area where my sense of practicality goes out of the window. Anyway, at the party I needed to go to the toilet and I said to David, 'Can you come with me as I won't be able to do up the dress when I come out.' So when I came out, he started to do the dress back up again and the zipper broke! All because I insisted on having it so tight! So there I was, standing with my dress half undone and I just thought, 'Oh, my God! What am I going to do? How embarrassing!' Suddenly, this girl came over with some safety pins and she got right down on her knees and started pinning me in. 'Just a minute, just a

I'VE NEVER BEEN ONE OF THOSE PEOPLE WHO TRIES TO MAKE A STATEMENT BY LOOKING REALLY SCRUFFY.

Roberto Cavalli

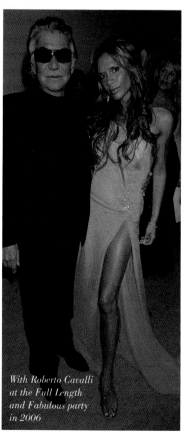

With Roberto Cavalli
at the Full Length
and Fabulous party
in 2006

Cruella de Vil!

Roberto Cavalli

The 7th Annual White
Tie and Tiara Ball

Roberto Cavalli

❝ *I am grateful for the possibility of being close to such a wonderful woman as Victoria for she is not only glamorous and beautiful but a person with a special sensibility, personality and true soul.* ❞

ROBERTO CAVALLI

minute, almost there!' she was saying, scrambling about on the ground while David held the top of my dress. Well, you'll never believe it, but it wasn't until she stood up and I could see her properly that I realized it was Joss Stone!

The moral of the story is, never buy a dress that's really too tight for you. But if you do … never go to a party without safety pins. And I really do always have them on me now.

The most important thing to remember if you're wearing a dress that won't let you wear a bra, such as one with a low back or a deep-plunge front, is to make sure you have lots of toupee tape to keep everything in place.

176 *parties*

HOW TO DRESS UP

BE WARY OF SHEER FABRICS

When choosing a dress, keep in mind how it will look under certain lights. I recently made myself a long flesh-coloured dress, but when I wore it in front of my mirror with the light behind me, I realized it was totally see-through! So that one went back in the closet. I'd learned my lesson before about that: once I went out in a summer dress and the next day it was all over the tabloids – 'Posh Nips Out!'

GO EASY ON EMBELLISHMENTS

One thing I personally don't like is too much heavy beading and too many jewels on a dress. It can look tacky, weigh the dress down and make it very expensive all at the same time. In vintage shops you can find fabulous flapper dresses made out of beads that make the dress hang down very elegantly. But when lots of beads are simply placed on top of the fabric they just give the dress unnecessary added bulk.

PHOTO SAVVY

When going to big parties it is triply important to avoid anything that has the potential to look a total disaster in photos, especially as these are the places where everyone is taking pictures. You'll be stuck with those party snaps for ever. It's a funny thing but the two situations when people often dress the worst are also the

times when they get photographed the most – holidays and big parties. So just bear that in mind when you're packing and when you're looking in your closet, getting ready for a night out.

GO FOR CLASSICS

If you're going to buy a dress for a big party, be careful not to get one that's too obviously in fashion at the moment because party dresses can be expensive and you'll have spent a lot of money on something you can wear only a few times before it dates. It's best to go for something really simple in a classic shape. I love clothes that look as if they're almost from a different era, like Vivienne Westwood's or Alexander McQueen's dresses.

FORGET THE LABEL; GO FOR STYLE

Don't get swayed by a label. The most important thing is how the dress looks, because that's what people will see, not the label! Nothing shows up your less-than-perfect features more quickly than just blindly following a trend or designer name. Being a label queen doesn't necessarily mean you look better. Picking the right dress for your personal style is the key.

Don't limit yourself to a few set looks simply out of habit. I recently went to dinner at Valentino's house and I wore a big ruffly party dress that was a totally different look from my usual style. But it appealed to me, somehow, despite all the frilliness, so I decided to take a risk, and it really worked and it's now one of my favourite party dresses. It's very easy to get stuck in a style rut but you sometimes have to force yourself to not put your blinkers on and to keep looking around.

THE RED-CARPET POSE

A lot of people often get nervous about posing for snapshots at parties, and who can blame them? I still feel nervous when I'm walking down the red carpet and I see all the cameras pointing at me. Elizabeth Hurley told me her posing trick is to stand with one leg sticking out and then pout her lips and exhale.

FASHION INSPIRATION

1. I get a lot of fashion inspiration just from looking at other people on the street. Suddenly, you'll see someone wearing something unexpected and looking totally amazing, and you'll wonder why you never thought of it yourself.

2. Some high-street stores are now offering a personal shopping service. (Topshop offers an excellent service.) Personal shoppers in department stores can help give you fashion advice.

3. Looking at celebrities in magazines can also give you ideas as they will often get the latest styles and looks before they hit the shops, thanks to stylists, and designers lending them pieces from the latest collections. Look at celebrities who bear the most resemblance to you, even if it's just skin tone, hair colour or body shape, to get a better idea of what would look best on you.

4. Remember to give the celebrity look you choose your own individual twist. If you saw a particular photo of that celebrity in that magazine, chances are other people will have done too. By all means take tips from magazines and celebrities, but have the confidence to do your own take on the outfit and wear something that shows your individual touch. Treat these celebrity photos as a springboard from which you can get inspiration – but then go a bit further with them.

5. One of my favourite things to do in London is just to drive around and look at what people on the street are wearing: no other city provides as much fashion inspiration as London. The trick is to have the confidence to try variations of these outfits for yourself and then find ways to make them individual to you, such as adding your favourite accessories.

top tip

"Don't forget to be honest with yourself if it's just not working. That's when it's crucial to have someone you know who's honest, who will tell you the truth and won't let you go out looking like a total disaster.

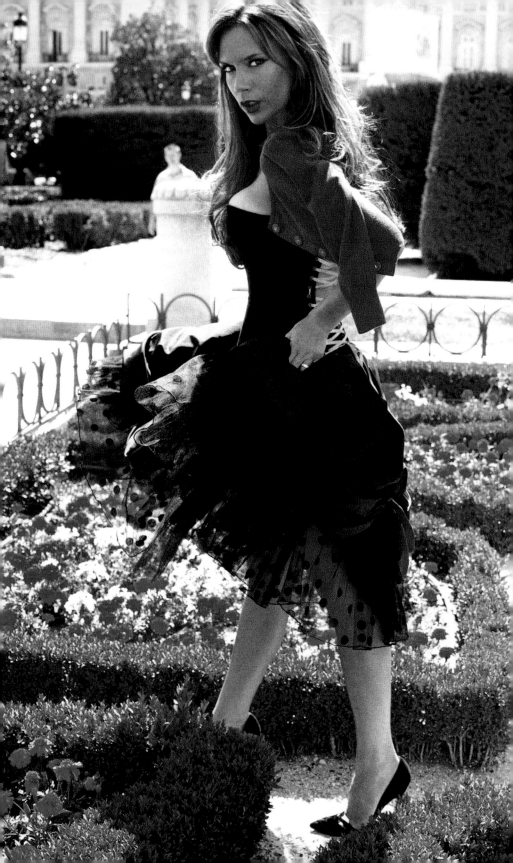

I GET A LOT OF FASHION INSPIRATION JUST FROM LOOKING AT OTHER PEOPLE ON THE STREET. SUDDENLY, YOU'LL SEE SOMEONE WEARING SOMETHING UNEXPECTED AND LOOKING TOTALLY AMAZING, AND YOU'LL WONDER WHY YOU NEVER THOUGHT OF IT YOURSELF.

Another thing you mustn't get distracted by is sizing. Almost every woman I know finds this the difficult part of shopping, and it is gutting to try on a dress in your usual size only to find it doesn't fit. But we've talked about this already with regard to trousers. The thing you have to remember is that there is no real standardization when it comes to sizing, so you could be a 14 in one shop and a 10 in another – really, those little numbers mean nothing. All that matters is finding a dress that fits well; numbers are literally meaningless.

DRESS ALTERNATIVES

Of course, you don't have to wear a dress to parties.

TROUSER SUITS

Wearing something quite masculine is often really sexy in a Patti Smith way, and can still cause as much of an impact as it did back in 1966 when Yves Saint Laurent first showed this look with his famous Le Smoking, a stylishly louche tuxedo for women. I recently gave this look a go and wore a trouser suit by Jaeger, a label I'd never tried before, and it worked because the suit was very clearly a great cut, with fantastic trousers that were narrow around the legs and had a defined waist. I then tied a thick piece of satin fabric, which acted like a cummerbund, around the white shirt underneath the jacket, to emphasize the curves and make it sexy but still masculine and sharp. The key is to choose a well-cut suit that flatters your figure, otherwise you'll look shapeless instead of sexily subversive. A trouser suit can make just as much of a statement as an evening dress if worn in the right way. Viktor & Rolf, Stella McCartney, Alexander McQueen and Junya Watanabe are all masters of the trouser suit or evening tux. On the high street, Reiss cuts a mean trouser suit and it's a worthwhile wardrobe investment.

PARTY SKIRTS

If you find dresses a little overwhelming but still want to go for a feminine look, there are so many pretty skirts out there, such as ones trimmed with beads or delicate piping. Elspeth Gibson does really beautiful ones, if you're looking to spend some serious money. But,

as I said earlier, if you're wearing a full or decorated skirt, keep your top simple, like the tulle skirt/tight top combo that I love so much. A cropped cardigan will complement a pretty tulle skirt perfectly. If you're going to the party with your boyfriend or partner, you should think about what the other person is wearing and, no, I'm not about to tell you to wear matching leather outfits. But you should check that the two of you won't clash, and if my husband was going to wear trainers to a party then I probably wouldn't wear a full-length dress. Anyway, it's fun to get ready with your partner, helping each other pick out what to wear, getting their opinion about your outfit. After all, they're the one who you want to look nicest for, and you can also gently steer them away from choosing anything awful that would just embarrass you. You see? Fun but also practical.

A TROUSER SUIT CAN MAKE JUST AS MUCH OF A STATEMENT AS AN EVENING DRESS.

PARTY ACCESSORIES

Accessories are where you can really go to town with your party outfit if you've played it safe with the dress. And, best of all, it's the high street that often supplies the most fabulous and affordable finishing touches. These are my top suggestions:

1. Large gold hoop earrings
2. Chainmail or sequinned clutch bags
3. Black satin elbow-length gloves or short cut-off evening gloves
4. Beaded silk evening bags
5. Vintage Chinese fans and lacquered wooden beads
6. Diamanté chokers and chandelier earrings
7. Coloured cocktail rings

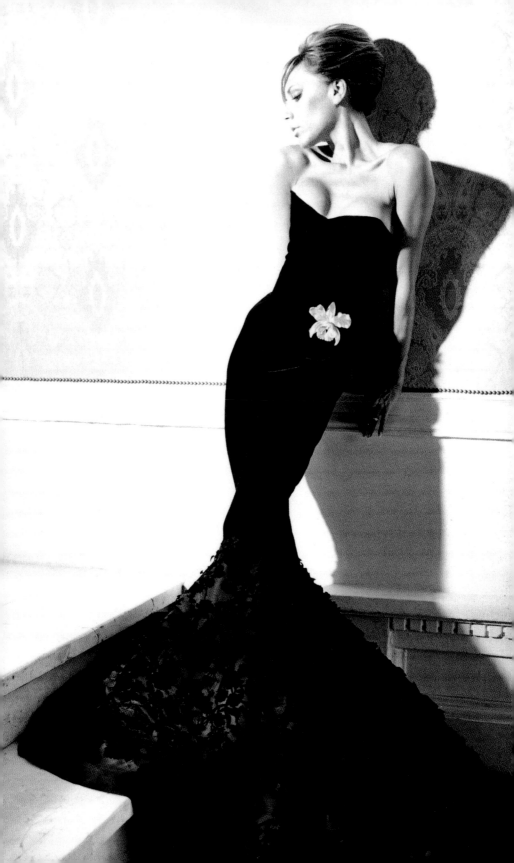

I was never one of those little girls who sat around and dreamed about her wedding day, and it wasn't until I met David that I thought I'd want to get married at all. But once I decided to, I had a pretty good idea how I wanted the wedding to look. My taste, as you can probably tell by now, tends to lean towards the classical side so I wanted a clean, simple gown and I'm so pleased I went for that because I still love the dress, after all these years.

THE DRESS

My dress was made by Vera Wang, who's famous for making really timeless, elegant wedding dresses, and the corset was made by a man called Mr Pearl. Now, he really is a bit of a character. He wears a corset himself all the time, even to bed, because he is so focused on maintaining his 18-inch waist. So he wears it literally day and night, which is true dedication to one's figure. But his corsets do honestly give you that womanly, 50s silhouette that I love, and it felt so sexy having that on my wedding day.

THE FLOWERS

Flowers can be difficult as they're so expensive. So to make things less complicated, and possibly even cheaper, I recommend going with a theme. At our wedding, I wanted to stick with the colour theme of our house, which is deep purple, red and green, particularly as I think strong colours give a really good dramatic effect. Alternatively, white flowers at a wedding always look lovely. Or you can skip flowers altogether and go for a more rustic theme with leaves, moss and twigs, especially if you're having an autumn wedding. Fruit can also look lovely – we had piles of apples by our wedding cake and they looked beautiful. So you see, you don't have to spend a fortune and cover everything with orchids.

top tip

I'd always recommend being properly measured for your dress on a regular basis as your figure may alter before the big day.

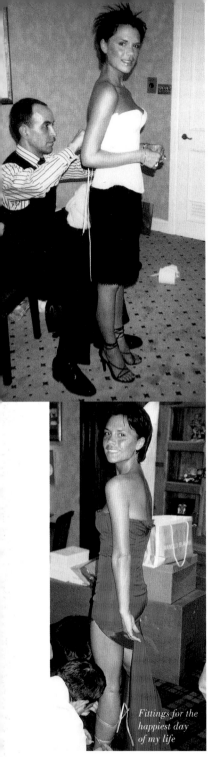

*Fittings for the
happiest day
of my life*

THE BRIDESMAIDS

Bridesmaids' outfits are tough because it's tempting to skimp on them after having spent so much on your own. But you're doing yourself no favours if you do: it's your wedding so you should try to make it look as nice as possible.

I wanted my sister up there with me, but she said she was too old to be a bridesmaid. So I bribed her with a Chloé dress and we made her the matron of honour. I ended up having younger bridesmaids – my two nieces – and got their outfits from Angels, a costumier in London. The point is, think outside the box when it comes to dresses for the bridesmaids and matron of honour because people tend to go automatically for that funny, frumpy style when you really don't have to. If you do have older bridesmaids a good tip is to get pretty party dresses that they can wear after the wedding, like I did with Louise and the Chloé dress. It's just a thoughtful gesture.

IF YOU DO HAVE OLDER BRIDESMAIDS A GOOD TIP IS TO GET PRETTY PARTY DRESSES THAT THEY CAN WEAR AFTER THE WEDDING.

Original illustrations of ideas for Victoria's wedding shoes designed exclusively for her by Manolo Blahnik

❛ *She's a lovely lady and when I met her, I was amazed at how much better she looks in real life than she does in pictures. And she moves so beautifully. She's petite and very, very charming.* ❜

MANOLO BLAHNIK

In terms of other special occasions, if you're going out for a romantic meal, all the rules I mentioned earlier about date outfits apply: show off your good features, but keep it modest.

Little black dresses are always a good option as they look sexy but are not too over-the-top. Remember to wear a good pair of high heels on your date as the extra height will give you confidence.

You can make anything into a special occasion and dress up for it. The late iconic fashion stylist Isabella Blow was my absolute heroine on that front. She once came with us to a football game in Manchester wearing a fabulous pencil skirt, fishnet tights, a really tight leather jacket, major high heels and a Philip Treacy hat that had a big cut-out photo of David on it – with a real diamond in his ear. At Manchester United! She looked fantastic when she walked in. It was definitely a bit more dressed up than the usual style at Old Trafford! She was a truly unique woman, and will be sorely missed.

YOU CAN MAKE ANYTHING INTO A SPECIAL OCCASION AND DRESS UP FOR IT.

WHERE TO BUY

1. PARTY DRESSES: Alexander McQueen, Christian Dior, Christopher Kane, Coast, Designers at Debenhams, Elie Saab, George at ASDA, Giambattista Valli, Giles, Karen Millen, Mango, Marc by Marc Jacobs, Marios Schwab, Moschino, New Look, Oasis, Paul & Joe, PPQ, Principles, Reiss, Roberto Cavalli, Sara Berman, Stella McCartney, Topshop, Valentino, Versace, Vivienne Westwood, Whistles, Zara

2. TROUSER SUITS: Alexander McQueen, French Connection, Gucci, Jaeger, Joseph, Junya Watanabe, Karen Millen, Mango, Principles, Reiss, Stella McCartney, Ted Baker, Viktor & Rolf, Zara

3. PARTY SKIRTS: Coast, D&G, Eley Kishimoto, Elspeth Gibson, French Connection, H&M, Karen Millen, Mango, Marc by Marc Jacobs, Miu Miu, Moschino Cheap and Chic, Nanette Lepore, Prada, Principles, Topshop, Vivienne Westwood, Wheels & Dollbaby, Whistles, Zara

4. PARTY ACCESSORIES: Agatha, Christian Dior, Claire's Accessories, Designers at Debenhams, Diva at Miss Selfridge, Dolce & Gabbana, Freedom at Topshop, Gucci, H&M, Mikey, Miu Miu, Monsoon, Moschino, Oasis, Prada, Reiss, Roberto Cavalli, vintage stores, Vivienne Westwood

5. DESIGNER WEDDING DRESSES:
Amanda Wakeley, Collette Dinnigan, Donna Karan, Elie Saab, Morgan Davies Bridal Shop, Narciso Rodriguez, Neil Cunningham, The Wedding Shop, Valentino, Vera Wang, Vivienne Westwood

6. BRIDAL ACCESSORIES: Basia Zarzycka, Butler & Wilson, Cherry Chau, Mikey

NOTES

vacations

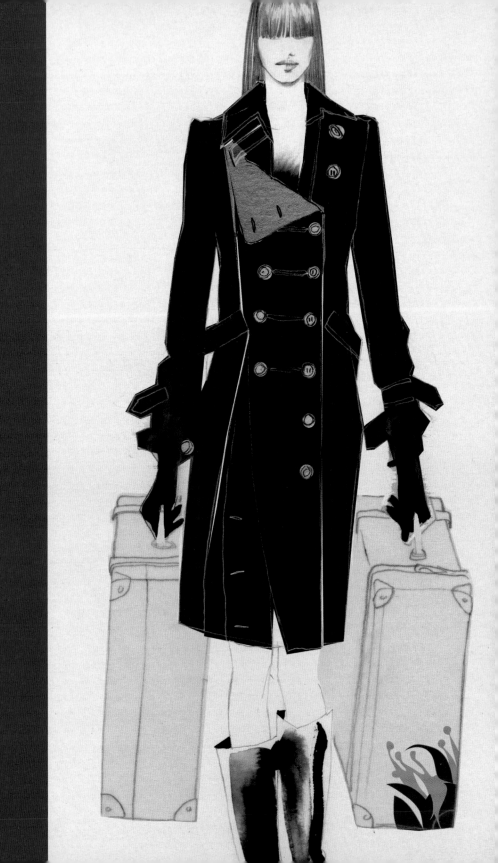

Packing really is one of the worst things about holidays. I just hate choosing what to take and what to leave out. So I take everything!

I'VE TRIED TO GET BETTER ABOUT THIS, THOUGH, BECAUSE A FEW YEARS AGO I LEARNED A HARSH LESSON. Yes, it was that ultimate holiday nightmare – my cases were stolen. And the worst thing was, I had packed everything in them, and I mean EVERYTHING. Like, there was this fantastic little Zara vest that I'd bought five years previously. As all girls know, it's not always the most valuable things that are irreplaceable. There are still times when I'm standing in front of my closet, deciding what to wear that day and thinking, 'Oh, yes, I'll wear those shoes with that dress' – and then I'll remember that those shoes are long gone. Let's start with the basics.

Don't bother with flashy designer luggage. There is a good chance it could get stolen as it attracts attention. Instead, just get plain black cases. I really like the *TUMI* range, which is expensive but is low key and high quality, the two things you want from your cases. For a special treat, I really like luggage from *VALEXTRA*, which specializes in custom-made travel cases. They are more expensive but are terribly chic and last for ever. I've also heard very good things about *MARKS & SPENCER* luggage.

Wheelie luggage is a total godsend if, like me, you take a lot of stuff on holiday, as you can just pull your bag around instead of carrying it and ending up with one arm longer than the other. Sometimes you can slip your wheelie bag on to the plane with you instead of having to check it in and wait ages hanging about the carousel at the other end. *ANYA HINDMARCH* has done pretty coloured ones and you can get colourful printed wheelie cases from surf labels like *ROXY* and *O'NEILL*; even *TOPSHOP* does its own range of luggage now.

If you're just going for a weekend all you need is a hold-all. *J&M DAVIDSON* and *MULBERRY* do great weekend bags which last for years and you can get good hardy leather ones from second-hand markets all over the place. One of the best countries for this is Morocco, so if you ever go to Marrakech make sure you go to the leather-goods stall in the main souk as they make some of the best – and cheapest – leather bags in the world.

FOR A SPECIAL TREAT, I REALLY LIKE LUGGAGE FROM VALEXTRA, WHICH SPECIALIZES IN CUSTOM-MADE TRAVEL CASES. THEY ARE MORE EXPENSIVE BUT ARE TERRIBLY CHIC AND LAST FOR EVER.

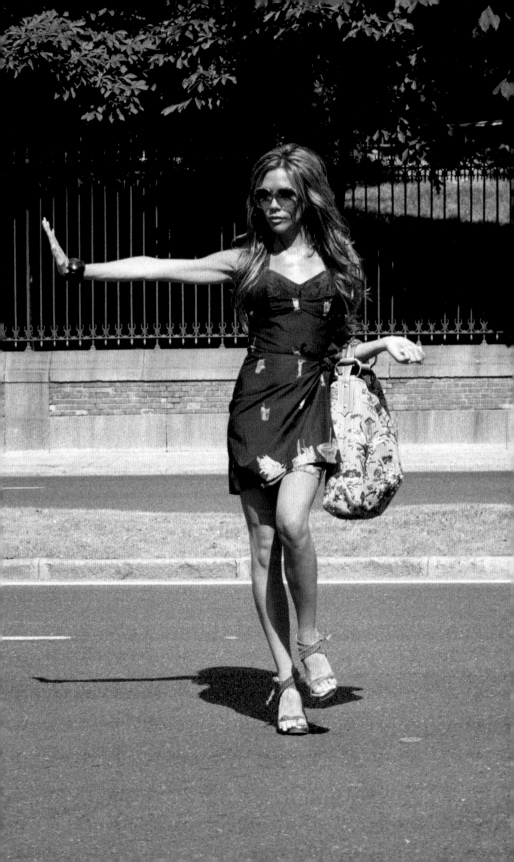

Personally, I won't go anywhere without my Mason Pearson hairbrush, my rollers and hairpins, a small make-up bag, toothbrush and toothpaste, Elizabeth Arden Eight Hour Cream and eye cream. Those are pretty much the essentials.

If I'm going for a week, I'll bring three pairs of jeans – in other words, a different pair for every other day – because they really are my staple, as you know.

I try to stick to the formula of bringing something casual (plain T-shirts, miniskirts), something classic (nice V-necks, a pencil skirt and a plain dress) and then something a bit more out there for some fun. For example, a recent 'out there' outfit was a pair of leather chaps that I took to LA last year, which Dean and Dan Caton from DSquared2 kindly gave me. Maybe they were a little too different for some people, but I loved them and had a lot of fun with them, and that's what really matters.

Oh, yes, and always bring a dressy outfit as you just never know where your holiday might take you (failing that, remember to pack an essential LBD for those last-minute occasions).

Pack some little slipper bags as they are so useful for putting your dirty knickers and socks in on the way back. It's just good sense to separate them out and secure them properly. I once saw some poor woman at an airport whose suitcase fell open on the carousel and she had to go scurrying around, chasing after all her dirty knickers on the conveyor belt, in front of everyone! Can you imagine?

BRING A DRESSY OUTFIT AS YOU JUST NEVER KNOW WHERE YOUR HOLIDAY MIGHT TAKE YOU.

Shielding
Lip/Tint 1
Baume Protecteur IP15
Lèvres/Teinté 1

SPF15

PRADA

PRADA

CARRY-ON ESSENTIALS

**IN YOUR CARRY-ON BAG,
I RECOMMEND BRINGING:**

1. A tracksuit you can change into if it's a long-haul journey.

2. Johnson's baby wipes to take your make-up off; a good, heavy moisturizer; eye cream; lip balm; herbal sleeping pills.

3. Chantecaille's Rose Water or Evian Spritz to help refresh and hydrate your face and get rid of that awful plane smell.

4. Some music, iPod, and a pile of magazines and books you've been saving up. That can pretty much get you through any flight, I find.

5. Get a good-sized carry-on bag that you can fit all of this into instead of relying on multiple handbags. Everyone picks up water, magazines and so on at the airport, so you want to be able to fit as many extra last-minute purchases in your hand luggage as possible, otherwise you'll find yourself carrying about four different bags.

I'm much worse at packing for beach holidays than for skiing ones, simply because I always end up bringing so much stuff that I never wear. For some reason, I always bring lots of dressy tops and trousers but, of course, I mainly wear T-shirts and cut-off shorts on beach holidays.

HOLIDAY PREPARATIONS

A bikini wax is a completely crucial pre-holiday treatment. There is nothing worse than seeing someone throwing their legs around on the beach and, well, let us say no more.

I also recommend getting your legs properly waxed as otherwise you'll be shaving every other day, which is not exactly glamorous and can also give you those horrible red bumps. Waxing, however, makes your legs look smooth and shiny. There are so many good places around now: *VAISHALY* and *HEIDI KLEIN* in London and the *LOWRY HOTEL's* spa in Manchester. My favourite place is *STRIP* in London. It is such a pretty little shop and salon where they do the most brilliant waxes and sell beautiful lingerie, and the fact that it is owned by my best friend is purely coincidence …

BATHING BEAUTY

For sunbathing, I prefer bikinis to one-pieces simply because you get less of a tan mark, and bikinis generally give a better shape. Whatever your shape and preference, you can find fantastic ones on the high street, with Topshop and H&M making some of the best. Sportswear brands, particularly Adidas, can do good ones too, in nice colours. Speedo has created some chic and sporty swimsuits by Comme des Garçons which are very hip and it's also produced a flashy new swimwear line by Brazilian designer Rosa Cha, in bright tropical prints. Another great way to find swimwear is through specialist websites like www.swimhut.com and www.figleaves.com. They stock some fantastic brands from overseas, like Vitamin A, who do ultra-sexy bikinis.

WHATEVER YOUR SHAPE AND PREFERENCE, YOU CAN FIND FANTASTIC BIKINIS ON THE HIGH STREET.

Very cute 50s pin-up bikinis with boy-shorts or pretty little skirts attached to the bottoms are so flirty and a million times sexier than some of the shocking swimming costumes you see some women wearing. The worst are those really high-cut, 80s-style swimsuits. Agent Provocateur does some very sexy swimwear, often with a naughty nautical theme, and Pistol Panties is a great place to find fun and flirtatious swimwear with plenty of ruffles and frills. Both sell online, which is a great way to buy swimwear as at least you can try it on at home instead of in a badly lit changing room.

If you're also a bikini girl, get ones that tie at the sides. That way, you can adjust them so they don't dig into your hips when you sit down – and, of course, they're sexier. Halterneck bikini tops are flattering on most figures but are great for women with bigger boobs, whereas

strapless tops and bandeau bikinis look better on flat-chested women. I don't understand it when women deliberately wear triangle bikinis that are too small for them so that half of their boobs are hanging out underneath. How anyone can think that looks sexy is beyond me.

In terms of colour, the best thing to do is to try to match your skin tone, so if you've got olive skin, like me, brown is a good bet and, once you're tanned, bright orange, yellow or even classy black always look good. Not many people can pull off white swimsuits and they can also look fatally see-through when they're wet, so steer clear of plain white costumes! For a bit of pool-side glamour, metallic gold and silver bikinis can look amazing with a tan, but I'd say they were strictly for looking good rather than doing laps of the hotel pool. American Apparel has some brilliant metallic bikinis which are very inexpensive.

FOR A BIT OF POOL-SIDE GLAMOUR, METALLIC GOLD AND SILVER BIKINIS CAN LOOK AMAZING WITH A TAN, BUT I'D SAY THEY WERE STRICTLY FOR LOOKING GOOD RATHER THAN DOING LAPS OF THE HOTEL POOL.

style no-no

I do love designer swimsuits but you have to be careful not to get one cut in odd shapes or with funny cut-outs on the side, which will just give you comedy tan marks. It takes a very special kind of woman to carry off brown diamond-shaped marks down the left side of her ribcage.

NAUTICAL

Racy red, white or blue stripes look great on holiday. Whether you're sunning yourself in St Tropez or in the Greek Islands, *stripes* will always look good under the sun. You can also team your stripy bikini top with some white denim hotpants for a relaxed beach-chic outfit.

I always pack *string bikinis* for my holidays as they look sexy and you don't get so many awkward tan lines. Bright zingy colours like yellow, orange or fluorescent shades of pink and lime look fantastic with a tan.

SEXY

CURVY

Curvaceous figures can look amazing in a bikini cut to flatter the figure. If you have big boobs make sure they are properly supported with a generous cup. Look for bottoms with side ties as they allow you to pull them in to fit your hips exactly.

Flirtatious bikinis are great for the unabashed! I love pretty 50s-style girlie ones with frilled skirts and flirty bows. They make you feel extra special – like you've really dressed up for the beach.

GIRLIE

BEACHWEAR

Well, I don't want to disillusion anybody but I generally opt for some flip-flops, usually from Topshop or some classic Havaianas, and suncream. Weirdly, I read somewhere recently that I wore high heels even when I go swimming. Now, come on – why would anyone do that to Manolo Blahnik? It would be just criminal.

I love to wear more natural jewellery on holiday – an anklet or bracelet made of shells or pieces of aquamarine. Accessorize is brilliant for that kind of stuff and they usually have very prettily decorated flip-flops. I also really love body jewellery and will sometimes wear a little tummy chain.

Stock up on beach essentials like colourful towels, oversized floppy hats, decorated beach sandals and classic beach bags from the high street. Monsoon and Accessorize are great places to shop for holiday essentials and Marks & Spencer and Primark also do a range of swimwear and inexpensive beach essentials. For an alternative, Heidi Klein has some amazing, if quite expensive, pieces for beach holidays, from its own range of swimwear to hats to jewellery, which definitely proves that you don't have to be boring on the beach. What's more, the store sells all the essentials you need for a stylish beach holiday all year round.

Liza Bruce is another one-off store in Pont Street, London, that sells beautiful kaftans, summery jewellery and beaded sandals, and swimsuits. They have such a high percentage of Lycra that they just suck you in and disguise all your lumps and bumps. As swimsuits go they're very expensive but definitely worth it. The key is to look nice but not to overdo it.

I READ SOMEWHERE THAT I WORE HIGH HEELS EVEN WHEN I GO SWIMMING. NOW, COME ON – WHY WOULD ANYONE DO THAT TO MANOLO BLAHNIK?

With regard to cover-ups, I'm not all that keen on women in long sarongs, although I know loads of people swear by them. Maybe just a little one when you're wearing a bikini, but keep the pattern simple as otherwise it can overwhelm you, not to mention any onlookers. Same story for kaftans, which can look very 70s in a good way. But, equally, they can make people look like they're wearing monks' habits.

For bags, it's best to have a waterproof one – obvious, really! Don't load up on too much stuff as it's easy for things to be ruined or even stolen on the beach, so just take the bare minimum: sunglasses, towel, sunscreen and a good book.

top tip

If you feel too self-conscious to be parading about in your bikini just slip on a little cotton summer dress or a pair of denim shorts – very cool and pretty and you won't look like a monk in a designer pattern.

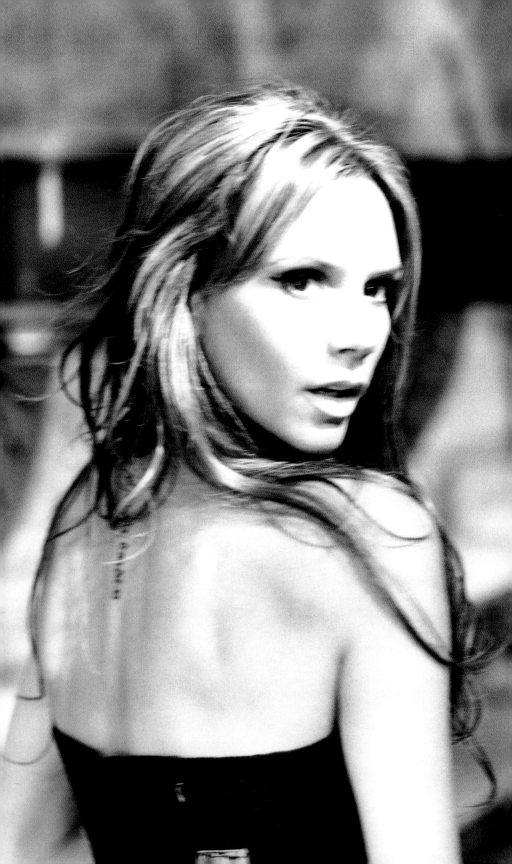

TANNING SECRETS

To get a good colour on holiday, exfoliate beforehand as this will ensure you get the best colour. Yes, it does mean that you'll look like a pasty ghost for your first few days of holiday but the end results will compensate. My favourite scrubs are both from Origins – Never A Dull Moment for my face and Paradise Found for my body, both of which I rely on for my pre-holiday prep. Of course, though, you have to be very careful when you tan and make sure you get a good sunscreen with a high SPF. No one wants to end up looking like one of those old ladies with a face like a Louis Vuitton handbag. In fact, I tend to try to get a tan on my body and leave my face lighter, which means my beach formula is sunblock on the face and a high-factor suntan lotion on the body. Having a tan on your face also means that you have to change your usual make-up palette, which is a total pain. Who can be bothered with that on holiday? So, given all the important health issues, be extra careful about covering yourself in sunscreen every time you go out.

HAIR ESSENTIALS

You have to look after your hair particularly carefully on beach holidays as the sun and salty sea are complete killers. If you don't treat it well, you'll look like a giant Brillo pad, and everyone will have their holiday snaps for proof and potential future blackmail. Remember that episode of *Friends* when they all went to Barbados and Monica's hair went totally mental in the heat? And you thought TV wasn't educational.

ON THE PISTE

Skiing holidays are, of course, a complete nightmare to pack for as you have to bring so much heavy stuff. My main problem is that I find it tricky to get any decent ski clothes: they tend to be hugely bulky or skin-tight salopettes.

THE REST OF YOUR NECESSITIES ARE
1. A good sunblock.
2. A fabulous pair of sunglasses (I'm really not into the goggle look).
3. A warm, thick headband to protect your ears and keep your hair from flying about and blinding you. I don't tend to wear a hat, mainly because I never ski when it's really cold so it's just not necessary.
4. The one item you should definitely spend some money on is a pair of gloves as you want to make sure you get a really good pair that are lined and waterproof. It is just dreadful skiing with cold hands so, for heaven's sake, never ski with fingerless gloves.

top tip

Get professional ski clothes, like North Face, because at least then you'll be sure that the clothes are warm and look great. Many designers like Chanel, Pucci and Prada do their own specific ski ranges.

APRÈS SKI

My favourite outfit for that is a fitted jumper or hooded top, a trusted pair of jeans and some moon boots (Marc Jacobs makes great ones) as they are so warm and comforting after a day on the slopes. Another rule is no winter holiday-themed clothes, so definitely no Bridget Jones-style snowflake jumpers if you're over the age of six. My other most beloved après-ski outfit is a sleeveless thick jumper dress, which is cosy but doesn't add bulk. Pair it with a good pair of boots and you're set up nicely for an evening in the chalet with fondue and a glass of Glühwein.

WHERE TO BUY

1. LUGGAGE: Anya Hindmarch, Asprey, Bally, Debenhams, Delsey, J&M Davidson, Kipling, local markets, Longchamp, Louis Vuitton, Marks & Spencer, Mulberry, O'Neill, Prada, Quiksilver, Roxy, Samsonite, Topshop, Tumi, Valextra

2. SWIMWEAR: Adidas, Agent Provocateur, Boden, Calvin Klein Swimwear, Chanel Swimwear, Chloé Swimwear, Debenhams, D&G Swimwear, Diesel, DKNY, Gap, H&M, La Redoute, Mango, Marks & Spencer, Missoni Mare, Monsoon, New Look, Next, Peacocks, Pistol Panties, Primark, Seafolly, Speedo, Topshop, www.figleaves.com, www.swimhut.com

3. SUNGLASSES: See accessories (page 162)

4. SKIWEAR: Adidas, Agent Provocateur, Belstaff, Bolle (for goggles), Burton, Chanel, Emilio Pucci, La Perla, La Senza, Lillywhites, Marc Jacobs (for moon boots), Marks & Spencer, Moncler, Myla, Prada Sport, Quiksilver, Roxy, Snow and Rock, The North Face

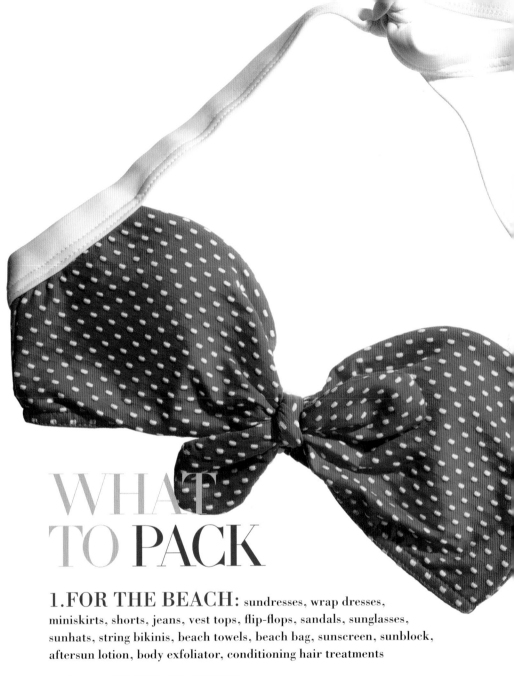

WHAT TO PACK

1.FOR THE BEACH: sundresses, wrap dresses, miniskirts, shorts, jeans, vest tops, flip-flops, sandals, sunglasses, sunhats, string bikinis, beach towels, beach bag, sunscreen, sunblock, aftersun lotion, body exfoliator, conditioning hair treatments

2.FOR THE SLOPES: thermal long-sleeved tops, hooded tops, warm sweaters, sweater dresses, ski suits, ski jackets, ski hats, waterproof boots, sheepskin boots, thick socks, warm ski gloves, sunglasses/goggles, headband, sunblock

NOTES

winter

People often think winter is about bundling up and feeling frumpy and miserable. But it can be easier to look stylish in cold weather than when it's warm.

PEOPLE OFTEN JUST WILT IN THE HEAT and get stuck in the old vest-and-shorts rut, which is fine, but not a very sophisticated look. In autumn and winter I'll wear a coat, nice shoes and well-fitting trousers, and, with a cool handbag, you can't get more sophisticated than that.

Victoria has such a strong personal love of fashion and clothes. She is able to successfully balance her hectic work, travel and family, with a real individual style.

CHRISTOPHER BAILEY
Creative Director, Burberry

SNUG AS A BUG

It's easy to panic about buying a coat because in all likelihood that's the winter item you'll spend the most money on. What you want is a shape that's proven to be timeless and that you can wear with jeans and dresses.

THE TRENCH

Trench coats definitely fulfil those criteria. Obviously, the original and the best are by Burberry, but these are very expensive.

Since the whole trench trend started up again the high street has been doing good versions, especially the mini trench, which is easier to wear. They've even done trench-style jackets that are just great with jeans in the late autumn and early spring. Look for trenches in the traditional stone or off-white. A red trench is great if you're going for a bit of a siren look and a black one will make any outfit look pulled together and elegant. For me, you can't beat a Burberry trench. Burberry's Creative Director, Christopher Bailey, has cleverly made the trench a little more dressy in the company's high fashion line, Burberry Prorsum (which is Latin for 'forward'), by offering them in gorgeous metallic fabrics, such as shimmery silver. They are absolutely beautiful, but expensive. You can occasionally find old second-hand Burberry trenches at markets, particularly Portobello, or, if you're lucky, in charity shops.

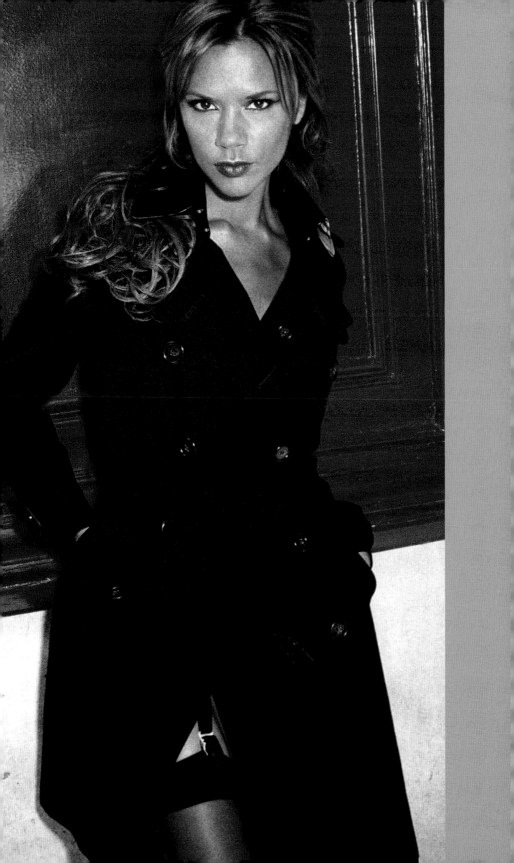

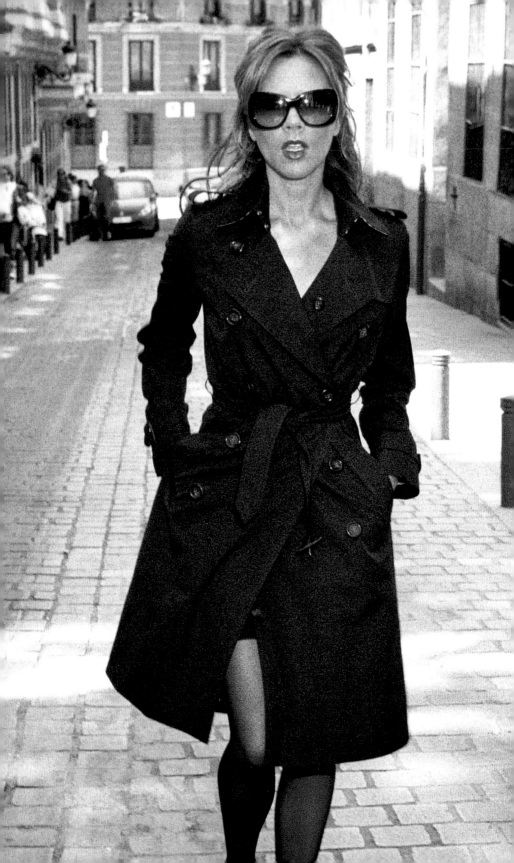

*MAKE SURE YOUR COAT IS WARM.
NO MATTER HOW BEAUTIFUL IT IS,
YOU JUST WON'T WEAR IT IF IT'S
NOT DOING ITS PRIMARY JOB.*

COATS AND JACKETS ESSENTIALS

1. If you want to get a trendy winter coat, you can buy great ones on the high street and that way you won't have spent too much money when the look has moved on.

2. Always make sure your coat is warm. No matter how beautiful it is, you just won't wear it if it's not doing its primary job.

3. Certain coats can often be shapeless so check that yours is properly cut along the torso, otherwise you can look a little lumpen. It should nip in around the waist, either in the way it is cut at the back or from having a belt that you can tie at the front or the back.

THE JACKET

Properly lined leather jackets also work and they almost always look better the older they get. You can often find them in vintage shops and second-hand markets.

Cropped jackets are more autumnal and not very suitable for winter, but look fabulous because they show off your shape in a way that most coats and jackets don't.

top tip

6 Invest in a proper coat that will keep you warm for years and won't look dated. It's best to go with a classic coat rather than something that's very fashionable that season. 9

Winter footwear can be tricky. I admit, I do wear open-toed sandals in the winter, but this isn't always practical. I haven't really got into the tights with open-toed shoes look that is very popular now. Here are a few top winter shoes tips:

1. It's just more sensible, and more classic, to wear pointy or round-toed shoes or boots during the winter.

2. Make sure your trousers break just on the tips of the shoes to elongate your legs.

3. Patent shoes and boots are always a stylish and practical option for wet winter weather.

4. Stylish wellies like those made by Hunter and Orla Kiely can do the trick when it's pouring.

IF THE GLOVES FIT

Gloves can really add style to an outfit: a few years ago I bought a pair of really fun demi gloves with fake-fur trim from Vivienne Westwood and they still look amazing.

Leather gloves are always the way to go and you can get some really beautiful ones from traditional places like Dents, which makes jewel-coloured ones in soft, thin leather. Gucci does great ones too, which isn't all that surprising as the label has always specialized in leather, as does Hermès, which makes very pretty and feminine ones. Burberry Prorsum has done some amazing long elbow-length gloves which really make a statement. At the other end of the spectrum, my sister bought me some amazing olive-green ones from H&M a while ago, made from the most beautiful leather at a snip of the designer price tag.

WRAP IT UP

Long chunky knit scarves look really beautiful and I recommend Louis Vuitton and Burberry. You can get them all over the high street, especially from New Look and Topshop. Very Ali MacGraw in *Love Story*, I think, tragic ending aside, of course. Look for scarves with a good length so you can wrap them around your neck at least once, à la Kate Moss. Jo Gordon, a Scottish knitwear designer, makes some of the best long knitted scarves in a range of lengths and colours, some with tassles and some in multicoloured stripes; they really are a winter staple. I prefer my scarves in plain colour blocks, but colourful striped ones look equally good. You can also find these on the high street at Gap, Benetton and New Look, but mail-order companies like Brora and Land's End do gorgeous ones too.

I PREFER MY SCARVES IN PLAIN COLOUR BLOCKS, BUT COLOURFUL STRIPED ONES LOOK EQUALLY GOOD.

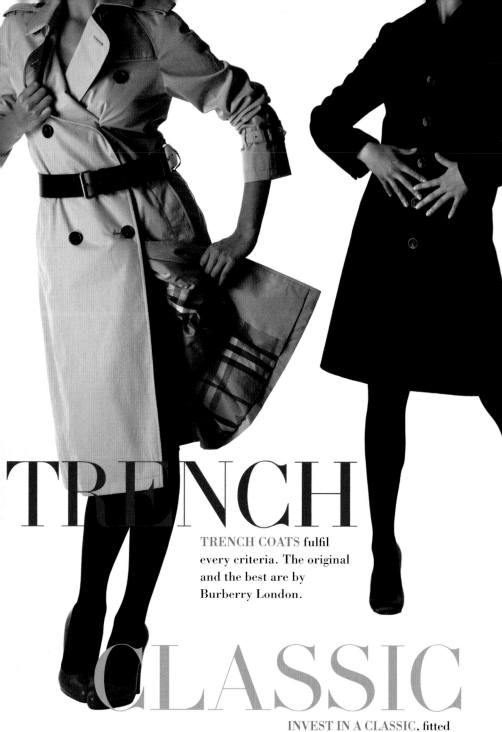

TRENCH

TRENCH COATS fulfil
every criteria. The original
and the best are by
Burberry London.

CLASSIC

INVEST IN A CLASSIC, fitted
shape that has a timeless appeal.
This style works well whether
you're wearing jeans or dresses.

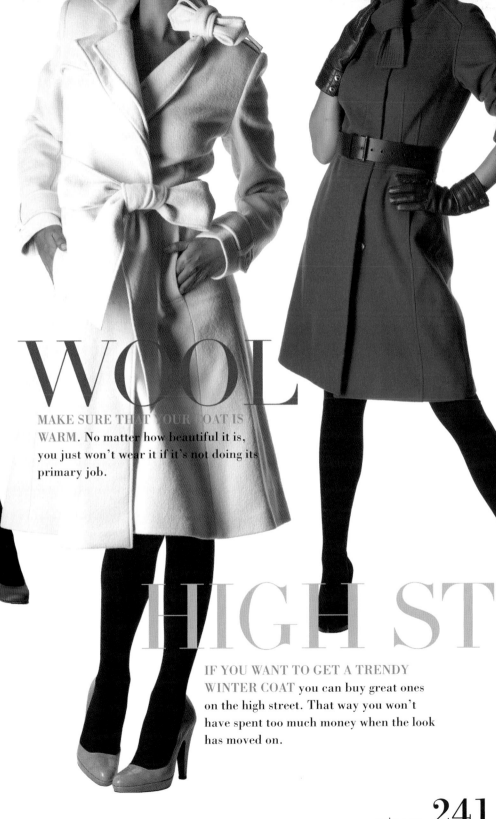

WOOL

MAKE SURE THAT YOUR COAT IS WARM. No matter how beautiful it is, you just won't wear it if it's not doing its primary job.

HIGH ST

IF YOU WANT TO GET A TRENDY WINTER COAT you can buy great ones on the high street. That way you won't have spent too much money when the look has moved on.

WHERE TO BUY

1. TRENCH COATS: 3.1 Phillip Lim, Alexander McQueen, APC, Aquascutum, Burberry Prorsum, Calvin Klein, Celine, DKNY, Gap, George at ASDA, Gérard Darel, Hugo Boss, La Redoute, Marc by Marc Jacobs, Marks & Spencer, Principles, Reiss, Topshop, Vivienne Westwood

2. LEATHER JACKETS: All Saints, Balenciaga, Bally, Belstaff, Diesel, Dolce & Gabbana, Gap, Gas, Gucci, H&M, Joseph, Loewe, Miss Sixty, New Look, Rick Owens, River Island, Warehouse, Zara

3. CLASSIC COATS: All Saints, Anna Molinari, Balenciaga, Betty Jackson, Burberry Prorsum, Diane von Furstenberg, Dolce & Gabbana, Gap, George at ASDA, Giambattista Valli, H&M, Hobbs, Karen Millen, Mango, Marc by Marc Jacobs, Margaret Howell, Miu Miu, Nicole Farhi, Oasis, Per Una at Marks & Spencer, Philosophy di Alberta Ferretti, Prada, Principles, Reiss, Roberto Cavalli, Sara Berman, Topshop, Versace, Warehouse, Zara

4. CROPPED JACKETS: All Saints, D&G, Dolce & Gabbana, Fornarina, Gap, H&M, Marc by Marc Jacobs, Marni, Miss Sixty, Oasis, Reiss, Rick Owens, River Island, Roberto Cavalli, Topshop, Urban Outfitters, Wallis, Warehouse

5. GLOVES: Burberry Prorsum, Carolina Herrera, Cornelia James, Debenhams, Dents, Gucci, Hermès, H&M, John Lewis, LK Bennett, Next, Pickett, Prada, Ralph Lauren, Topshop, Tu at Sainsbury's, Versace, Vivienne Westwood, Zara

6. SCARVES: All Saints, Benetton, Brora, Burberry Prorsum, Gap, Georgina von Etzdorf, H&M, Jo Gordon, Joseph, Land's End, La Redoute, Louis Vuitton, Marc by Marc Jacobs, Missoni, New Look, Nicole Farhi, Primark, Reiss, Sonia by Sonia Rykiel, Topshop, vintage stores

7. WINTER BOOTS & SHOES: Bally, Burberry Prorsum, Dune, Faith, Fendi, French Connection, Frye, Gucci, Hogan, Hunter, Kate Kuba, Kurt Geiger, LK Bennett, New Look, Office, Orla Kiely, Prada, Tod's, Ugg, Vivienne Westwood, Yves Saint Laurent

NOTES

special

occasions

JO MALONE
LONDON

Lime Blossom
Scented Candle
Bougie Parfumée

JO MALONE
LONDON

Orange
Blossom
Scented Candle
Bougie Parfumée

JO MALONE
LONDON

Wild Fig
& Cassis
Scented Candle
Bougie Parfumée

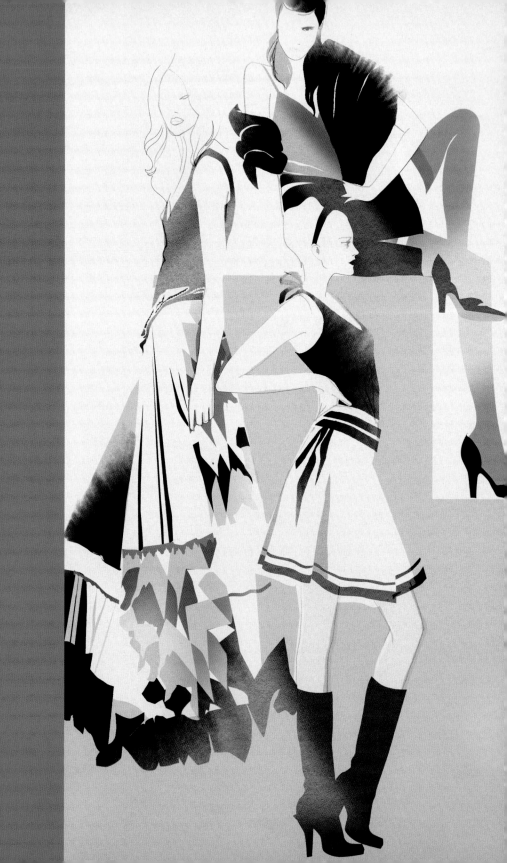

The first thing I will say about dressing for the holidays is to get all images of reindeer jumpers out of your head.

ONLY CHILDREN SHOULD WEAR CLOTHES SPECIFIC TO AN OCCASION – HALLOWEEN OR CHRISTMAS, SAY. I love putting the boys in Christmas pyjamas and that kind of thing. However, for adults, dressing at Christmas is about being comfortable but also looking decent, as chances are you'll all be taking pictures of one another and you really don't want photographs of you in a reindeer jumper to sit in your living room for the rest of your life. If it's just us, I'll often simply wear my pyjamas and a dressing gown. If we have family over for a traditional Christmas dinner, I'll put on a nice pair of trousers and a good shirt. I'm certainly not going to be tottering about the house all day in some uncomfortable get-up. Basically, we tend to go down the traditional route.

Buying fashion presents for Christmas is a highly risky affair, but there are some things that are always going to be winners, even if the gift is for the toughest sort of fashion snob who seems to have everything.

1. DIPTYQUE CANDLES are always popular, come in a huge range of gorgeous fragrances and will be very much appreciated by a stylish recipient. Diptyque also now sells a selection of smaller candles.

2. THE WHITE COMPANY has really nice candles and scented room sprays too.

3. JO MALONE's range is rightly a classic. She does very pretty scents and lovely room fragrances, particularly the Pine & Eucalyptus, which instantly makes any room smell like Christmas, whatever the time of year.

4. David and I also both love the scented candles from HÔTEL COSTES in Paris; they have a really strong, sexy smell and always make us feel like we're in that gorgeous city, even if we're just playing with the kids in the kitchen.

5. LIBERTY in London has a fantastic selection of really unusual candles, including ranges from Comme des Garçons to Slatkin. Excitingly, my favourite shoe designer – yes, Manolo Blahnik – has started making candles, so if you can't quite stretch to a pair of Manolo stilettos, at least you can get some beautiful-smelling scents!

top tip

❛ **Try to avoid cheaper ranges of scented candles as these tend not to last very long because they contain relatively little of the oil that gives the candle its smell. If you can buy a more expensive one, you'll find you burn it for less time and it therefore lasts an age.** ❜

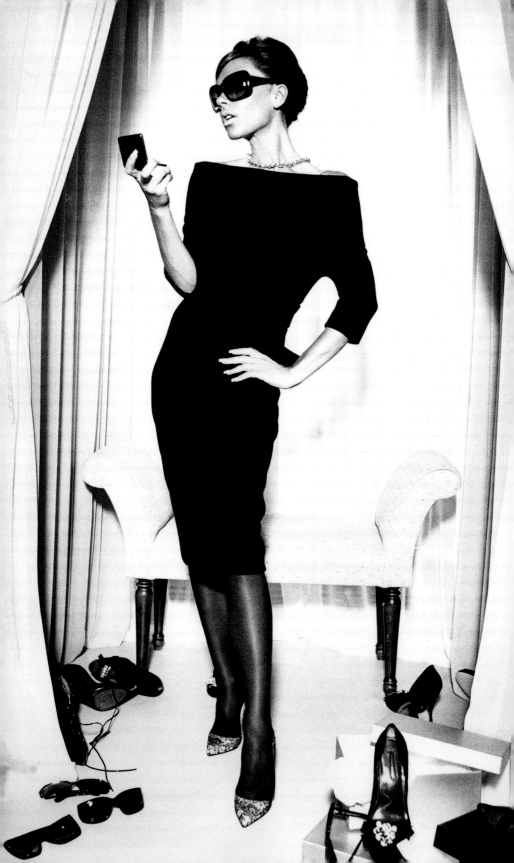

GIFTS FOR GIRLS

Teeny little designer things that have the designer's name or logo on them are always cute, such as tiny PRADA key rings or MIU MIU brooches. The MARC BY MARC JACOBS store in New York is the best place in the world for this. There, you can find Marc Jacobs colouring pencils, pretty plastic compacts, animal-shaped pencil sharpeners and sweet little pens, all for under $20. So if you ever go to New York, go straight there and stock up because you can give those as presents for years.

1. Pretty things from SMYTHSON, such as plain notecards or sweet little notebooks – you can get cute doll-sized ones that aren't too expensive – always look wonderful and they giftwrap things so beautifully there.

2. CATH KIDSTON also does really pretty, vintage-looking things such as gorgeous mugs, little bags and great knick-knacks for the home.

3. PAUL & JOE also stocks some gorgeous scented candles along with other great gift ideas like sweetly packaged cosmetics and make-up bags.

4. For girlfriends, little accessories are generally safe bets, such as small, pretty handbags, clutch bags, or even bits of jewellery and pretty compact mirrors.

style no-no

I do think it's a bit of a risk to buy clothes for your girlfriends unless you know for sure that they like the item and that you've bought it in the right size. Yes, of course, you can always include the receipt so they can return it, but it is a bit of a pain for the person to have to go back to the shop.

Giving beauty products and make-up can be equally tricky,
but there are some things that any girl would love.

1. NARS Body Glow and MAC's Strobe Lotion are both fabulous, giving a subtle sheen to your skin, and they work brilliantly on bare legs and arms in the summer.

2. The LAURA MERCIER body and bath range is divine: the Almond Coconut Milk Scrub makes you smell absolutely delicious, and the Crème Brûlée Honey Bath is the most soothing thing in the world after a long day. Geri first introduced me to these products and she gave me a whole basketful after I had Cruz; it was the perfect post-birth present.

Bath products in general are a good idea as surely everybody loves
having a pampering bath; or just a pot of really gorgeous moisturizer!

3. A boxed set of ORIGINS' 'A Perfect World' range is fantastic. Space NK Apothecary also does some lovely box-sets with divine bath salts and lotions.

4. MILLER HARRIS does some great shower gels in really prettily decorated packaging – they are lovely to see first thing in the morning.

BATH PRODUCTS IN GENERAL ARE A GOOD IDEA AS SURELY EVERYBODY LOVES HAVING A PAMPERING BATH; OR JUST A POT OF REALLY GORGEOUS MOISTURIZER!

254 *special occasions*

For someone really special, buying them a professional facial or massage is a real treat.

1. JO MALONE gives some of the best facials and her skincare products smell good enough to eat. They're always beautifully packaged and make gorgeous gifts.

2. The ELEMIS spa in London has to be one of the most amazing inner-city spas in the world. You enter through this little door on a cobbled street and it's like you're in some mysterious Moroccan temple; the treatments themselves are incredible.

3. HARRODS offers wonderful treatments in its Urban Retreat salon, particularly the luxurious Crème de la Mer facial.

4. DERMALOGICA facials are super-effective and widely available – you can find your nearest branch at www.dermalogica.co.uk.

PERSONALLY I LOVE TREATMENTS AND I'LL ALWAYS WELCOME A GIFT OF A MASSAGE!

dermalogica®

a skin care system researched and developed by The International Dermal Institute

5. BLISS Spa in London and New York is so white and clean you feel refreshed before you've even had anything done to you, and the products smell amazing.

6. For a cheaper but still good facial, the Green Room uses products from THE BODY SHOP and has branches all over the country.

7. BENEFIT and POUT also offer speedy make-up treats and touch-ups like eyelash and brow tints – you can buy these as gifts for girlfriends.

Personally I love treatments and I'll always welcome a gift of a massage!

Boys can be an absolute nightmare to buy presents for, mainly because so many things they like are so expensive! Gadgets, cars, weird electronic things – hardly pocket change, really. They're even trickier to buy fashion presents for because, despite most of them claiming they don't care about fashion, they're even pickier than girls! My solution? I find that almost all boys like vintage T-shirts and hoodies, and these are not only really easy to find, but also generally pretty cheap. Just go to any market, vintage shop, or sometimes even really good record shops and you will almost certainly be able to find them. Abercrombie & Fitch is always a good bet, and Amplified does some cool men's rock 'n' roll T-shirts.

You can find some super gifts in designer stores, but just remember to have a budget in mind. Ralph Lauren is always a hit for shirts, T-shirts and boxer shorts, and Hermès has some beautiful small leather goods. Selfridges buys really good menswear and is a good starting point for accessories like belts, shoes and underwear. It also stocks interesting menswear labels like Unconditional, Prada Sport and Dior Homme. You can also find some great designer menswear online from www.brownsfashion.com and www.matchesfashion.co.uk. Browns stocks amazing silver jewellery by LA label Chrome Hearts which is very rock 'n' roll – Karl Lagerfeld is even a fan of it! On the high street, Reiss, Topman and Zara do excellent menswear and COS, a new label from Sweden, have some sharp suits and shirts at very good prices.

I FIND THAT ALMOST ALL BOYS LIKE VINTAGE T-SHIRTS AND HOODIES, AND THESE ARE NOT ONLY REALLY EASY TO FIND, BUT ALSO GENERALLY PRETTY CHEAP.

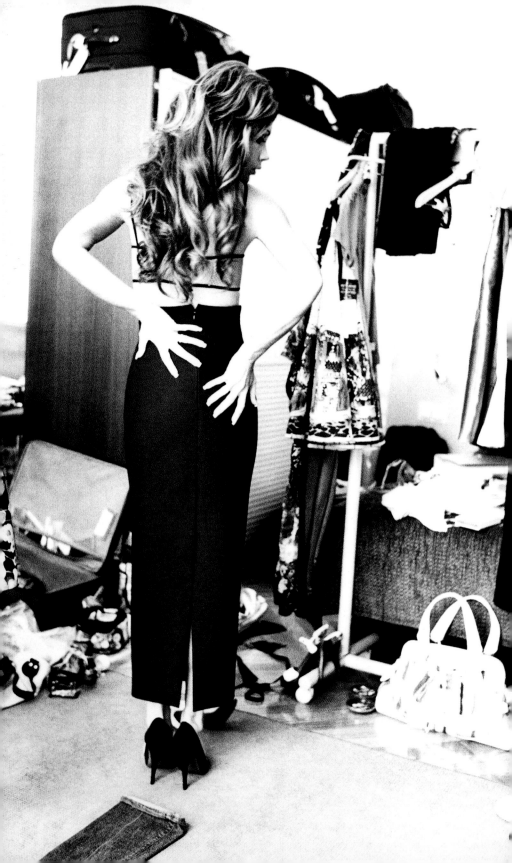

DESPITE CLAIMING THEY DON'T CARE ABOUT FASHION, BOYS ARE EVEN PICKIER THAN GIRLS!

Vintage stores are a great place to pick up a smart tie-pin, a watch or cufflinks. I often like to give these to David as gifts. I found some good ones at the top of Sloane Street in London.

If you happen to be overseas, check out these boutiques for some unusual boys' gifts:

1. COLETTE in Paris – great for CDs and trainers.
2. 10 CORSO COMO in Milan – for unusual and fun little gadgets, designer accessories and interesting books of photographs. Most men love these.
3. URBAN OUTFITTERS in the USA – good for boy-orientated bits and bobs like T-shirts, baseball caps and belts.

There are now so many good children's
clothes around that kids are easy to buy for.

1. ZARA, GAP and H&M all do great,
inexpensive clothes for children and
babies and Topshop also has a great
baby-wear range.

2. PETIT BATEAU is, of course, a classic
and the perfect place to shop for lovely
babygros and T-shirts.

3. MARKS & SPENCER is always
reliable for kids' underwear and
nightwear.

4. PAUL & JOE has gorgeous
childrenswear and special gift ideas.

5. MOLLY BROWN is a children's
jewellery designer that makes exquisite
silver charm bracelets and necklaces with
coloured jelly-bean charms.

6. CARAMEL in Ledbury Road, London,
stocks beautiful one-off childrenswear.

7. DAISY & TOM on the King's Road is a
great stop for children's apparel.

8. Another good kids' brand is
NO ADDED SUGAR.

9. For a special treat, BONPOINT,
a French childrenswear company, is
divine, although a little expensive. It has
beautiful full-skirted dresses for girls and
also does some totally amazing
children's footwear.

10. CAMPER does brilliant shoes for
boys and girls in fun crayon colours.

11. For a keepsake, TIFFANY & CO
makes gorgeous sterling silver children's
charm bracelets that are beautifully
packaged in the Tiffany blue boxes.

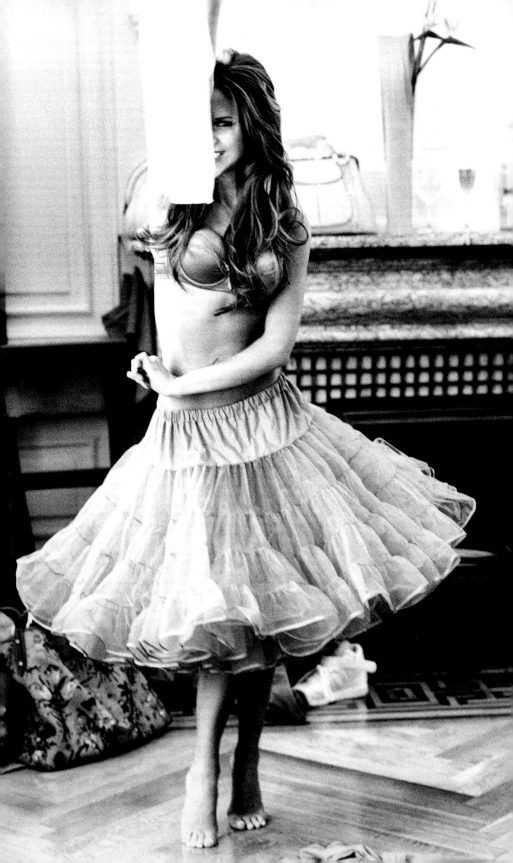

DESIGNER KIDS' CLOTHES ARE CERTAINLY ON THE INDULGENT SIDE. AS LOVELY AS THE OUTFITS ARE, THE KIDS GROW OUT OF THEM FAIRLY QUICKLY.

With my love for all things denim it will come as no surprise that I'm designing a range of kids' clothes. As a mother of three I have plenty of practice knowing what works!

Designer kids' clothes are certainly on the indulgent side. As lovely as the outfits are, the kids grow out of them fairly quickly. But they are quite nice to give as baby presents: someone gave Cruz some Baby Dior, which I love, and it was one of my favourite baby gifts. But designer outfits aren't, of course, hugely practical. In less than five minutes my kids will have covered their clothes with mud and grass stains from playing football in the garden. But as a fun little present, they are fabulous.

David and I have also recently discovered a T-shirt line for children called Jakes, available at www.jakesofsoho.co.uk. All the proceeds from the sale of the T-shirts go towards helping Jake, a boy with cerebral palsy who is truly an inspiring character. I wholeheartedly believe in supporting children's charities wherever I can.

WHERE TO BUY

gifts for girls

1. CANDLES: Acqua di Parma, Agent Provocateur, Calmia, Diptyque, E'Spa, Hôtel Costes, John Lewis, Jo Malone, Liberty, Manolo Blahnik, Paul & Joe, The White Company, Tocca

2. ROOM FRAGRANCES: Floris, Jo Malone, Kenneth Turner, Marks & Spencer, Miller Harris, The White Company

3. BOX-SETS: French Connection, John Lewis, Marks & Spencer, Neal's Yard Remedies, Nougat, Origins, Space NK Apothecary

4. SPA GIFTS: Agua Spa at the Sanderson Hotel, Bliss Spa, Body Shop Green Room, Dermalogica Facial, Elemis Day Spa, Harrods' Urban Retreat, Jo Malone Facial
FOR MANICURES AND MAKEOVERS: Benefit, Pout

5. LIFESTYLE GIFTS: STATIONERY AND NOTEBOOKS: Liberty, Paperchase, Smythson HOMEWARES: Armani Casa, Cath Kidston, Donna Karan Home, Habitat, Hermès, Muji, Nicole Farhi, Ralph Lauren, Zara Home SMALL DESIGNER FASHION ACCESSORIES: Emilio Pucci, Hermès, Marc by Marc Jacobs, Missoni, Miu Miu, Paul Smith, Prada

gifts for boys

1. VINTAGE T-SHIRTS: Amplified, Rokit, Urban Outfitters, Worn By

2. SHIRTS: Dior Homme, Paul Smith, Thomas Pink, TM Lewin

3. SMALL LEATHER GOODS: Burberry, Hermès, Louis Vuitton, Mulberry, Prada

4. FRAGRANCE: Calvin Klein, Comme de Garçons, Hermès, Intimately Beckham, Intimately Beckham Night

5. UNDERWEAR: Abercrombie & Fitch, Calvin Klein, Ralph Lauren, Ted Baker

6. JEANS: Abercrombie & Fitch, Diesel, Energie, Replay, Ted Baker, Topman, Urban Oufitters

7. VINTAGE WATCHES AND CUFFLINKS: Rokit, second-hand stores, vintage jewellery shops

gifts for children and babies

1. DESIGNER BABYWEAR & GIFTS: Baby Dior, Bonpoint, Brora, Burberry, D&G, Evisu, Gucci, Juicy Couture, Molly Brown, Neck & Neck, Paul & Joe, Tiffany & Co, Timberland

2. HIGH-STREET CHILDRENSWEAR: Baby Gap, H&M, Jigsaw Junior, Marks & Spencer, Mini Boden, Mitty James, Monsoon, Mothercare, Next, Nike, Petit Bateau, Zara Baby

NOTES

pregnancy

&

post-

pregnancy

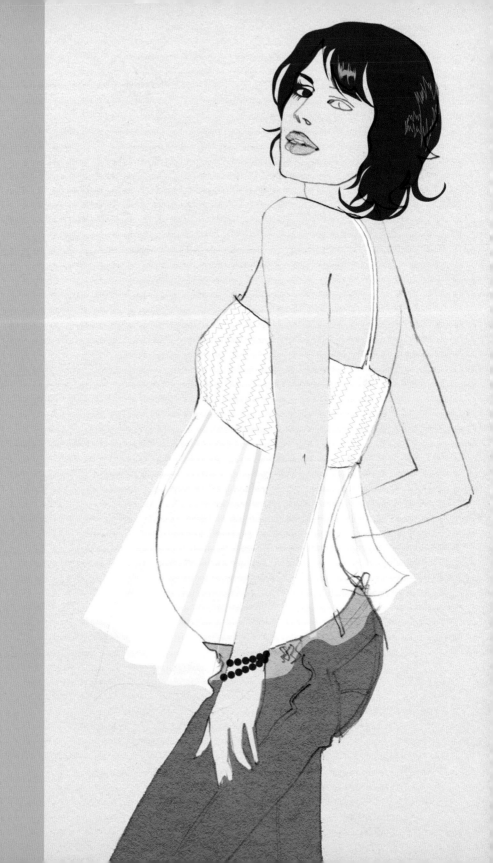

*The difference between
the maternity clothes
in the shops when I was
pregnant with Brooklyn
and when I was pregnant
with Cruz is incredible.*

THINGS REALLY HAVE BECOME SO MUCH BETTER WITHIN THE
PAST DECADE, thanks in no small part to labels like Juicy Couture
and Seven who have started doing maternity clothes, proving that just
because a woman gets pregnant doesn't mean she abandons her sense of
style. There is a huge market out there for nice maternity wear; sadly
Topshop's brilliant maternity line wasn't available when I was pregnant,
so I missed out on that one. I have noticed that things are improving
all the time and there is much more choice available to expectant mums
now. Shops like Blossom and 9 London have jumped on this trend by
offering designer maternity wear – they can even get certain designers
to make up special maternity versions of their beautiful dresses and
trousers.

But for the longest time, maternity clothes were pretty much a disaster zone – all those baggy trousers and silly frock tops. After all, just because I'm pregnant doesn't mean I want to look like Demis Roussos. Yes, of course, it's harder to make an effort when you feel like a two-tonne whale, but that is precisely the reason why brands should make nice, easy-to-wear clothes that help pregnant women to feel good about themselves, not some horrible tent dress that makes them look like a walking mountain.

BE WARNED

Some women really love being pregnant, and I know a lot of men find it very sexy. But, personally, though I love having kids I find the pregnancy part tricky. It certainly has not helped matters that in the past so few maternity clothes took into account what actually happens to a woman's body when she's pregnant.

It's not just your tummy and boobs that get bigger but sometimes also your hips, your bottom and often your back. Even your face can change shape and sometimes your skin tone alters so that your make-up starts to look all weird.

It's not enough making dresses that have room at the front. They have to make room for everything else, too. It really doesn't make a pregnant woman feel too good to be walking around in jackets and tops that really squeeze her around her ribs.

274 *pregnancy & post-pregnancy*

'Whenever I'm pregnant I make my own maternity jeans by taking a normal pair, cutting V shapes in the side by the pockets and stitching elastic there. That way, I keep the normal zipper fly in front, and that is a lot nicer-looking than a big strip of elastic.'

I fell in love with ponchos when I was pregnant with Cruz, my third baby: they were one of the few things I could find that had room for my tummy, my boobs and my back.

Maternity jeans can be problematic too: often they just have elastic in the front but no allowance on the sides for your expanding hips. Also, putting the elastic in the front is not particularly attractive.

The keys to getting through pregnancy and feeling stylish are, first, not to think you suddenly have to buy into the cliché of how a pregnant woman should dress (i.e. frumpy tent dresses and smock tops) and, secondly, to play up the parts of your body you feel fine about and be more discreet about the parts you aren't so happy with.

Remember to emphasize your good parts. Different people swell up in different places.

style no-no

For God's sake, don't make any drastic changes to your physical appearance when you're pregnant: I've seen so many pregnant women suddenly decide to dye their hair or cut it all off. But, because you're all hormonal and not thinking straight, nine times out of ten you'll come out of the pregnancy and think, 'What the bloody hell did I do that for?!'

LEGS, BUMS AND TUMS

I would recommend wearing sharp jackets or side-skimming tops that are tailored on the sides to give a bit of shape but are loose in front. Look for fitted-leg trousers that you can let out at the top but which retain your shape to flatter your pins.

I would not recommend wearing a low-cut top. My boobs get so big during my pregnancies that they practically start around my back. Many women's often become really veiny as well and basically look like a map of the motorway network, so wearing a plunge-front top would be totally inappropriate. This is not about hiding the fact that you're pregnant but rather finding ways to feel confident about your appearance during your pregnancy.

THE WRAP DRESS

The number-one item I think every pregnant woman needs is a wrap dress. We've already spoken about how useful wrap dresses are generally, but they are totally brilliant when you're pregnant. They're adjustable in precisely the places that change during your pregnancy – your back, your boobs, your tummy – and are particularly handy when it comes to breast-feeding. In fact, some women can wear their usual, non-maternity wrap dress for a fair way into their pregnancy, which really helps them to feel both more normal during this time, and that they haven't become a different person. Wrap dresses are also incredibly flattering to all pregnant women because the cotton jersey just skims over your body as opposed to clinging and making you feel self-conscious. They play down your boobs, too, because the material crosses over them, thereby separating them, so there's no cleavage for people to stare down. You can also decide whether you feel more comfortable having the belt over your tummy or under it – it's different for all women as each individual's bump grows differently.

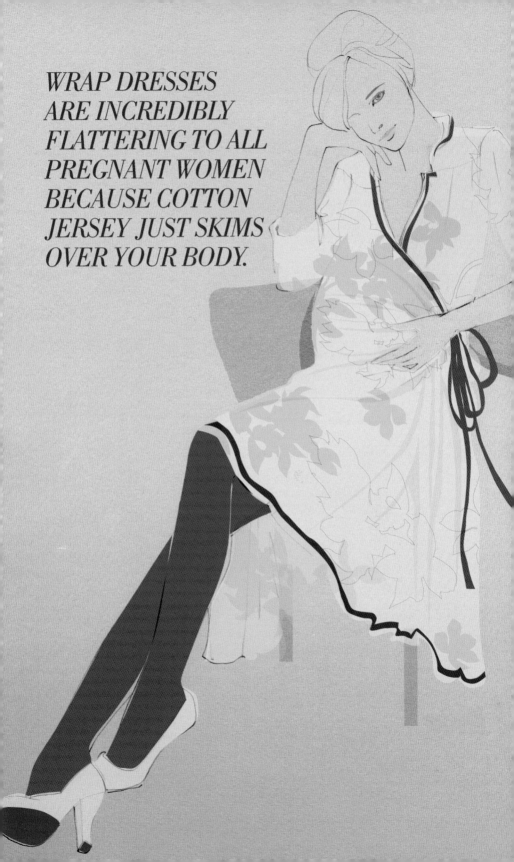

WRAP DRESSES
ARE INCREDIBLY
FLATTERING TO ALL
PREGNANT WOMEN
BECAUSE COTTON
JERSEY JUST SKIMS
OVER YOUR BODY.

As your boobs get so mammoth towards the end of your pregnancy, nipples the size of hubcaps and everything, a lot of dresses and tops give you an enormous cleavage, which can be really embarrassing, not to mention distracting for others.

1. It is essential that you get a good maternity bra.

2. As your boobs are changing so much, it is definitely worth getting them re-measured, which you can do in any decent lingerie section of a department store or Mothercare.

3. Most department stores now sell good maternity bras, especially Marks & Spencer, which has a fantastic selection. Splendour and Blooming Marvellous also make very good ones.

4. Always check that your maternity bra has wide straps and a broad side and back for support.

style
no-no

One thing that definitely does not change, pregnant or not, is my opinion of cropped tops and I think they look even worse than usual when pregnant women wear them. Personally, I would feel so exposed and just not right having my bump so much on show. And it looks to me like the baby inside seems so unprotected. This may sound strange to some people but it just makes me feel really uncomfortable.

This is one time in your life when little empire-line vests and tops work with a big bust because they act a bit like a protective curtain covering your tummy, but just make sure they are cut big enough for your boobs at the top and long enough to cover your bump. Wear one with your home-made maternity jeans and a fitted leather jacket that you can just leave open at the front, and you have a perfect maternity look. Really, you just need your maternity clothes to be practical, and in this outfit you won't feel exposed, you have total freedom of movement, nothing's hugging you uncomfortably, and you can run around and just get on with your day.

There are some things, though, on which I will not compromise, even if they are impractical. You remember how I said I am a high-heels girl?

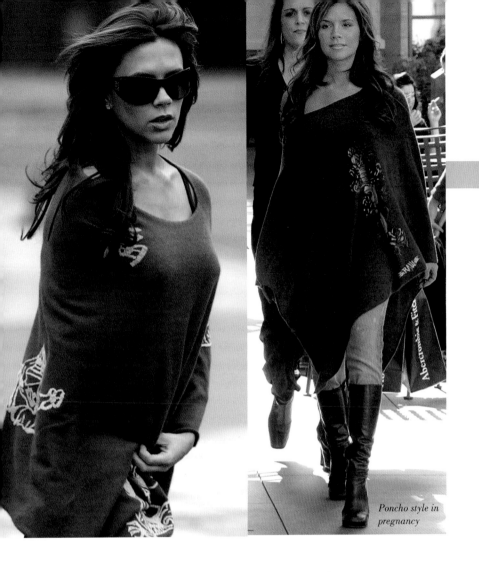

Poncho style in pregnancy

I JUST REFUSE TO ACCEPT THAT I HAVE TO TOTALLY CHANGE MY LOOK WHEN I'M PREGNANT.

And remember that I also said you shouldn't change your usual style when you're pregnant? So, yes, I do still wear my stilettos when I'm pregnant, but I'm certainly not recommending it for anyone else, and most women will opt for simple flats. This is particularly true if they suffer from any kind of back pain, which is a miserably common problem for pregnant women. I remember when I was heavily pregnant with Romeo, my mum and I took Brooklyn to Legoland, of all places, in the middle of August, and there I was, tottering around in my high heels. Now that was, I admit, incredibly uncomfortable, but, like I said, I just refuse to accept that I have to totally change my look when I'm pregnant.

PAMPER YOURSELF

One thing you can do during pregnancy to make yourself feel better is to indulge yourself with some beauty treatments. Just slathering yourself in really delicious body moisturizers will make you feel happier in your skin – and sexier – and can be a good way to help prevent stretch marks.

Massages are amazingly good for you too, as is the occasional facial, but just make sure you check with your GP first and always tell the beauty therapist that you're pregnant because some products can get into the bloodstream and may not be good for the baby. During all my pregnancies, the one product I really relied on was Elemis's Japanese Camellia Oil, which is really great for preventing stretch marks and is one of the few aromatherapy oils you can put on yourself when pregnant. I would just cover myself in it, really massaging it into my tummy, my bottom, my thighs and my boobs and, honestly, that stuff really works. Space NK does some nice maternity products as well, but always check with your doctor first before trying out products during your pregnancy.

After giving birth, I do tend just to wear tracksuits and pyjamas for six weeks. But even when you emerge from that cocoon of the immediate aftermath of the birth, there is no question that post-pregnancy dressing can be as tricky as dressing during pregnancy. I remember one time, about three months after I had Romeo and we were still living in Manchester, David and I went to an Usher concert for our first night out since the birth. I got all dressed up in my nice clothes

DURING ALL MY PREGNANCIES, THE ONE PRODUCT I RELIED ON WAS ELEMIS'S JAPANESE CAMELLIA OIL, WHICH IS GREAT FOR PREVENTING STRETCH MARKS.

and was really looking forward to being a bit glamorous for an hour or two. But just as the concert began and the crowds were all screaming, my boobs started leaking like nobody's business. So I spent most of my big night out mopping up my soggy front.

To prevent any unfortunate leakages, you can get little nipple cover-ups from Mothercare and Boots so you don't find yourself cleaning milk off your dress all evening. They aren't very alluring but they're better than the bowl-shaped things I've seen in some chemists.

Possibly the best thing you can do for yourself after having a baby is to go back and have, yes, more beauty treatments, but, again, check with your GP first about when you can start having them as everyone's needs are different. Just getting a foot massage from a friend or your partner will make such a huge difference, not only for the physical relief but also just to enjoy a few minutes of self-indulgence. Foot massages are also really fantastic for getting rid of the water retention that many women develop around their ankles after giving birth.

POSSIBLY THE BEST THING YOU CAN DO FOR YOURSELF AFTER HAVING A BABY IS TO GO BACK AND HAVE, YES, MORE BEAUTY TREATMENTS.

I used to love getting ready in the mornings: having my bath, doing my hair, choosing what to wear – I had my whole little routine. But when you become a mum you just don't have as much time. There were some jokes a while ago in which people claimed I'd said I'd never read a book. What actually happened was I gave an interview to a Spanish publication and I said that once you have three kids you hardly have time to finish a book, which, as any mum will tell you, is perfectly true.

Because kids do take over your life, it is essential for you and your partner to make sure you take a little time out for just the two of you, whether this means going out for supper together, spending the night in a hotel or simply curling up for a proper chat. As any parent will know, your priorities will change when you have a family.

And as well as your life changing, a lot of people say that their style changed when they became a mum. For me, at least, I don't think that's true, but I do think it's changed as I've got older. I think my look now is less contrived and that reflects how – as most people do – I have become more relaxed in myself and make fewer mistakes as I've got older.

WHERE TO BUY

1. WHERE TO SHOP: 9 London, Agent Provocateur, Blooming Marvellous, Blossom, Diane von Furstenberg, Formes, Juicy Couture, Mamas and Papas, Marks & Spencer, Monsoon, Next, Pink Lining (for bags), Pumpkin Patch, Push Maternity Wear, Topshop, www.figleaves.com

2. WHAT TO BUY: empire-line tops, wrap dresses, short smock dresses, drawstring trackpants, stretch jeans, tailored jackets, ponchos, maternity bras, comfy flats

3. BEAUTY PRODUCTS: Bliss Spa, Clarins, Dermalogica, Elemis, Mama Mio, Neal's Yard Remedies, Origins, Space NK Apothecary

NOTES

lingerie

You don't have to match your bra to your knickers!

THIS IS WHAT I SAID TO A FASHION MAGAZINE A WHILE AGO.
You'd have thought I said the world was flat for all the fuss it caused. Of
course they don't have to match! I have other things to think about than
whether my bra is properly coordinated with my knickers.

BE PRACTICAL

Of course I adore beautiful lingerie. But there's no need to get carried
away about things that really don't matter, particularly when they're
just not practical. I'm all for sexy lingerie in the bedroom, but for under
clothes you need to be more realistic. Get something that will give you a
nice shape and proper support.

It's ridiculous to wear a frilly bra beneath a T-shirt, for example, as the
lace will bump up through the material and make you look like you have
four boobs. Instead, get a practical bra that will give you a nice bustline.
My favourites are Calvin Klein Underwear's T-shirt bras, which I call
my teabag bras because they just look like two simple little teabags on
a strap.

If you want to feel a bit sexier, you can wear your seductive frilly
knickers with it. They may not match, but it does allow you to be
both practical and sexy.

WEARING THE WRONG SIZE BRA DOES ABSOLUTELY NOTHING FOR YOUR BUST.

294 *lingerie*

But never mind the whole matching debate, the first thing to pay attention to with bras is the size.

I strongly recommend that you get measured properly by a professional. So many women in this country wear the wrong size of bra, and you can tell. Wearing the wrong size does absolutely nothing for your bust: often it minimizes it, or if the cups are too big they'll poke out slightly under your clothes so that you look like you have two little domes under there.

People often get their back measurement wrong too, so that the strap either digs in badly or drapes awkwardly and doesn't give you any support. Most lingerie shops now have a measuring service, as do many lingerie sections in department stores. Probably the best-known place to be measured is Rigby & Peller. They are next to Harrods and are the approved suppliers to the Queen. Well, if it's good enough for her, it's good enough for the rest of us.

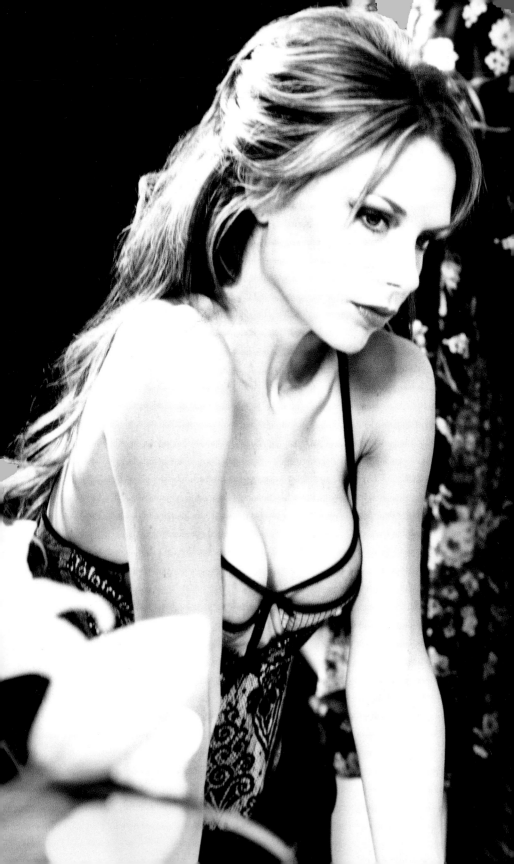

SIMPLE & PRACTICAL UNDIES SOLUTIONS

Once you know how many practical and sexy bras and knickers you need, and you know your size, there are so many good places to buy your lingerie.

1. **CALVIN KLEIN UNDERWEAR** makes the most comfortable and best plain underwear all round.

2. **BONDS** from Australia makes nice cotton boy-pants, which are practical and cute.

3. **MARKS & SPENCER**, of course, does great knickers: its lace and cotton boy-pants are fab. And to give it credit, its strapless bras really do work and last for ages, and you can bung them in the washing machine without any worries that they'll come out all mangled.

4. **PLAYTEX** makes great simple and practical bras, as it has done for decades, and they are just the thing to wear under T-shirts, V-necks and pullovers. They are, though, it has to be said, passion killers!

5. **PETIT BATEAU**'s are so sweet and French and comfortable.

6. **ELLE MACPHERSON INTIMATES** is also a favourite of mine, making practical pieces that look beautiful.

7. **BODAS** does beautiful seamless underwear in sheer fabrics which are simple but sexy – they're so comfy you don't even feel like you're wearing underwear.

top tip

❝ **Don't forget to always wear a good sports bra when you're exercising as you don't want to trip over your boobs on the running machine or end up with two black eyes!** ❞

I'M ALL FOR SEXY LINGERIE IN THE BEDROOM, BUT FOR UNDER CLOTHES YOU NEED TO BE MORE REALISTIC. GET SOMETHING THAT WILL GIVE YOU A NICE SHAPE AND PROPER SUPPORT.

298 *lingerie*

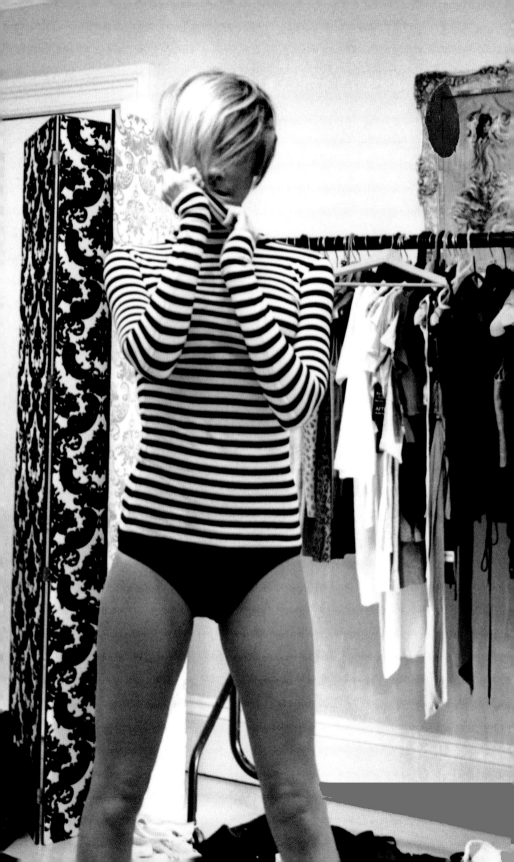

GET ON THE WEB

There are a lot of good websites now too, such as www.figleaves.com and www.chantilly.co.uk, which is a real boon for anyone who finds lingerie shopping embarrassing, or just doesn't have the time. Just make sure you know your size (or better still get measured). Agent Provocateur has a fantastic website (www.agentprovocateur.com) and of course everything comes beautifully packaged. Bodas sells online too (www.bodas.co.uk), as does Myla (www.myla.com), who does bridal lingerie and gorgeous pieces for special occasions.

SEX IT UP

For sexy lingerie, there is even more choice, mainly thanks to Agent Provocateur, which was the first shop in this country to show that sexy knickers didn't have to mean nasty tacky stuff but could be really beautiful. It is my favourite lingerie place along with La Perla, but both are expensive. Fifi Chachnil make just the cutest, flirtiest pieces that give you a great shape (their range is also available in Agent Provocateur).

In the States I love popping into Victoria's Secret and, no, not just for the name. It's got some beautiful bras, knickers and nightwear, as well as practical pieces and lots of other accessories.

AGENT PROVOCATEUR WAS THE
FIRST SHOP IN THIS COUNTRY TO
SHOW THAT SEXY KNICKERS DIDN'T
HAVE TO MEAN NASTY TACKY STUFF.

There are now a lot of Agent Provocateur-like ranges in Britain that sell gorgeous bits and bobs. You can get some really pretty pieces from Coco Ribbon, Alice & Astrid, So She and Jane De Lacey, which are very beautiful and tend to be quite girlie and frilly. Intimissimi is an Italian lingerie label that is new to the UK, but it's really gorgeous and well-priced too.

Lingerie really does make a great fashion present that most men love to give. I'm so lucky that David likes getting it for me and, even more fortunately, I think he has very good taste. But then, we have been together for a long time and he knows me very well. If you're in a younger relationship, or your boyfriend is just not very clued-up about this kind of thing, it might be worth giving him a bit of gentle guidance, either by letting him accompany you on a lingerie-shopping trip or simply by subtly and tactfully offering a few guiding words.

In bed, the best options are simple silky nighties or pyjamas.

1. For silky nighties, VICTORIA'S SECRET makes gorgeous ones, as do AGENT PROVOCATEUR, ELLE MACPHERSON and LA PERLA.

2. ELLE MACPHERSON's pyjamas are fantastic, particularly the vest tops with boy-shorts, which come in great fabrics. (Pretty much her entire range is just perfect for wandering around the house in on Sunday mornings.)

3. CALVIN KLEIN UNDERWEAR and RALPH LAUREN both do cute vests and boy-shorts, which would be ideal for that too. BODAS and ALICE & ASTRID do very pretty cotton loungewear.

4. TOPSHOP and AGENT PROVOCATEUR make gorgeous little silken camisoles with matching shorts.

5. MARKS & SPENCER also offers excellent machine-washable nightwear.

6. GAP BODY often does sweet pyjamas, with long trousers and little vest tops that are really cosy in the winter. Or you can go the other way and wear a pair of pretty boxers with a matching long-sleeved top.

For dressing gowns, I just really want a big fluffy one that I can snuggle into, though not a full-length one because I trip over them. I always recommend

Marks & Spencer for these. Just a cosy knee-length terry-cloth dressing gown will do perfectly and you can always find them in any department store like John Lewis or Habitat. The White Company is really great for nice bedding, bathrobes and scented candles, and not too expensive, either.

In the summer I switch over to little silky dressing gowns, which you can get in Agent Provocateur or La Senza, or even kimonos, which you often find in vintage stores or Japanese shops. But silky ones in general are pretty widely available in the bed or bath section in any department store.

For slippers, a lot of people will probably find my tastes quite surprising. Sure, those high-heeled marabou pumps look rather fabulous, but they're hardly going to work when you're running about and getting the Frosties ready for the kids. Instead, I just love little flat ones with patterns on them, like stars or little monkeys. My mum gets them for me at Marks & Spencer and sends them out to me for a treat. Primark does some cute patterned slippers at rock-bottom prices too.

IN SUMMER I SWITCH TO LITTLE SILKY DRESSING GOWNS OR EVEN KIMONOS.

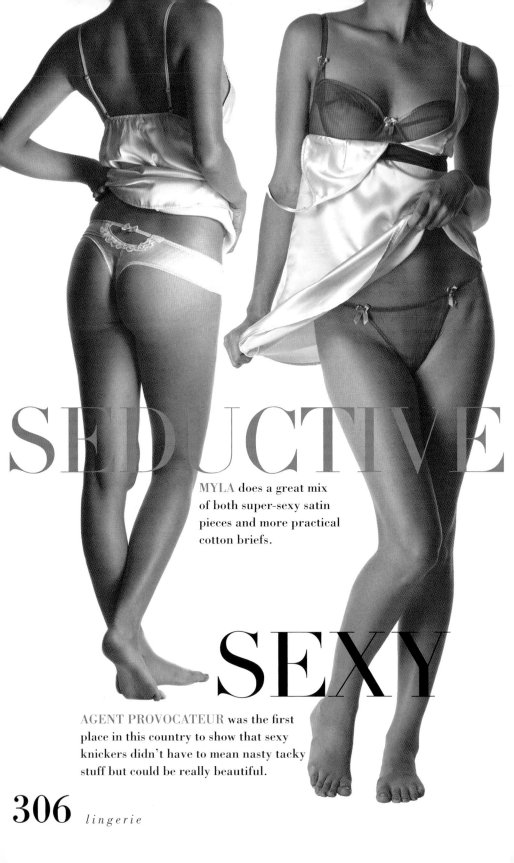

SEDUCTIVE

MYLA does a great mix
of both super-sexy satin
pieces and more practical
cotton briefs.

SEXY

AGENT PROVOCATEUR was the first
place in this country to show that sexy
knickers didn't have to mean nasty tacky
stuff but could be really beautiful.

306 *lingerie*

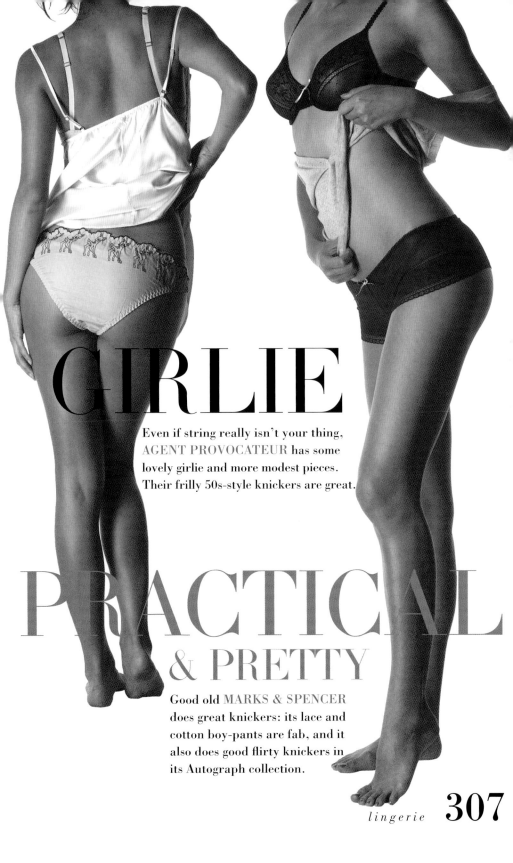

GIRLIE

Even if string really isn't your thing,
AGENT PROVOCATEUR has some
lovely girlie and more modest pieces.
Their frilly 50s-style knickers are great.

PRACTICAL
& PRETTY

Good old MARKS & SPENCER
does great knickers: its lace and
cotton boy-pants are fab, and it
also does good flirty knickers in
its Autograph collection.

WHERE TO BUY

1. PRACTICAL UNDIES: American Apparel, Bodas, Bonds, Calvin Klein Underwear, DKNY, French Connection, Gap Body, Hanro, H&M, Marks & Spencer, Miss Selfridge, Muji, Petit Bateau, Playtex, Tommy Hilfiger, Topshop

2. SEXY UNDIES: Agent Provocateur, Alice & Astrid, Ann Summers, Cacharel, Charnos, Coco Ribbon, Damaris, Dolce and Gabbana, Elle Macpherson Intimates, Fifi Chachnil, Fleur T, Gossard, Huit, Knickerbox, La Perla, Lejaby, Marks & Spencer, Mimi Holiday, Myla, Odille by Oasis, Paul Smith, Playboy Intimates, Princesse Tam-Tam, Sexy Panties and Naughty Knickers, Topshop, Victoria's Secret, Wonderbra, www.figleaves.com

3. NIGHTWEAR: Agent Provocateur, Bodas, Boden, Calvin Klein Underwear, Cyberjammies, Gap Body, H&M, Hush, La Perla, La Redoute, La Senza, Marks & Spencer, Next, Polo Ralph Lauren, Ted Baker, Topshop, Victoria's Secret

4. ROBES: Agent Provocateur, Bodas, Calvin Klein, Elle Macpherson Intimates, Hanro, Marks & Spencer, La Perla, La Senza, Myla, Polo Ralph Lauren, Princesse Tam-Tam, Ralph Lauren, The White Company, Tommy Hilfiger, www.figleaves.com

NOTES

hair
&
make-up

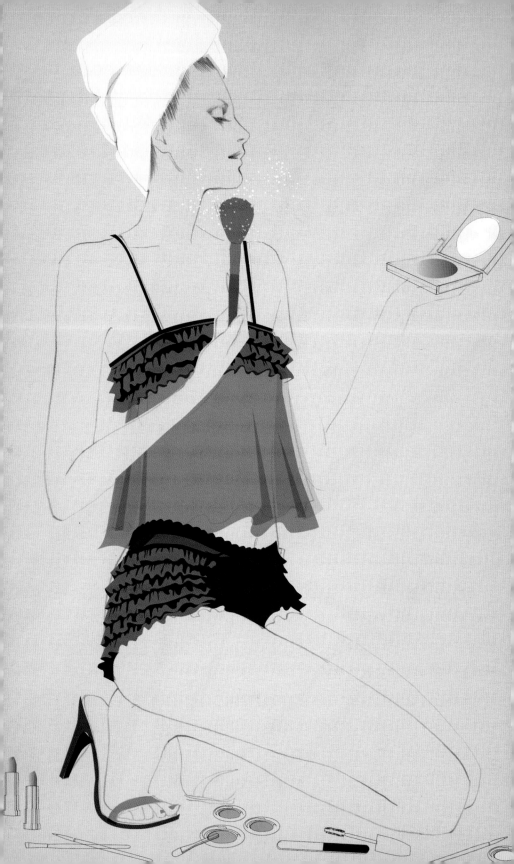

My earliest make-up memory is my mum rubbing a bit of lipstick on my cheeks before I went to school, to try to make me look perkier in the mornings.

BUT I STARTED TO GET INTO IT MYSELF FROM AN EARLY AGE. I certainly had my experimental years and – now bear in mind these were the 80s – my first ever lipstick was called Twilight Teaser by Boots No.17 and it was an iridescent purple. Classy, don't you think? I never could resist a bit of iridescence. As a kid, instead of playing with dolls, I would make collections of sequins and diamantés – anything girlie and shiny. In fact, I probably haven't changed that much.

When I was younger I used to struggle with make-up because of my skin. I had bad skin as a teenager. This was really what propelled me towards the make-up counter from a pretty early age. When I was about

SUPER SKIN TRICKS

1. KEEP IT CLEAN Cleanse your face morning and night and always take off your make-up at the end of the day.
TOP PRODUCT:
Johnson's baby wipes

2. SPOT TREATMENT Don't slather spots with heavy concealer as this only clogs the pores, and definitely don't pick!
TOP PRODUCT:
MAC studio stick concealer

3. DON'T CLOG Avoid overly oily moisturizers and use deep cleaning cleansers and scrubs to exfoliate the skin.
TOP PRODUCT:
Jo Malone Vitamin E Gel

thirteen, every day before school I would cover my face in concealer, and every day the teachers would make me scrub it off in the toilets. Teenage acne is definitely not a stroll in the park. Seriously, when I was a teenager I had so many spots I could barely put a pin between them. It was just awful. Finally, I went to a doctor to see what was wrong and it turned out I had some bad food allergies, and as soon as I changed my diet my skin totally cleared up. I have been extremely fortunate in that I've never had any scars from the acne, but that really is the luck of the draw.

I am still very careful with my skin, but through experience I've found what works best for me.

WHEN I WAS A TEENAGER I HAD SO MANY SPOTS I COULD BARELY PUT A PIN BETWEEN THEM. IT WAS JUST AWFUL.

GROOMING ISSUES

When I studied dance as a teenager, it was drummed into me right from the start that you have to have nice fingernails and nice hair, and I think it's just ingrained in me now. I'm always really strict with myself about grooming. But that doesn't mean I haven't occasionally gone very wrong. When I look back at photographs of the Spice Girls I see a lot of make-up mistakes, but I think many pop stars suffer from the same problem: because you're working so hard and are getting so tired you just plaster on the make-up to cover the signs of stress and fatigue. So your make-up gets thicker and thicker and your hair gets bigger and bigger and you just end up looking like the creature from the Black Lagoon. Putting too much make-up on – whoever or whatever you are – really is the worst mistake you can make. So make sure you never apply it in bad light; find somewhere that mimics natural sunlight.

There are some beauty treatments that you should definitely only do when you're on your own.

1. I'm a great believer in well-kept feet and hands. Try a moisturizing hand and foot cream – some creams come with gloves which you need to put on to let the cream soak in properly. But I'd recommend saving that one for when your man is away.
TOP PRODUCT: **Bliss Spa's All You Need is Glove Set**

2. Fake tanning is another thing to do when you're on your own. When David's away, I'll apply the St Tropez. Put it on at night before getting into bed, then shower off in the morning.
TOP PRODUCT: **St Tropez Instant Self Tanning Air Spray**

3. Face packs work wonders. I try to do two a week, but that's another one I try to leave for when I'm alone as face packs really can make you look like an axe murderer in some low-rent horror movie.
TOP PRODUCT: **Dermalogica's Multivitamin Power Recovery Masque**

The Body Shop is one of my favourite places for skin and body products. It's always such a pleasure going into the stores as they all smell so nice and familiar. Their exfoliating gloves – which are basically Brillo pads for your hands that you take with you into the shower to give your skin a really good scrub, getting rid of all the dead skin cells and boosting your circulation – are the best I've ever found. Their wood-handled body brushes are great too: just brushing your skin in an upward motion towards your heart before your shower will get your circulation going, and that helps to minimize cellulite.

Another one of my true staple products is Elizabeth Arden's Eight Hour Cream. There's no frilliness about it, it just does what it says and does it really well – as you'd expect of a product that was originally invented to be used on the shanks of race horses to soothe their irritated skin, which gives a sense of just how moisturizing it is. It's extremely thick so you need only a tiny amount, meaning it lasts for ages, and is the best thing in the world for chapped lips, elbows and knees, and even faces on long-haul, dehydrating flights.

FACE AND BODY KIT

1. The Body Shop exfoliating gloves, wooden body brushes and Cocoa Butter Body Butter
2. Elizabeth Arden's Eight Hour Cream
3. Tweezerman tweezers
4. Prada Shielding Lip Balm
5. Alterna Caviar Anti-Aging Conditioner
6. Origins Paradise Found body scrub and A Perfect World body cleanser
7. Miller Harris Citron Citron shower wash
8. Kiehl's Crème de Corps Nurturing Body Washing Cream
9. La Prairie Skin Caviar Luxe Body Emulsion
10. Dermalogica Multivitamin Hand and Nail Treatment

'Put a small slick of Elizabeth Arden Eight Hour Cream on your eyelashes to bring them out a little bit more.'

One of the things Geri taught me when we were in the Spice Girls was that just before you get out of the shower you should turn the temperature down and get a blast of freezing-cold water. It makes your skin look really taut and smooth and is great for the circulation, but it is not very pleasant, I have to say, and it is something you have to force yourself to do.

‘Make sure you give yourself a good scrub at least twice a week when you're on holiday – after all, that is when you want your skin looking its best.’

As for body scrubs, Origins' Paradise Found is great, and Bliss and Laura Mercier do some really gorgeously scented ones, as does Marc Jacobs, whose scrub also gives your skin a tiny hint of glitter. The nice thing about body scrubs is that they are a delicious way to help wake yourself up and get the circulation going, and a much more fun way to do it than dry body brushing. Plus, of course, they are great for exfoliating, which always makes everyone's skin look better. I know, it's really tempting not to exfoliate when you have a tan as you want to keep your colour for as long as possible, but, really, it's a choice between your tan going all patchy and flaking off or just tackling it yourself properly.

Scented body washes are a lovely way to help wake yourself up in the shower in the morning. A nice blast of pretty perfume, combined with giving yourself a good clean, is a much more pleasant way to come to consciousness than having the radio alarm blast your ear off. Miller Harris does really nice body washes, particularly the Citron Citron one, which smells so fresh and lemony. Chantecaille does a range of delicate floral ones and Slatkin makes some with really unusual fragrances. For unscented washes, Origins' A Perfect World creamy body cleanser makes your skin squeak, it gets it so clean. Kiehl's has made a shower range from its brilliant Crème de Corps body lotion. The Crème de Corps Nurturing Body Washing Cream is a great way to clean your skin and moisturize it at the same time.

Nivea's hand cream really takes some beating, and Dermalogica's lasts you through the day. Origins makes a good one, the aptly named Make A Difference hand cream, and Bliss's is excellent. To moisturize the rest of my body, I usually go for my beloved The Body Shop Body Butter, which smells so delicious I often catch myself nearly giving my arm a bit of a lick. For a special treat I might sometimes use La Prairie's Skin Caviar Luxe Body Emulsion, which is very expensive but divine.

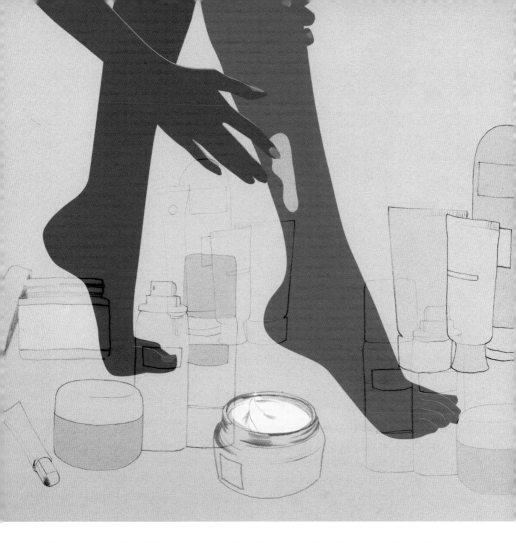

Johnson's baby oil is another good moisturizer, but do not use it on the
soles of your feet or you'll end up skating across the bathroom floor!
Whatever you use, it is important to whack on the body moisturizers
as soon as you dry off after your bath or shower since your skin can
go very scaly and flaky after getting wet. And remember: moisturizers
work best after you've exfoliated as the cream can really get into your
skin instead of just sitting on top of all the dry flakes.

On the days when I have the time (and believe me I can do this very
quickly), my morning routine is shower, cleanser, toner, moisturizer, neck
cream, eye cream, foot cream, hand cream, make-up (if going out), and
then the same in the evening, minus the make-up, of course.

SKIN SAVERS

For daily moisturizers, I use a combination of products by Dermalogica, Yon-ka, RéVive, La Prairie and Jo Malone, depending on what I feel my skin needs at that time. Obviously, I don't use all of the products listed below at once as that would not only really clog my skin but also take half the morning to put on! So think of these recommendations as things to pick and choose from according to your skin's needs:

MOISTURIZERS FOR OILY SKIN

YON-KA Firming Treatment Cream – light enough for my oily skin
RÉVIVE Sensitif Oil Free Lotion and **Eye Renewal Cream** – very light and works well for daytime

DAILY MOISTURIZERS

JO MALONE Orange and Geranium Moisturiser and **Protein Serum** – almost good enough to eat, they smell gorgeous
CLARINS Gentle Day Cream – perfect for everyday use and not too heavy

MOISTURIZERS FOR YOUNG SKIN

ORIGINS A Perfect World Skin Guardian – gives your skin extra protection against daily dirt and grime
CLINIQUE Dramatically Different Moisturizing Lotion – light but moisturizing at the same time

NIGHT CREAM

LA PRAIRIE Cellular Radiance Night Cream – you only need a dab
YON-KA Elastine Nuit – a rich and replenishing night cream that plumps your skin up overnight

EYE CREAM

LA PRAIRIE Cellular Radiance Eye Cream – an essential part of my skincare routine
DR HARRIS & CO Crystal Eye Gel – keep it in the fridge and put a touch on when needed

NECK CREAM

LA PRAIRIE Cellular Neck Cream – essential as your neck has different moisturizing needs from your face

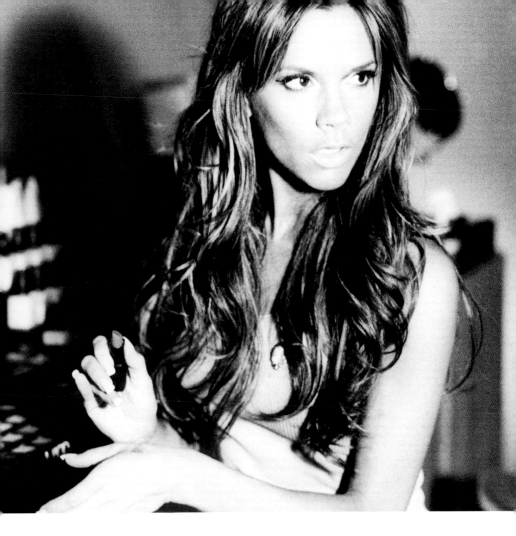

Really, you can spend a squillion pounds on your skin but the most important thing is to protect your skin from the sun. Always make sure that your moisturizer and foundation have an SPF in them, and it doesn't hurt to add some extra sunblock on top, to protect you from the sun's harmful rays all year round.

One thing I really want to stress is that looking after your skin is not about trying to hold back the years, despite what some moisturizers claim. Because nothing, and I mean nothing, is going to keep you looking twenty and that is just fine. Looking good is not dependent on looking young. It's about making the best of yourself and feeling good and healthy. Make sure you get lots of sleep and drink lots of water.

GLAM IT UP

Then for the rest of your body, it's always flattering to have a bit of body shimmer or tinted moisturizer if you're wearing a short dress or skirt or a sleeveless top. Just a slick of something shimmering can make you look healthier, radiant, more toned and even out your skin colour.

SUPER GLAM BRONZING PRODUCTS

MAC **Strobe Cream** – perfect for the dancefloor as it really catches the light and glows on your skin in the dark

RODIAL **Instant Glow Self-Tan** (available at Space NK) – a fantastic easy-fix self tan that only takes 2–4 hours to develop

MODEL CO **Tan Airbrush in a Can** – my favourite and a real essential in my bathroom cabinet

MODEL CO **Bronze Airbrush Sun** – gives a lovely natural tan to your face

MODEL CO **Shimmer Airbrush Illuminator** – gives a light tan with just a hint of shimmer

SCOTT BARNES **Body Bling** – the best tinted body lotion around. I stock up on it whilst I'm in the States. All the A-list actresses use it for their red-carpet events, it's so brilliant

Make a point of checking out the beauty products on offer when you go abroad as you'll find all sorts of cool things that you can't get at home. America is great for fake tans and France has good moisturizer, whilst Japan has a whole host of interesting make-up ranges.

With make-up, the first thing to ask yourself is whether you're stuck in a beauty rut. If you've been automatically using the same make-up in the same way for the past ten years, then you definitely are and you could look out of date too. Plus, what suited you when you were, say, eighteen is not going to suit you when you're twenty-eight, as your face and personal style will obviously have changed. A lot of people get quite nervous about the idea of changing their make-up, mainly because they feel they just don't know what to do or where to start.

I would recommend going to a department-store beauty hall and getting tips from the sales assistants. Concentrate on what new colours and shades they're putting on your eyes and what new creams they're putting on your face. My favourites are Bobbi Brown for a subtle, natural look, particularly its tinted powders and shimmery eyeshadows. And MAC is brilliant if you want something more dramatic. MAC was set up by a professional make-up artist because he couldn't find anything that worked on fashion shoots, so the make-up always comes in fabulous colours and really lasts. I have found that the sales assistants at the MAC make-up counters are very, very good and honest.

ASK YOURSELF IF YOU HAVE A MAKE-UP CRUTCH ... MINE IS DEFINITELY LIPLINER.

Get inspired by looking through the beauty sections of fashion magazines as these are generally pretty reader-friendly and they also have the most up-to-date techniques and looks. *Glamour*'s beauty section is always really good and *Vogue* always features the latest products and treatments available.

Ask yourself if you have a make-up crutch: a product or look that you rely on too much. Look through photos of yourself over a long period of

time and see if you can spot something. Geri used to be really addicted to eyeliner, for example, and, as though she were an alcoholic, we had to wean her off it. Mine is definitely lipliner and I have a real tendency to put on much too much, although I am trying to give up!

One thing I really love about make-up is how you can bond over it with other girls, swapping tips and trying out one another's products. You can spend a lot of money on bits and bobs, but there are loads of cheaper ranges around now that are great, like Bourjois. For more luxurious ranges, my favourite brands are Chanel and Nars and I definitely recommend Giorgio Armani.

MAKE-UP BOX

FOUNDATION
MAC **Mineralize Satin Finish SPF15 Foundation** – I rely on this easy-to-use liquid foundation to give great coverage
MAC **Prep+Prime Skin** – a primer that keeps your make-up intact and stops you getting all shiny
GIORGIO ARMANI **Matte Silk** – Armani foundations are so light anyone can master them
PRESCRIPTIVES **Traceless** – really smoothes out your complexion
CHANTECAILLE **Real Skin** – a favourite of many professionals

FACE ILLUMINATORS
These help to brighten up your face and give it a bit of sparkle
MAC **Glimmershimmer** – a light lotion that adds a high-gloss shimmer to your cheekbones
POUT **After Glow Illuminator** – a handy little tube which adds just the right amount of glow to your complexion
GUERLAIN **Divinora Pure Radiance**
DIOR **Bronze Blush**
CHANEL **Teint Innocence Naturally Luminous Compact Make-up**

COLOUR PALETTES
MAC **Amazon Eyes** – its eyeshadow packs are simply the best
NARS **Multiple in Copacabana** – I use this on my cheekbones to give them a bit of a lift
CHANTECAILLE **Lasting Eye Shadow** – its multi-palettes are amazingly useful

LIP GLOSS
POUT **Lip Gloss** – luscious colours in gorgeous girlie packaging
STILA **Lip Glaze** – comes in a handy pen-shaped brush for easy application
LANCÔME **Juicy Tubes** – have such delicious flavours it's hard to choose
VERSACE – they make your lips look really plump but not sticky, and are really glittery

CONCEALER

MAC Select Cover-Up – effortlessly camouflages your blemishes
YVES SAINT LAURENT Touche Éclat – the ultimate concealer no woman should be without. I'll dab a bit on if I'm feeling tired

POWDERS

MAC Select Sheer Pressed Powder – comes in a glam compact that slips easily into your evening bag
CRABTREE & EVELYN Facial Blotting Tissues – a great alternative to piling on the pressed powder. These rose-scented tissues smell gorgeous too

EYELASH CURLERS

SHU UEMURA – these are the best. You should always curl your lashes before applying mascara as that opens your eyes
RUBY & MILLIE – handy little ones that fit nicely in your make-up bag

dVb

I am developing my own range of beauty products. I want to capture all my favourite elements in one fabulous range, devised through my love of beauty products in general.

IT'S NOT A GOOD LOOK TO LEAVE THE HOUSE WITH YOUR SKIRT TUCKED INTO YOUR KNICKERS AND MASCARA HALFWAY DOWN YOUR FACE.

That's one thing I love about make-up: it lets you enjoy designer labels and packaging – like me and my Gucci school-satchel carrier bag. It's not about snobbery; it's about being able to enjoy life's luxuries without having to spend a fortune.

If I'm looking a little tired, I'll dab on some Touche Éclat by YSL as that is amazing at covering up dark circles, and maybe put in some Optrex eye drops, depending on how bad the situation is. Always curl your lashes – I like Shu Uemura curlers – as that opens your eyes out, and this is doubly true if you're looking a bit puffy and sleepy, and then give them a bit of a comb through with a lash comb to get rid of any clumps. Finally, I'll have a quick spritz of Oxygen 81's Oxygen Revitalizing Treatment, which fixes your make-up in place. I'll just chuck some Johnson's baby wipes in my bag with Elizabeth Arden's Eight Hour Cream, gloss for my lips and maybe some blusher, and I'm set for the day. But, for heaven's sake, before you leave the house, always take a good hard look at yourself in a full-length mirror. It's not a good look to leave the house with your skirt tucked into your knickers and mascara halfway down your face.

PERFUME MATTERS

Ever since I was collecting empty No. 5 bottles, I've always had a real
thing about perfume. Perfume scents can take me back like nothing else:
Raffinee reminds me of my mum kissing me goodnight before heading out on
a Saturday night back in the 80s, wearing shoulder pads and a velvet skirt.
Then there's Charlie, Anaïs Anaïs, Joy and Poison, all of which take me
back to my childhood too. But because I love perfume so much, I do have
very particular rules about how it should be worn:

1. Don't wear too much because it just becomes overpowering instead
of subtly seductive, as it's supposed to be. So just dab it on, don't douse

yourself in it. Just dab a little on the back and sides of the neck and on the inner wrists, as those are the pulse points and emit fragrance best.

2. Don't spray any in your hair as this can make your hair go frizzy and funny if you colour it.

3. Avoid heavy and overpowering scents. I prefer light perfumes, as strong ones can give me a headache, and I was really strict about that when David and I were creating our perfume, Intimately Beckham, with Coty. It was so interesting to learn about the process, seeing how they press the flowers and mix the oils and how the smallest adjustment of the proportions completely alters the scent.

One range of perfume that looks good and smells wonderful is Miller Harris. A couple of years ago, Patsy Kensit made me such a kind present of a personalized bottle of perfume from Miller Harris. She told the company what kind of fragrances I like, they mixed up the oils accordingly and it was then presented in the most beautiful bottle engraved with my name. This is, of course, a pretty expensive present, but it is a very, very special one.

ONE RANGE OF PERFUME THAT LOOKS GOOD AND SMELLS WONDERFUL IS MILLER HARRIS.

SEXY SCENTS

MARC JACOBS Marc Jacobs Woman Solid Perfume Compact – you can carry it around in your handbag without threat of spillage

STELLA MCCARTNEY Amber Solid Perfume – solid perfumes look so gorgeous on your dressing table

MILLER HARRIS Coeur de Fleur – their single note scents are very fresh and light and the bottles are brilliant

PHILOSOPHY Amazing Grace Fragrance – this actually makes you smell as clean and fresh as a baby!

CREED Fleurissimo – the bottles look so grand and this fragrance was originally created for Grace Kelly's wedding

KIEHL'S Musk Oil – you can use this scented oil as a perfume

BECKHAM FRAGRANCES Intimately Beckham and **Intimately Beckham Night**

NAIL BASICS

I'll tell you one thing that you really don't have to spend lots of money on. I wear acrylic nails and I'm always looking for people who can put them on properly as a badly applied nail is not a pleasant thing to see. I've been out in the States and people tell me, 'Oh, you must go see this person, she does so and so's nails, they cost a fortune but they're the best,' and so on. So I go, get them done, pay a ridiculous amount of money and the next day the bloody things fly right off my hand! I think if you find a nail technician that is quick and good, make sure that they are not overcharging and use quality products. I see this amazing Vietnamese man up in north London and I can tell you, he costs a lot less than some of the overly hyped people I've seen, and his work lasts much, much longer. So you need to find someone good and, contrary to what a lot of people think, good does not always mean expensive.

I wear fake toenails too, because I'm almost always wearing open-toed shoes. There is one situation, though, when having long acrylic fingernails is not so helpful – changing babies' nappies. You can get some really unpleasant things stuck under your nails then …

For nail colour, I recommend either the colour of the season, deep red, which is always a classic, or beige, as that makes your legs and fingers look longer, in the way beige shoes do. It's also not so obvious when the paint chips. And, speaking of chips, always give your nails a top coat of clear polish to help protect the paint that little bit longer. One of my favourite brands of nail polish is Nars.

Eyebrow threading is another treatment that doesn't have to cost much and makes a real difference. This is an ancient hair-removal technique in which someone twists cotton and uses it to pull out stray hairs around your eyebrows or anywhere on your face. It is much less painful than plucking and the hairs grow back thinner and lighter. As you can imagine, this is a real skill that takes time to learn, but there are increasing numbers of threading salons around.

ALWAYS GIVE YOUR NAILS A TOP COAT OF CLEAR POLISH TO HELP PROTECT THE PAINT THAT LITTLE BIT LONGER.

HAIR ESSENTIALS

One part of your beauty routine that is worth spending money on is your haircut and colour. It might seem extravagant to spend over £50 on something that will need to be done again in six weeks' time, but think about it: this is the very first thing people see when they look at you; it completely affects how you look – more, even, than anything you might

IF ANYTHING IS WORTH GETTING DONE PROPERLY, IT IS A GOOD HAIRCUT.

wear; and you'll see it every time you look in the mirror. So if anything is worth getting done properly, it is a good haircut. Ask around before you go to a salon as you'll find that even some of the best-known places are only good for straight hair and others are not so great for short hair, or whatever, and the only way you'll learn is by reliable word of mouth.

With regards to hair extensions, you really have to go somewhere that knows how to put them in properly. There are so many people walking around with very bad extensions: you can see the glue holding the bonds in at the scalp, the extensions themselves look all frizzy because they're made out of nylon instead of real hair, and the whole thing doesn't look great. Once you have them, you have to look after them carefully and accept that they are quite high maintenance. First, you need to use a special shampoo and conditioner, something many people mistakenly don't bother about. You need to check that the shampoo doesn't have any oil in it as this can cause the extensions to fall out. Only put conditioner on the mid-length and tips, never the roots of the extensions.

ALTERNA®
enzymetherapy®

CAVIAR

ANTI ○ AGING
SHAMPOO

SHAMPOOING
ANTI ○ ÂGE

Then, after you've rinsed everything out of your hair, give it a blast of cold water as that seals the cuticles and gives your hair a real shiny glossiness. So, as you're standing there, shivering to death in the shower, just repeat to yourself, 'Short-term pain, long-term pleasure, short-term pain, long-term pleasure.'

Next, be careful when you go swimming. Sometimes I see people running into the sea with their hair extensions and it just makes me wince as there is nothing like sea water for making your extensions go all matted; then you have to cut them out, and I know people who've had to have theirs cut out along with their own hair too. If you go swimming in the sea, always tie your hair back very tightly.

IF YOU GET HIGHLIGHTS, ALWAYS GET SUBTLE ONES, NOT THOSE WEIRD ZEBRA STRIPES; JUST GO FOR A SHADE OR TWO LIGHTER THAN YOUR NORMAL COLOUR.

I would say, though, that hair extensions are a great way of adding colour to your hair without damaging it. Highlights can be very high maintenance and not always the best thing for your hair. Having said that, I tend to get them done for special occasions, and maybe sometimes in the summer too. I often get them done for Christmas parties and my hairdresser calls it turning on the Christmas lights! But whenever you get them, always get subtle ones, not those weird zebra stripes; just go for a shade or two lighter than your normal colour.

If your hair is straight, like mine, it can have a tendency to go a little flat. So I often spray some lift on to the roots – I really like the Body Double range by Sebastian, especially the Volumizing Spray. To give your hair a bit more of a lift, comb it through with a wide-toothed comb – one of the best things to use on wet hair – and then finish off with a

hair & make-up

*I always like to go for
a natural kind of look*

Blonde ambition

JUST REMEMBER THAT LOOSER, BUT STILL TIDY, HAIR IS SEXIER, AND HORRIBLE HELMET HAIR CAN MAKE A PERSON LOOK LIKE A FIFTY-YEAR-OLD LIBRARIAN.

good blast under the hairdryer. To give long hair an extra lift, try blasting it under the hairdryer while hanging your head upside down, until it's about 75 per cent dry, then work through the hair with a wide-paddle natural-bristle brush – Mason Pearson brushes are the best. Also, if you have long hair and want to add some texture you can take some large tongs and work them through the whole length of your hair, from root to tip, holding the tips on to the tongs so you get a really nice large-wave effect through your hair.

As you can see, I really don't use many hair products. I hate that feeling of having loads of gunk in my hair, and that First Lady look of a big immobile helmet of hair is so not me. I want my hair to look quite relaxed, but groomed and clean. At most, I might top off my hair with some Redken products, which are very light, to keep the style a little, but only rarely. For special occasions or big parties you should just give your hairdo a quick once-over and then go. Just remember that looser, but still tidy, hair is sexier, and horrible helmet hair can make a person look like a fifty-year-old librarian.

NOTES

conclusion

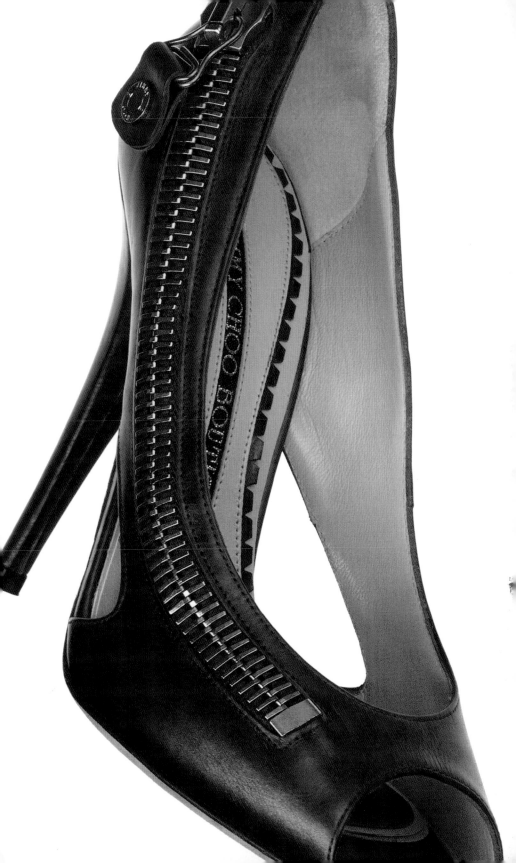

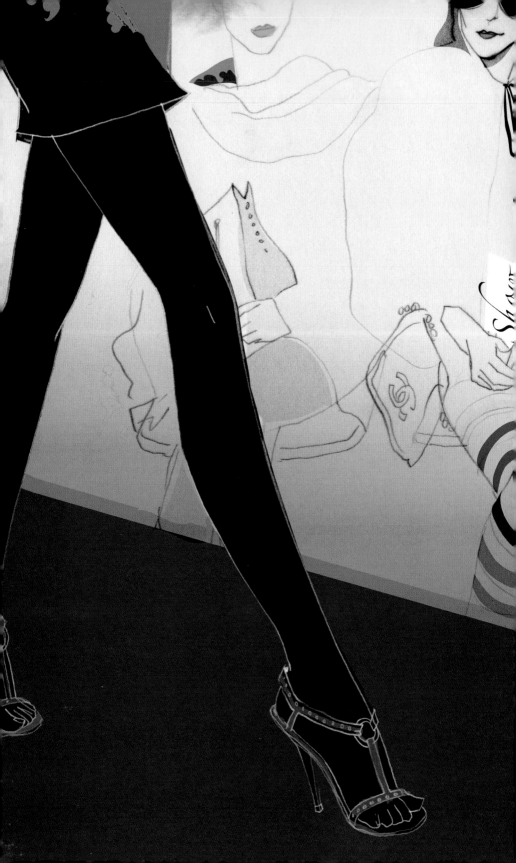

The first fashion show I ever went to was in Milan. It was 1997 and I was still very much a Spice Girl.

WHICH IS WHY WE WERE STUCK IN THIS CHATEAU IN THE SOUTH OF FRANCE REHEARSING – getting our act together as you might say – for our first ever stadium show.

For six weeks we had had no social life at all – so suddenly finding myself in the front row of one of the most prestigious catwalk shows in the world felt as magical (and unlikely) as Cinderella finding herself at the ball. My fairy godmother was Donatella Versace, who invited me not only to the show itself but to the party afterwards, and then to stay the night at her amazing palazzo on Lake Como. Of course, Cinderella Spice could hardly turn up in her little black Miss Selfridge dress – nice as it was – but Donatella had thought of everything and waved her wand in the direction of the Versace shop, and I can still remember the thrill of being let loose and told I could choose whatever I wanted. I honestly thought it was a once-in-a-lifetime experience and, of course, in many ways it was. But this was the first time I had ever been that close to the fashion world, and it was like the fuse of a firework had been lit.

Eight years down the line, Roberto Cavalli invited me to actually be in his show. After being a spectator for so long I was unbelievably nervous, terrified I would do something really stupid, like trip over. In fact, every model has that fear – however many times they've done it before – knowing that with one false move they'll end up on the front page, and not for the right reasons. They joked that at least I wouldn't have far to fall. And it was true that, even when I was wearing my highest heels, the girls towered above me.

SUIT YOUR OWN STYLE

What you never see when you're sitting out front is what the models put on once the runway clothes are handed back. Naturally they all have their individuality, but one thing remains the same: they have bags of style, but keep it simple. Which brings me back to Cinderella. If you have ever seen a production of the pantomime, you will know that the biggest laughs come from the Ugly Sisters – or rather from what they are wearing. It's the annual opportunity for everyone to poke fun at fashion. Obviously the fashions concerned are exaggerated, but what the pantomime does show is the thin line between trying too hard and total hilarity. Trendy and cool are not the same thing.

The moment you stand in front of that mirror and feel those little questions creeping in – Is this really me? Could I be a walking inspiration for an Ugly Sister? – then it's time to think again. I'm not saying you should never take risks, far from it, because fashion is one of

I've known Victoria since she married David and saw her growing with a very special style that today has inspired millions of girls. I like her way of working with accessories to make a dress become more special.

VALENTINO

the few areas of your life where you don't have to conform to other people's ideas about who you are. It's where you can truly show your individuality. The trick is to find the balance, to wear what works for your own body shape whilst at the same time keeping track of what's happening in the fashion world, to ensure you don't get stuck in a rut. Have you ever noticed how some older women can look as if they're in a time warp? It's what I call the security-blanket style of dressing. Just because something suited you once doesn't mean you have to go on wearing it for ever. In the same way that fashion moves on, so should you.

CATWALK INSPIRATION

The easiest way of keeping up with fashion trends is by keeping tabs on the heart of the industry, the collections. In the old days the shows were kept strictly under wraps. Cameras weren't allowed in and journalists could only do sketches. Now there are as many photographers as spectators and it's easy to pick up all you need to know from fashion magazines or, best of all, online at www.style.com.

Photographs taken on the catwalk are great for showing you how to wear the looks – for preparing you for that moment six months later when you're in the shop, standing in front of the mirror, thinking: I like it, but what have I got to go with it? Because of the way the fashion year is structured, there's plenty of time to digest the ideas before the clothes become

available in the shops. However glamorous they might appear, the collections are basically trade shows, and the clothes on the catwalk are the samples. If the buyers don't like what they see (and most of the people sitting alongside the runways are buyers, not celebrities) they won't put in their orders and the clothes won't get made. It's that simple.

Make that delay work for you. There are some trends that take time to get used to. Take shorts. Until recently they were strictly for holidays or lap dancers. It was only when they began appearing on the runway that their full fashion potential was realized, and the moment they arrived in Topshop they walked out of the door – as if everyone was making up for all those lost summers in the city.

As somebody once said, time spent on research is never wasted, and this is particularly true in fashion. Although designer pieces are usually outside the price range of girls in their teens or early twenties, the collections are still a great place to look for inspiration and to spot trends. Among the younger designers I would include Marc Jacobs, Marc by Marc Jacobs, Miu Miu, Chloé, Alexander McQueen, Balenciaga, Lanvin and Stella McCartney. Shows are also the time when fashion writers really get an opportunity to flex their muscles; their take may not always be your take, but they can tell you about the origins of a particular look and the way it can translate from the runway to everyday life.

That first time I went to Milan, I felt as out of place as a shell suit in a couture showroom. But over the last ten years, both as a consumer and

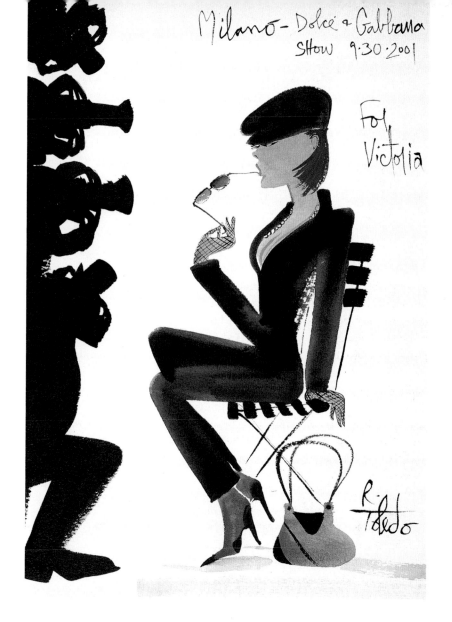

Milano - Dolce & Gabbana
Show 9.30.2001

For Victoria

R. Toledo

THAT FIRST TIME I WENT TO
MILAN, I FELT AS OUT OF PLACE
AS A SHELL SUIT IN A COUTURE
SHOWROOM.

now as a designer myself, I have felt increasingly comfortable, having discovered that the fashion world is not the intimidating place I once imagined it to be. And I can honestly say that some of the nicest people I have ever met work in the industry. Fashion is like anything else: the more you know, the less scary it is.

VINTAGE INSPIRATION

Shopping should be one of the most pleasurable activities in the whole world. One of my own pleasures comes from rifling through rails of vintage clothes. I do love the history that comes with vintage; it's almost as if each garment has its own story to tell. Also, you're guaranteed never to bump into anyone else wearing the same thing so you can truly look and feel unique!

For cool one-off pieces and special finds, look for classic labels such as Lanvin, Versace, Chanel, Yves Saint Laurent and Valentino. Vintage clothes are getting much more popular these days as a lot of women are looking for something more individual. A lot of celebrities are wearing vintage dresses to red-carpet events and LA based A-list stylists are really raiding the vintage archives to get the best and most eye-catching finds for their starlets.

COOL VINTAGE STORES

LONDON: Cornucopia, One of a Kind, Orsini, Rellik, Steinberg & Tolkien, Virginia
PARIS: Didier Ludot
NEW YORK: Resurrection, Screaming Mimi's, What Goes Around Comes Around
LA: Decades

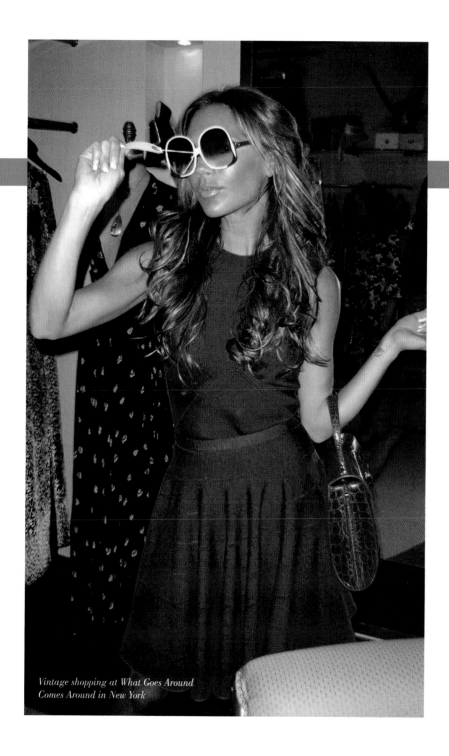

Vintage shopping at What Goes Around
Comes Around in New York

I DO LOVE THE HISTORY THAT COMES WITH VINTAGE ... IT'S ALMOST AS IF EACH GARMENT HAS ITS OWN STORY TO TELL.

Importantly, the people who work in all these shops are very knowledgeable, which is the sure sign of a good shop as it shows they have faith in their merchandise. At What Goes Around Comes Around in New York, for example, they kindly took me to see their archive, which was totally inspiring. I found lots of original Azzedine Alaïa pieces, and I really do think that Azzedine Alaïa is probably the best when it comes to cutting clothes properly to suit a woman's shape. Just seeing all these amazing original pieces really helped me to understand what I should be looking for when buying clothes and how to put great outfits together, which is what you should always get from a vintage store. Patricia Field in New York is another one of my real favourites and she has just opened her second shop. I first met Patricia before she became the superstar Costume Designer working on *Sex and the City*, and she has always been such an inspiration to me. Her shop in New York is just brilliant: you can find anything there, from tiny hotpants to tutus to leotards with attached cardigans; it's just such fun to rummage around in there.

With regard to second-hand and charity shops, you can also find some real treasures. Car-boot and jumble sales can also come up with amazing goods and the prices are low, of course, because there's no store taking any cut. There is no denying that both vintage and second-hand shopping takes a little longer than normal shopping as you really have to go through the rails to squirrel out the good stuff, but that is half the fun!

BOUTIQUE HEAVEN

If you are in the market for something a bit more expensive you could try little boutiques, as they often stock young designers you've never heard of, or just really unusual pieces. Even if you're not going to buy anything they are almost always inspiring. I love Dover Street Market as it has a shopping environment like nowhere else I've seen in London – you can always find cool labels you don't normally find in other boutiques. It often has really amazing exhibitions and installations of art. The menswear is good too and I often pick up pieces for David there.

BOUTIQUE HEAVEN

LONDON:
1. DOVER ST MARKET
2. BROWNS and BROWNS FOCUS, South Molton St
3. MATCHES SPY and MATCHES, Notting Hill
4. A LA MODE, Sloane Square
5. SOUVENIR, Lexington St
6. START, Rivington St

REGIONAL:
1. CRICKET, Liverpool
2. SQUARE, Bath
3. FLANNELS, Manchester
4. THE CLOTHES ROOM, Harrogate
5. POLLYANNA, Barnsley
6. BERNARD'S, Esher
7. CRUISE, Glasgow
8. JANE DAVIDSON, Edinburgh
9. BODY BASICS, Cardiff

CLICK FIXES

As a mum, I don't have as much time to stroll around the shops as I used to. However, the internet is great for fast shopping and perfect for when I'm abroad. My favourite website for clothes and accessories is www.net-a-porter.com. I love it for special buys as the items arrive so quickly, are beautifully wrapped and the company has a fantastic returns policy, but the labels they stock do tend to be expensive. Another fabulous website for great designer pieces is www.shopbop.com, and you can even pick up my dVb eyewear online! Also great both for womenswear and for menswear is www.matchesfashion.com and www.brownsfashion.com – you can browse all the different labels they stock for extra inspiration.

FABULOUS FASHION WEBSITES

1. www.net-a-porter.com
2. www.my-wardrobe.com
3. www.ilovejeans.com
4. www.brownsfashion.com
5. www.matchesfashion.com
6. www.asos.com
7. www.shopbop.com

My attitude to fashion is pure *Sex and the City* – as the millions of girls who fell under Carrie Bradshaw's spell will recognize. She didn't blindly follow trends; the way she put together her own outfits was totally original and fabulous. Like herself: beautiful, but in an unconventional way. Sarah Jessica Parker and her stylists on the show brought in new fun pieces, and would work them into the existing wardrobe rather than chucking everything out and starting again. If you looked carefully you could see that it was based on gorgeous classics, sexy pencil dresses and amazing accessories, like the perfect Manolos. They simply gave them their own spin. Best of all, Carrie dressed for herself: she knew that she looked great and she was having fun. Who cared that some of her boyfriends didn't get it? In other words, she was a girls' girl and that is really why women fell for her.

MAKE A GOOD FOUNDATION, THEN ADD THOSE LITTLE DETAILS TO BRING IT UP TO DATE.

Of course, it takes time to build up the confidence to carry this off, and it's particularly hard when you're a teenager and all you want to do is fit in. Sometimes it seems easiest to just follow the trends or make yourself look older. Don't do it. Don't listen to the voices that say you have to look a certain way. Fashion is about looking like you. Make a good foundation, then add those little details to bring it up to date. For twenty-somethings, feminine and cool looks best, such as little white T-shirts under dresses. For thirty-somethings, cut back on the make-up and try experimenting with dress and skirt shapes you wouldn't have even noticed a year or two back. These kinds of changes are not a sign that you're starting to dress frumpily: they show that you are getting to know what looks best on you.

If I could go back in time, I would tell my teenage self to have more confidence about these things, as that was one thing I definitely lacked. When I go out now, I dress first for myself, then for David and then for my girlfriends. Knowing that the people I care about like how I look

LISTEN TO YOUR INNER VOICE. NO ONE KNOWS BETTER THAN YOU WHAT MAKES YOU FEEL GOOD ABOUT YOURSELF AND LOOK FANTASTIC.

gives me more confidence than anything else ever could. If you feel particularly good about yourself in something, or someone important in your life makes a nice comment about it, you will always associate that outfit with that moment, and that's why clothes work almost like a scrapbook of your life. At least they do for me, which is one reason why I have kept virtually everything I've ever worn, from the little black Miss Selfridge dress from the Spice Girls' days and the brown suede dress I wore on one of my first dates with David, to the Cavalli Ming Vase print dress I wore to Elton's ball, made all the more special to me because David picked it out. And every time I look at those clothes, they bring back the memories that they hold, and I smile.

If there's one thing I hope you take away from this book, it's that fashion is brilliant, brilliant fun, and the knowledge that something's working for you will have you walking on air every time you leave the house. And if you're happy with the way you look, then this will communicate itself to everyone you meet.

The day I did the Roberto Cavalli show in Milan, I was so petrified of falling over in front of the whole fashion world that I did what every girl does when she's scared. I rang my mum. 'Victoria,' she said, 'you've been walking for thirty-one bloody years, you should have mastered it by now!' And she was absolutely right. I didn't fall over, and I had a brilliant time.

So that's what I would like to say to all of you: listen to your inner voice, not to the comments other people might make. No one knows better than you what makes you feel good about yourself and look fantastic. So take a deep breath, keep your head up and just walk down that catwalk.

where to buy

3.1 PHILLIP LIM www.net-a-porter.com

7 FOR ALL MANKIND available at Joseph and Selfridges and www.7forallmankind.com

9 LONDON 020 7352 7600 www.9london.co.uk

10 CORSO COMO 10 Corso Como, Milan 00 39 02 2900 2674 www.10corsocomo.com

18TH AMENDMENT available at Matches and www.ilovejeans.com

A LA MODE 10 Symons St, SW1 020 7730 7180

ABERCROMBIE & FITCH 7 Burlington Gdns W1 0844 412 5750 www.uk.abercrombie.com

ACCESSORIZE 0870 412 9000 www.accessorize.co.uk

ACNE JEANS available at Matches and Selfridges www.acnejeans.com

ACQUA DI PARMA available from Fenwick 020 7629 9161

ADIDAS 0870 240 4204 www.adidas.com

AGATHA 4 South Molton St, W1 020 7495 2779

AGENT PROVOCATEUR 0870 600 0229 www.agentprovocateur.com

AGNÈS B 01865 790 799 www.agnesb.com

AGUA SPA at the Sanderson www.sandersonlondon.com

ALDO 020 7836 7692 www.aldoshoes.com

ALEX GORE BROWNE 020 7419 1200 www.alexgorebrowne.com

ALEXANDER MCQUEEN 4–5 Old Bond St, W1 020 7355 0088 www.alexandermcqueen.com

ALICE & ASTRID 30 Artesian Rd, W11 enq 020 7985 0888 aliceandastrid.com

ALL SAINTS enq 0870 428 3500 www.allsaints.co.uk

ALLY CAPELLINO enq 020 7613 3073

ALTERNA www.4alterna.com

AMANDA WAKELEY 80 Fulham Rd, SW3 020 7590 9105

AMERICAN APPAREL 020 7734 4477 www.americanapparel.net

AMPLIFIED available at Topshop and www.sugarbullets.com; www.amplifiedclothing.com

ANGELS 020 8202 2244 www.angels.uk.com

ANN SUMMERS 0845 456 2320 www.annsummers.com

ANNA MOLINARI www.annamolinari.net

ANNA SUI available at Fenwick, 020 7629 9161, The Cross

020 7727 6760, www.net-a-porter.com and www.annasui.com

ANONYMOUS BY ROSS & BUTE 57 Ledbury Rd, W11 020 7727 2348 www.anonymousclothing.com

ANYA HINDMARCH 020 7501 0177 www.anyahindmarch.com

APC AIME 32 Ledbury Rd, W11 020 7221 7070; enq in Paris 00 33 1 4987 0404 www.apc.fr

AQUASCUTUM 100 Regent St, W1 enq 0800 282 922 www.aquascutum.com

ARMANI 37 Sloane St, SW1 020 7235 6232 www.armani.com

ARMANI COSMETICS 020 7318 2486

AROMATHERAPY ASSOCIATES www.aromatherapyassociates.com

ASPREY 020 7493 6767 www.asprey.com

AUSSIE www.aussiehair.com

AVEDA 0870 034 2380 www.aveda.co.uk

AZZEDINE ALAÏA available at Browns, and Dover Street Market, 17–18 Dover St, W1 020 7518 0680

BABY DIOR 31 Sloane St, SW1 020 7172 0172 www.diorboutique.com

BALENCIAGA available at Harrods, Harvey Nichols and Selfridges www.balenciaga.com

BALLY enq 020 7408 9878 www.bally.com

BARNEYS enq in New York 001 888 222 7639 www.barneys.com

BASIA ZARZYCKA 52 Sloane Sq, SW1 020 7730 1660

BATHING APE www.bape.com

BELINDA ROBERTSON 020 7838 9170 www.belindarobertson.com

BELLA FREUD available at Matches 020 8969 2518 www.bellafreud.co.uk

BELLE & BUNTY enq 020 7267 3322 www.belleandbunty.co.uk

BELSTAFF 12–13 Conduit St, W1 020 7495 5897 www.belstaff.com

BENEFIT enq 0901 1130 001 www.benefitcosmetics.com

BENETTON 0845 389 9455 www.benetton.com

BERNARD'S 4–6 High St, Esher, Surrey 01372 464 604

BERTIE 020 7380 5800 www.shoestudiogroup.com

BETTY JACKSON 020 7589 7884 www.bettyjackson.com

BEYOND RETRO 020 7613 3636 www.beyondretro.com

BILLY BAG 020 7723 0427 www.billybag.com

BLACKOUT II 51 Endell St, WC2 020 7240 5006

BLAKES available at www.net-a-porter.com

BLISS 0808 100 4151 www.blisslondon.co.uk

BLOOMING MARVELLOUS 0845 458 7408
www.bloomingmarvellous.co.uk

BLOSSOM MOTHER & CHILD 020 7589 7500
www.blossommotherandchild.com

BLUE CULT available at Selfridges www.bluecult.com

BOBBI BROWN available at Fenwick, House of
Fraser and Selfridges

BODAS 020 7229 4464 www.bodas.co.uk

BODEN www.boden.co.uk

BODY BASICS 79 Pontcanna St, Cardiff 029 2039 7025

BOLLE www.bolleeyewear.co.uk

BONDS OF AUSTRALIA available at Topshop
www.bondsaustralia.co.uk

BONPOINT 15 Sloane St, SW1 020 7235 1441
www.bonpoint.com

BOOTS 0845 070 8090 www.boots.com

BOTTEGA VENETA 020 7838 9394 www.bottegaveneta.com

BOUCHERON 164 New Bond St, W1 020 7514 9170

BOURJOIS www.bourjois.com

BRORA 020 7736 9944 www.brora.co.uk

BROWNS 020 7514 0000 www.brownsfashion.com

BROWNS FOCUS 020 7514 0063 (website address as above)

BURBERRY enq 07000 785 676 www.burberry.com

BURTON enq 0800 731 8283 www.burton.com

BUTLER & WILSON 020 7409 2955
www.butlerandwilson.co.uk

C&C CALIFORNIA available at Browns, Liberty,
Harvey Nichols and Selfridges www.candccalifornia.com

CACHAREL 020 7383 3000 available at Selfridges and
www.net-a-porter.com

CALMIA available at Liberty www.calmia.com

CALVIN KLEIN UNDERWEAR enq 020 7290 5900
www.cku.com

CAMDEN MARKET www.camdenlock.net

CAMPER FOR KIDS 020 7409 3130 www.campershoes.com

CARAMEL BABY & CHILD 291 Brompton Rd, SW3
enq 020 7589 7001

CAROLINA HERRERA www.carolinaherrera.com

CATH KIDSTON 020 7229 8000 www.cathkidston.co.uk

CELINE 160 New Bond St, W1 020 7297 4999 www.celine.com

CHANEL 26 Old Bond St, W1 020 7493 5040 www.chanel.com

CHANEL FINE JEWELLERY 173 New Bond St, W1
020 7499 0005

CHANTECAILLE 020 7629 9161 available at Fenwick and
www.spacenk.co.uk

CHANTILLY www.chantilly.co.uk

CHARNOS 0800 032 7000 www.figleaves.com

CHEAP MONDAY www.urbanoutfitters.co.uk

CHEROKEE 0800 505 555 www.clothing@tesco.com

CHERRY CHAU available at Harvey Nichols and Selfridges

CHIP & PEPPER available at Selfridges and
www.ilovejeans.com

CHLOÉ 153 Sloane St, SW3 020 7823 5348 www.chloe.com

CHOPARD 14 New Bond St, W1 020 7409 3140

CHRISTIAN DIOR 31 Sloane St, SW1 020 7172 0172
www.diorboutique.com

CHRISTIAN LOUBOUTIN 23 Motcomb St, SW1
020 7245 6510 available at www.net-a-porter.com

CHRISTOPHER KANE available at Browns
www.brownsfashion.com

CHROME HEARTS available at Browns
www.brownsfashion.com

CITIZENS OF HUMANITY available at Harvey Nichols,
House of Fraser stores, Selfridges, Matches and
www.ilovejeans.com

CLAIRE'S ACCESSORIES www.claires.co.uk

CLARINS 0800 036 3558 www.clarins.com

COAST 01865 881 986 www.coast-stores.co.uk

COCO RIBBON 21 Kensington Park Rd, W11 020 7229 4904
www.cocoribbon.com

COLETTE enq in Paris 00 33 1 55 35 33 90 www.colette.fr

COLLETTE DINNIGAN 26 Cale St, SW3 020 7589 8897

COLLONIL 00 49 0 30 414 04511 www.collonil.com

COMME DES GARÇONS available at Dover Street Market
www.doverstreetmarket.com

CONNECT HAIR SYSTEM 020 7483 3845

CONVERSE available at Office nationwide www.office.co.uk

CORNELIA JAMES 020 7499 9423 www.corneliajames.com

CORNUCOPIA 12 Upper Tachbrook St, SW1 020 7828 5752

COS 020 7478 0400 www.cosstore.com

COWSHED PRODUCTS 020 7851 1173
www.cowshedproducts.com

CRABTREE & EVELYN enq 020 7603 1611
www.crabtree-evelyn.co.uk

CREED available at Harrods 020 7730 1234

CRÈME DE LA MER 01730 232 566 www.cremedelamer.com

CRICKET 9 Cavern Walks, Mathew St, Liverpool
0151 236 0373

CRUISE 180 Ingram St, Glasgow 0141 572 3230

CUTLER & GROSS available at Harvey Nichols, SW1
020 7581 2250 www.cutlerandgross.co.uk

CYBERJAMMIES www.cyberjammies.co.uk and
www.figleaves.com

D&G 53–55 New Bond St, W1 020 7495 9250

DAISY & TOM 181 King's Rd, SW3 020 7352 5000

DAMARIS available at www.becheeky.com and
www.figleaves.com

DAY BIRGER ET MIKKELSEN 020 7432 8088 www.day.dk

DE GRISOGONO www.degrisogono.com

DEBENHAMS 08445 616 161 www.debenhams.com

DECADES www.decadesvintage.com

DELSEY available at Selfridges and main department stores
nationwide; www.delsey.com

DENTS 01985 212 291 www.dents.co.uk

DERMALOGICA 0800 591 818 www.dermalogica.com

DIANE VON FURSTENBERG 83 Ledbury Rd, W11
020 7221 1120 www.dvflondon.com

DIDIER LUDOT enq in Paris 00 33 1 42 96 06 56
www.didierludot.com

DIESEL enq 020 7833 2255 www.diesel.com

DIOR FINE JEWELLERY enq 020 7245 1330

DIOR HOMME available at Selfridges 08708 377 377

DIOR SUNGLASSES 020 8415 999

DIPTYQUE 195 Westbourne Grove, W11 020 7727 8673
www.diptique.com

DIVA at Miss Selfridge 01277 844 157
www.missselfridge.co.uk

DIVERSE 294 Upper St, Islington N1 020 7359 8877

DKNY 27 Old Bond St, W1 020 7499 6238 www.dkny.com

DOLCE & GABBANA 020 7201 0989 www.dolcegabbana.it

DONNA KARAN 19 New Bond St, W1 020 7495 3100
www.donnakaran.com

DOROTHY PERKINS 08451 214 515
www.dorothyperkins.co.uk

DOVE 0800 085 1548 www.dove.com

DOVER STREET MARKET 17–18 Dover St, W1
020 7518 0680 www.doverstreetmarket.com

DR HARRIS & CO 020 7930 3915 www.drharris.co.uk

DSQUARED2 available at Harvey Nichols 020 7600 4841
www.dsquared2.com

DUNE 020 7258 3605 www.dune.co.uk

DVB DENIM available at Harrods, Harvey Nichols, Question
Air and Selfridges in London; Cricket in Liverpool; Brown
Thomas in Dublin; Cruise in Glasgow

DVB EYEWEAR available at Harrods, Harvey Nichols,
Question Air and Selfridges in London; Cricket in Liverpool;
Brown Thomas in Dublin; Cruise in Glasgow and
www.davidclulow.com

E'SPA available at Harvey Nichols and Liberty
enq 01252 741 600 www.espaonline.com

EARNEST SEWN 020 7713 9392 www.earnestsewn.com

EC ONE 020 7713 6185 www.econe.co.uk

EDUN available at Harvey Nichols

ELEMIS 01278 727 830 www.elemis.com

ELEY KISHIMOTO available at Selfridges
www.eleykishimoto.com

ELIE SAAB www.eliesaab.com

ELIZABETH ARDEN 0870 034 5622 www.elizabetharden.com

ELIZABETH GALTON 0845 055 7250
www.elizabethgalton.com

ELLA MOSS available at Selfridges www.shopbop.com
020 7713 9392 www.ellamoss.com

ELLE MACPHERSON INTIMATES 020 7478 0280
www.ellemacphersonintimates.com

ELSPETH GIBSON www.elspethgibson.com

EMANUEL UNGARO www.ungaro.com

EMILIO PUCCI 020 7201 8171 www.emiliopucci.com

ENERGIE enq 0870 751 6040

EPISODE enq 0845 855 3090

ERICKSON BEAMON 38 Elizabeth St, SW1
020 7259 0202 www.ericksonbeamon.co.uk

ESTÉE LAUDER 01730 232 566 www.esteelauder.co.uk

EVISU available at Selfridges 020 7734 2540
www.evisu.com

F&F COLLECTION AND FLORENCE & FRED
0800 505 555 www.clothingattesco.com

FABRIS LANE 020 8974 1642 www.fabrislane.co.uk

FAITH 0800 289 297 www.faith.co.uk

FALKE 020 7493 8442 available at www.tightsplease.co.uk

FENDI 22 Sloane St, SW1 020 7838 6288 www.fendi.com

FENWICK 63 New Bond St, W1 020 7629 9161

FIFI CHACHNIL www.fifichachnil.com

FIONA KNAPP 178a Westbourne Grove, W11 020 7313 5941
www.fionaknapp.com

FLANNELS 14 Lower Temple St, The Burlington Arcade,
Birmingham 0121 633 4154

FLEUR T 0117 970 6701 www.fleurt.com

FLORIS 0845 702 3239 www.florislondon.com

FOGAL 020 7235 3115 www.fogal.com

FORMES 020 8689 1133 www.formes.com

FORNARINA 020 7287 4564 www.fornarina.com

FRANKIE B available at www.ilovejeans.com
www.frankieb.com

FREEDOM AT TOPSHOP 01277 844 186
www.freedomjewellery.co.uk

FREEMANS 0800 900 200 www.freemans.com

FRENCH CONNECTION 020 7036 7200
www.frenchconnection.com

FRENCH SOLE 020 7730 7331 www.frenchsole.com

FRYE www.fryeboots.com

GAP 0800 427 789 www.gap.com

GAS 020 7354 2784

GEORG JENSEN 15 New Bond St, W1 020 7499 6541

www.georgjensen.com

GEORGE AT ASDA 0500 100 055 www.george.com

GEORGINA GOODMAN 020 8605 3660

www.georginagoodman.com

GEORGINA VON ETZDORF 4 Ellis St, SW1 020 7409 7789

GÉRARD DAREL available at Fenwick 020 7629 9161

GHOST 020 7229 1057 www.ghost.co.uk

GIAMBATTISA VALLI available at Browns, Dover Street

Market and www.matchesfashion.com

GILES available at Harvey Nichols 020 7235 5000 and

www.net-a-porter.com

GILES DEACON GOLD FOR NEW LOOK

www.newlook.co.uk/gilesdeacon

GINA 9 Old Bond St, W1 020 7409 7090 www.gina.com

GIUSEPPE ZANOTTI DESIGN available at Harvey Nichols

www.giuseppe-zanotti-design.com

GOLD SIGN available at www.revolveclothing.com

GOSSARD www.figleaves.com

GRASS LOS ANGELES www.grassla.com

GUCCI 34 Old Bond St, W1 020 7629 2716

www.gucci.com

GUERLAIN 01932 233 909 www.guerlain.com

GUESS available at Selfridges 020 7751 4430 www.guess.com

H&M enq 020 7323 2211 www.hm.com

HABITAT 0845 601 0740 www.habitat.net

HABITUAL available at www.ilovejeans.com;

www.habitual.com

HANRO available at Harrods and www.figleaves.com

HARRIET'S MUSE 020 7734 1773 www.harrietsmuse.com

HARRODS 020 7730 1234 www.harrods.com

HARVEY NICHOLS 020 7235 5000 www.harveynichols.com

HAVAIANAS available at Office www.office.co.uk

HEAD & SHOULDERS www.headandshoulders.com

HEIDI KLEIN 020 7243 5665 www.heidiklein.co.uk

HERMÈS 179 Sloane St, SW1 020 7499 8856 www.hermes.com

HOBBS 020 7586 5550 www.hobbs.co.uk

HOGAN 10 Sloane St, SW1 020 7245 6363

HÔTEL COSTES enq in Paris 00 33 1 42 44 50 00

www.hotelcostes.com

HUGO BOSS 020 7534 2700 www.hugoboss.com

HUIT www.figleaves.com

HUMMEL 020 8275 1170

HUNTER 01387 269 591 www.hunterboots.com

HUSH available at Coco Ribbon and www.hush-uk2.com

ISSA available at Harrods 020 7730 1234, maternity available

at Blossom Mother & Child 020 7589 7500

J BRAND available at Matches, www.ilovejeans.com and

www.net-a-porter.com

J&M DAVIDSON 42 Ledbury Rd, W11 020 7313 9532

www.jandmdavidson.co.uk

JACOB & CO enq in New York 001 212 719 5887

www.jacobandco.com

JAEGER 0845 051 0663 www.jaeger.co.uk

JAMES JEANS available at Matches and Selfridges

www.matchesfashion.com

JAMES PERSE available at Selfridges www.jamesperse.com

JANE DAVIDSON 62 Thistle St, Edinburgh 0131 225 3280

www.janedavidson.co.uk

JANE DE LACEY 01273 326 686 www.janedelacey.co.uk

JASPER CONRAN 020 7292 9080 www.jasperconran.com

JD SPORTS 0870 873 0300 www.jdsports.co.uk

JEAN PAUL GAULTIER 020 7584 4648

www.jeanpaul-gaultier.com

JEFFREY enq in New York 001 212 206 1272

JIGSAW 020 8392 5600 www.jigsaw-online.com

JIMMY CHOO 27 New Bond St, W1 020 7493 5858

www.net-a-porter.com

JO GORDON www.jogordon.com

JO MALONE 0870 034 2411 www.jomalone.co.uk

JOE'S JEANS www.joesjeans.com

JOHN LEWIS 08456 049 049 www.johnlewis.com

JOHN SMEDLEY 24 Brook St, W1 020 7495 2222

www.johnsmedley.com

JOHNNY LOVES ROSIE 020 7247 1496

www.johnnylovesrosie.co.uk

JONATHAN ASTON 01277 204 744 www.mytights.com

JONELLE available at John Lewis 08456 049 049

JOSEPH 020 7590 6200 www.joseph.co.uk

JUICY COUTURE available at Harvey Nichols 020 7235 5000

www.juicycouture.com

JULIEN MACDONALD available at Harrods

JUNGLE 020 7379 5379 www.junglehardwear.com

JUNYA WATANABE available at Browns

www.brownsfashion.com

KAREN MILLEN 0870 160 031 www.karenmillen.com

KAREN WALKER www.karenwalker.com

KATE KUBA 24 Duke of York Square, SW3 020 7259 0011

KATE MOSS for Topshop enq 0845 121 4519

www.topshop.co.uk

KATE SPADE www.katespade.com

KATHARINE HAMNETT www.katharinehamnett.com

KEDS available at Selfridges www.keds.com

KENNETH TURNER 01442 838 181 www.kennethturner.com

KIEHLS 020 7240 2411 www.kiehls.com

KIPLING available at main department stores nationwide

www.kipling.com

KITSON www.shopkitson.com

KNICKERBOX 01883 629 421 www.knickerbox.co.uk

KOOKAÏ www.kookai.co.uk

KURT GEIGER available at Harrods enq 0845 257 2571
www.kurtgeiger.com

LA PERLA 020 7291 0930 www.laperla.com

LA PRAIRIE 01932 827 060 available at House of Fraser
020 7963 2000

LA REDOUTE 0870 0500 455 www.redoute.co.uk

LA SENZA 020 8561 9784 www.lasenza.co.uk

LACOSTE 020 7439 2213 www.lacoste.com

LANCÔME www.lancome.co.uk

LANDS' END 0800 376 7974 www.landsend.co.uk

LANVIN available at Harvey Nichols, Selfridges and
www.matchesfashion.com

LAURA MERCIER available at Harrods, Harvey Nichols,
House of Fraser, Liberty and Space NK 020 7299 4999
www.lauramercier.com

LAURENCE CORNER 020 7813 1010

LEE enq 0845 600 8383 www.lee.com

LEJABY www.figleaves.com

LEVI'S enq 01604 599 752 www.eu.levi.com

LIBERTY 020 7734 1234 www.liberty.co.uk

LILLYWHITES 24–36 Lower Regent St, W1 0870 333 9600
www.lillywhites.co.uk

LINDA FARROW VINTAGE available at Harrods, SW1
020 7713 1105 www.lindafarrowvintage.com

LINDA MEREDITH 020 7225 2755 www.lindameredith.com

LINEA AT HOUSE OF FRASER www.houseoffraser.co.uk

LK BENNETT enq 020 7637 6731 www.lkbennett.com

LOCKONEGO 020 7795 1798 www.lockonego.com

LOEWE available at Harrods 020 7730 1234

LONGCHAMP 28 New Bond St, W1; enq 020 7493 5515
www.longchamp.com

LOUIS VUITTON 17–18 New Bond St, W1 020 7399 4050
www.louisvuitton.com

LOUISE GALVIN 020 7289 5131 www.louisegalvin.com

LOWRY HOTEL & SPA 0161 827 4000 www.thelowryhotel.com

LUELLA available at Harrods and Harvey Nichols 020 8963
2978 www.luella.com

LULU GUINNESS 020 8483 3333 www.luluguinness.com

M:UK 020 8974 1642

MAC 020 7534 9222 www.maccosmetics.co.uk

MADE IN HEAVEN available at www.ilovejeans.com 020 7349
9030 www.madeinheaven.co.uk

MAMAS AND PAPAS www.mamasandpapas.co.uk

MAMMA MIO www.mammamio.co.uk

MANGO 020 7434 3694 www.mangoshops.com

MANOLO BLAHNIK 49–51 Old Church St, SW3
020 7352 8622

MARC JACOBS AND MARC BY MARC JACOBS
24–25 Mount St, W1 020 7399 1690 www.marcjacobs.com

MARC JACOBS COSMETICS 0800 652 7661

MARGARET HOWELL 34 Wigmore St, W1 enq 020 7009 9009
www.margarethowell.co.uk

MARIA LUISA enq in Paris 00 33 1 47 03 48 08

MARIOS SCHWAB available at Browns www.brownsfashion.com

MARKS & SPENCER enq 0845 302 1234
www.marksandspencer.com

MARNI 16 Sloane St, SW1 020 7245 9520 www.marni.com

MARTIN MARGIELA available at Matches
www.matchesfashion.com

MASON PEARSON www.masonpearson.co.uk

MATALAN www.matalan.co.uk

MATCHES 60–64 Ledbury Rd, W11 020 7221 0255
www.matchesfashion.com

MATTHEW WILLIAMSON 020 7629 6200
www.matthewwilliamson.com

MAXMARA 32 Sloane St, SW1 020 7518 8010

MCQ BY ALEXANDER MCQUEEN available at Harrods,
Harvey Nichols, Liberty, Matches, Selfridges
www.mcq-alexandermcqueen.com

MIKEY available at Selfridges and Topshop
www.mikeyjewellery.com

MILLER HARRIS 020 7629 7750 www.millerharris.com

MIMI HOLLIDAY available at www.figleaves.com

MISS SELFRIDGE 0800 915 9900 www.missselfridge.co.uk

MISS SIXTY 0870 751 6040 www.misssixty.com

MISSONI available at Harvey Nichols and Matches
020 7352 2400 www.missoni.com

MITTY JAMES www.mittyjames.com

MIU MIU 123 New Bond St, W1 020 7407 0900 available at
www.net-a-porter.com

MODEL CO available at Space NK 020 7299 4999
www.spacenk.co.uk; www.modelco.com.au

MOLLY BROWN available at Harrods and Selfridges
0870 851 8818 www.mollybrownlondon.com

MONCLER www.moncler.com

MONSOON 020 7313 3000 www.monsoon.co.uk

MOOD AT DEBENHAMS 08445 616 161

MORGAN 0800 731 4942 www.morgandetoi.com

MORGAN DAVIES Wedding Shop 62 Cross Street, N1
020 7354 3414

MOSCHINO 28–29 Conduit St, W1 020 7318 0555
www.moschino.com

MOTHERCARE 08453 304 030 www.mothercare.com

MUJI 187 Oxford St, W1 020 7323 2208 www.muji.co.uk

MULBERRY 41–42 New Bond St, W1 enq 020 7491 3900
www.mulberry.com

MYLA enq 08707 455 003 www.myla.com

NANETTE LEPORE www.nanettelepore.com

NARCISO RODRIGUEZ available at Harvey Nichols
020 7235 5000

NARS available at Liberty 020 7734 1234 and Space NK
020 7229 4999; www.narscosmetics.com

NEAL'S YARD REMEDIES enq 020 7627 1949
www.nealsyardremedies.com

NECK & NECK www.neckandneck.com

NEIL CUNNINGHAM 020 7482 7277 www.neilcunningham.com

NEW LOOK 01305 765 000 www.newlook.co.uk

NEXT 0845 600 7000 www.next.co.uk

NICOLE FARHI 020 7499 8368 www.nicolefarhi.com

NIKE 0800 056 1640 www.nike.com

NINA RICCI available at www.net-a-porter.com

NIVEA 0800 616 977 www.nivea.com available from
pharmacies nationwide

NO ADDED SUGAR 020 7226 2223 www.noaddedsugar.co.uk;
available at Fenwick, Harrods and Selfridges

NORTH FACE 020 7240 9577 www.thenorthface.com

NOTIFY available at Matches, www.ilovejeans.com and
www.net-a-porter.com

NOUGAT available at Fenwick 020 7323 2222
www.nougatlondon.co.uk

NYDJ www.ilovejeans.com

O'NEILL 15–19 Neal St, W1 0191 419 1777 www.oneill.com

OASIS 01865 881 986 www.oasis-stores.com

OFFICE 0845 580 777 www.office.co.uk

OLD SPITALFIELDS MARKET www.visitspitalfields.co.uk
and www.spitalfields.org.uk

OLIVER PEOPLES 020 7813 1234 www.oliverpeoples.com

OLIVIA MORRIS 020 8962 0353 www.oliviamorrisshoes.com

ONE OF A KIND 253 Portobello Rd, W11 020 7792 5284

ONITSUKA TIGER 15 Newburgh St, W1 020 7734 5157
www.onitsukatiger.co.uk

OPTREX www.optrexeyes.com available from pharmacies
nationwide

ORIGINS 0800 731 4039 www.origins.co.uk

ORLA KIELY 31 Monmouth St, WC2 020 7585 3322
www.orlakiely.com

ORSINI 020 7937 2903 www.orsini-vintage.co.uk

OXFAM 0845 3000 311 www.oxfam.org

PAMELA MANN www.tightsplease.co.uk

PAPER DENIM & CLOTH www.couturecandy.com

PATRICIA FIELD enq in New York 001 212 966 4066
www.patriciafield.com

PATRICK COX 020 7730 8886 www.patrickcox.co.uk

PAUL & JOE 39 Ledbury Rd, W11 enq 020 7243 5510
www.paul-joe-beaute.com

PAUL SMITH 020 7379 7133 www.paulsmith.co.uk

PAUL SMITH (UNDERWEAR) www.figleaves.com

PEACOCKS 02920 270 000 www.peacocks.co.uk

PEBBLE 020 7262 1775 www.pebblebluedesign.co.uk

PEDRO GARCIA available at www.net-a-porter.com

PEPE JEANS 020 7439 0523 www.pepejeans.com

PETIT BATEAU 62 South Molton St, W1 enq 020 7838 0818
www.petit-bateau.com

PHILIP TREACY 020 7730 3992 www.philiptreacy.co.uk

PHILOSOPHY www.spacenk.com

PHILOSOPHY DI ALBERTA FERRETTI 205–206 Sloane St,
SW1 020 7235 2349 available at www.net-a-porter.com

PICKETT 020 7493 9072 www.pickett.co.uk

PIED A TERRE www.piedaterre.com

PIERRE HARDY Dover Street Market 020 7518 0680
www.matchesfashion.com and www.pierrehardy.com

PINK LINING available at Harrods www.pinklining.co.uk

PISTOL PANTIES 75 Westbourne Park Road, W2
020 7229 5286 www.pistolpanties.com

PLAYBOY INTIMATES www.figleaves.com

PLAYTEX available at www.figleaves.com

POLLYANNA 16 Market Hill, Barnsley 01226 291 665
www.pollyanna.com

POLO RALPH LAUREN www.polo.com

PORTOBELLO ROAD MARKET www.portobelloroad.co.uk

POUT 32 Shelton St, WC2 020 7379 0379 www.pout.co.uk

PPQ 47 Conduit St, W1 020 7033 3400 www.ppqclothing.com

PRADA 16–18 Old Bond St, W1 020 7647 5000 www.prada.com

PRESCRIPTIVES 01730 232 566 www.prescriptives.com

PRESS STORE 3 Erskine Road, NW3 020 7449 0081

PRETTY BALLERINAS www.prettyballerinas.com

PRETTY POLLY 01623 444 299 www.figleaves.com

PRIMARK 0118 160 6300 www.primark.co.uk

PRINCESSE TAM-TAM www.figleaves.com

PRINCIPLES 0870 122 8802 www.principles.co.uk

PRINGLE 0800 360 200 www.pringle-clothes.co.uk

PUMA 020 7439 0221 www.puma.com

PUMPKIN PATCH www.pumpkinpatch.co.uk

PURE CASHMERE www.purecollection.com

PUSH MATERNITY WEAR www.pushmaternity.com

QUESTION AIR 229 Westbourne Grove, W11 020 7221 8163

QUIKSILVER 020 7436 6800 www.quiksilver.com

R SOLES 109a King's Rd, SW3 020 7351 5520 www.rsoles.com

RADCLIFFE available at Selfridges www.radcliffedenim.com

RADIO DAYS 020 7928 0800 www.radiodaysvintage.co.uk

RAG & BONE available at Browns and Harvey Nichols
020 7235 5000 www.rag-bone.com

RALPH LAUREN 1 New Bond St, W1 www.ralphlauren.co.uk

RAVEL 01458 843 809 www.ravel.co.uk

RAY-BAN available at Harrods and Selfridges
www.raybansunglasses.co.uk

REDKEN available at www.salonskincare.co.uk

REISS 020 7473 9600 www.reiss.co.uk

Rellik 8 Golbourne Rd, W10 enq 020 8962 0089
www.relliklondon.co.uk

REPETTO available at Paul & Joe, www.toast.co.uk and
www.repetto.com

REPLAY enq 020 7713 9404 www.replaybluejeans.com

RESURRECTION enq in Los Angeles 001 323 651 5516
www.resurrectionvintage.com

RÉVIVE 0800 085 2716 www.reviveskincare.com

RICK OWENS available at Browns www.brownsfashion.com

RIGBY AND PELLER 020 7491 2200 www.rigbyandpeller.com

RIMMEL 0845 070 8090 www.rimmellondon.com

ROBERTO CAVALLI 020 7878 8600 www.robertocavalli.net

ROCK AND REPUBLIC available at Harrods, Harvey Nichols
and Selfridges 020 7734 2039 www.rockandrepublic.com

RODIAL available at Fenwick www.rodial.co.uk

ROGAN www.my-wardrobe.com

ROGER VIVIER 188 Sloane St, SW1 020 7245 8270
www.rogervivier.com

ROKIT 020 8801 8600 www.rokit.co.uk

ROLEX www.rolex.com

ROXY BY QUIKSILVER 020 7436 6800 www.roxy.com

RUBY & MILLIE available at Boots nationwide

RUPERT SANDERSON 33 Bruton Place, W1
enq 0870 750 9181 www.rupertsanderson.co.uk

RUSSELL AND BROMLEY 020 7629 6903
www.russellandbromley.co.uk

SAMANTHA THAVASA www.samantha.co.jp

SAMSONITE available at Selfridges and main department
stores www.samsonite.com

SARA BERMAN enq 020 7485 1425 www.saraberman.com

SASS & BIDE available at Harvey Nichols, Selfridges and
www.net-a-porter.com; www.sassandbide.com

SCOOP enq in New York 001 212 929 1244 www.scoopnyc.com

SCOTT BARNES 01273 408 800 www.scottbarnes.com

SCREAMING MIMI'S enq in New York 001 212 677 6464
www.screamingmimis.com

SEAFOLLY available at www.figleaves.com; www.seafolly.com

SEBASTIAN www.sebastianprofessional.com

SEE BY CHLOÉ available at Harvey Nichols, Selfridges and
www.net-a-porter.com

SELFRIDGES 0870 837 7377 www.selfridges.com

SERFONTAINE available at www.ilovejeans.com;
www.serfontaine.com

SERGIO ROSSI 207a Sloane St, SW1 020 7811 5900
www.sergiorossi.com

SEXY PANTIES AND NAUGHTY KNICKERS
www.sexypantiesandnaughtyknickers.com

SHELLYS 020 7437 0452 www.shellys.co.uk

SHU UEMURA 020 7235 2375 www.shuuemura.com

SIWY available at Harvey Nichols and www.net-a-porter.com

SK-II 0800 072 1771 www.sk2.co.uk

SLATKIN www.slatkin.com

SMYTHSON 020 7318 1515 www.smythson.com

SNOW & ROCK 4 Mercer St, WC2 020 7240 1444
www.snowandrock.com

SOLANGE AZAGURY-PARTRIDGE
187 Westbourne Grove, W11 020 7792 0197
www.solangeazagurypartridge.com

SONIA RYKIEL 27–29 Brook St, W1 020 7493 5255
www.soniarykiel.com

SOUVENIR 53 Brewer St, W1 020 7287 9877

SPACE NK 020 7299 4999 www.spacenk.co.uk

SPEEDO available at www.figleaves.com; www.speedo.co.uk

SPITFIRE contact@spitfire-design.com

SPLENDID available at Harvey Nichols, Selfridges and
www.shopbop.com

SQUARE 43 Milsom St, Bath 01225 444 001

ST TROPEZ 0115 983 6363 www.sttropeztan.com

START 42–44 Rivington Street, EC2 020 7729 3334
www.start-london.com

STEINBERG & TOLKIEN 193 King's Rd, SW3
020 7376 3660

STELLA MCCARTNEY 020 7518 3100
www.stellamccartney.com

STELLA MCCARTNEY SUNGLASSES 020 7841 5999

STEPHEN COLLINS available at Fenwick and
www.stephencollins.co.uk

STEPHEN JONES MILLINERY 36 Great Queen St, WC2
www.stephenjonesmillinery.com

STEPHEN WEBSTER 1a Duke St, W1 020 7486 6575
www.stephenwebster.com

STILA 01730 232 566 www.stilacosmetics.com

STRIP 020 7727 2754 www.2strip.com

STYLE.com www.style.com

SUPERFINE available at Matches 020 7608 9100
www.matchesfashion.com; www.superfinelondon.com

SWEATYBETTY 0800 169 3889 www.sweatybetty.com

TATTY DEVINE 57b Brewer St, W1 020 7434 2257
www.tattydevine.com

TED BAKER 0845 130 4278 www.tedbaker.co.uk

THE BODY SHOP 01903 844 554 www.bodyshop.co.uk

THE BUTTON QUEEN 020 7935 1505
www.thebuttonqueen.co.uk

THE BUTTON SHOP www.button-shop.com

THE CLOTHES ROOM 1 Masham Road, Harrogate
01423 889090

THE GREEN ROOM 020 8940 4073 www.thegreen-room.co.uk

THE WEDDING SHOP 171 Fulham Road, SW3
www.weddingshop.com

THE WEST VILLAGE 35 Kensington Park Rd, W11
020 7243 6916

THE WHITE COMPANY 01865 881 986
www.thewhitecompany.com

THOMAS PINK 020 7498 3882 www.thomaspink.co.uk

THOMAS WYLDE available at Browns and
www.net-a-porter.com

TIFFANY & CO 25 Old Bond St, W1 020 7499 4577
www.tiffany.com

TIMBERLAND 020 7240 4484 www.timberland.com

TIMPSONS www.timpsons.com

TM LEWIN 0845 389 1898 www.tmlewin.co.uk

TOAST 0870 220 0460 www.toast.co.uk

TOCCA www.tocca.com; candles available from Fenwick
020 7629 9161

TODS 2–5 Old Bond St, W1 enq 020 7493 2237
www.tods.com

TOMAS MAIER 001 888 373 0707 www.tomasmaier.com

TOMMY HILFIGER 6 Sloane Street, SW1 020 7235 2500
www.tommy.com

TOPSHOP enq 0845 121 4519 www.topshop.co.uk

TRISH MCEVOY available at Harvey Nichols 020 7235 5000

TRUE RELIGION available at Selfridges and
www.net-a-porter.com

TSUBI available at Browns, www.ilovejeans.com and
www.my-wardrobe.com

TU AT SAINSBURY'S 0800 636 262 www.sainsburys.co.uk

TUMI 0800 783 6570 www.tumi.com

TWEEZERMAN 020 7237 1007 www.tweezerman.com

UGG 01475 746 000 www.uggaustralia.com

UNCONDITIONAL available at Selfridges 08708 377 377

UNIQLO 188 Oxford St, W1 020 7734 5369 www.uniqlo.com

URBAN OUTFITTERS 020 7907 0815
www.urbanoutfitters.co.uk

VAISHALY 020 7224 6088 www.vaishaly.com

VALENTINO 174 Sloane St, SW1 020 7235 5855
www.valentino.it

VALEXTRA www.valextra.it

VANESSA BRUNO available at Selfridges and
www.net-a-porter.com

VBH available at Browns and www.net-a-porter.com

VELVET (BOUTIQUE) 01282 699 797

VELVET 01707 645 828 www.matchesfashion.com

VERA WANG available at Harvey Nichols

www.verawang.com

VERSACE 020 7355 2700 www.versace.com

VERSACE BEAUTY available at Harrods and Selfridges
01273 408 800

VICTORIA'S SECRET 001 937 438 4200
www.victoriassecret.com

VIKTOR & ROLF available at Joseph, Harvey Nichols and
Selfridges; www.viktor-rolf.com

VIRGINIA 98 Portland Rd, W11 020 7727 9908

VITAMIN A available at Harvey Nichols 020 7235 5000
www.figleaves.com

VIVIENNE WESTWOOD 020 7924 4747
www.viviennewestwood.com

WALLIS 0845 121 4520 www.wallis-fashion.com

WAREHOUSE 0870 122 8813 www.warehouse.co.uk

WHAT GOES AROUND COMES AROUND enq in New York
001 212 313 9303 www.myvintage.com

WHEELS & DOLLBABY available at Harvey Nichols
and Selfridges

WHISTLES 0870 770 4301 www.whistles.co.uk

WOLFORD available at Harrods, Selfridges, House of Fraser
and department stores nationwide;
www.wolfordboutiquelondon.com

WONDERBRA available at www.figleaves.com;
www.wonderbra.com

WORN BY www.wornby.co.uk

WRANGLER enq 0845 600 8383 www.wrangler.co.uk

YON-KA www.yonka.com

YSL BEAUTÉ 01444 255 700

YSL SUNGLASSES 020 7841 5999

YVES SAINT LAURENT 171–172 Sloane St, SW1
020 7235 6706

ZARA 020 7534 9500 www.zara.com

with thanks to...

PENGUIN BOOKS: It was so brilliant to be back working with the same team as my first book, *Learning to Fly*. You have all been amazing and have put up with my perfectionist streak which drives everyone else around me wild. So a big thank you to all: Tom Weldon, Louise Moore, John Hamilton, Georgina Atsiaris, Seyhan Esen, Chantal Gibbs, Carly Cook, Sophie Brewer, Clare Pollock, Naomi Fidler, Mike Symons, Sarah Hulbert, Caroline Pretty, Clare Parkinson, Margaret Bluman, Rob Williams, Sarah Hunt Cooke, Jessica Jefferys and all the different departments who have worked so hard to turn this book from a glint in my eye to the sparkling finished product that I am so proud of. To Nikki Dupin, a special thank you for your brilliant design. And to Katy Follain, my wonderful publisher: thanks for your support, encouragement and vision throughout.

HADLEY FREEMAN: I have long been an admirer of your edgy take on fashion, and what we have both brought to this book is what's made it what it is. Thank you.

JO BURSTON: Without you, Jo, I'd be all over the place. Thank you for keeping me on track, and just being there. Not only for me, but for David as well. We both really appreciate everything you do for us.

MELISSA ENRILE: Your friendship and help in Madrid has been invaluable to me.

ALL AT 19 ENTERTAINMENT: Robert Dodds, Catri Drummond, Wendy Edwards, Niki Turner, Charlotte Martin, Sarah Farrow, Sarah Best, Carla Williams, Ali Parry, Zach Duane and Katie Morrison. Heartfelt thanks to Nez Gebreel and Maya Maraj for your passion and commitment. Nez, you are my number-one partner in crime, and Maya, you laid down your life for this book and that's meant a lot to me.

AND OF COURSE SIMON FULLER: Otherwise known as **Mr Make-It-Happen.** You have taken my sometimes crazy creative ideas and turned them into business reality. These last few years have not been easy. Thank you for being there for me and David. You are my rock.

SAIREY STEMP: Thank you for all your help with the paperback – your knowledge and expertise have proved vital.

ANDREW THOMPSON AND MARK ASHELFORD: (The grim reapers.) Who said lawyers don't have a sense of humour? Thank you for everything.

JULIAN HENRY AND JO MILLOY FOR PUBLICITY: Jo, you had a life before you met me! Joking aside, thank you for your hard work and friendship.

Huge thanks to everybody involved in the photography for this book and whose work in these pages is proof that there's more to me than simply a moody bitch with a pout (otherwise known as the VB paparazzi special).

THE MADRID SHOOT: The wonderful Ellen Von Unwerth and her crew. D&V Management, especially Lawrence Vuillemin, Victoria Adcock, Liz Pugh, Ben Cooke and all at Candella, the invaluable Spanish production team.

THE FIRST LONDON SHOOT: Benoît Audureau for photography, Sairey Stemp, Sarah Joan Ross, Jasmine Hennessy from MOT models and all at Size Creative.

THE SECOND LONDON SHOOT: Ellen Von Unwerth and her team again. Victoria Adcock, Liz Pugh and James Brown.

BEN COOKE AND MARIA LOUISE FEATHERSTONE – MY CLOSEST FRIENDS: Thank you for all your help and honesty. Maria Louise, in 1982 that Naf Naf jumper of yours had me green with envy on our first skiing holiday together and it started an avalanche which is still rolling. Thank you for everything.

THE GIRLS: Otherwise known as Geri, Emma, Melanie C and Melanie B. You recognized the person who was there underneath, but who I couldn't see, and gave me the confidence to be myself and not to follow the herd. You put me in the position to write this book. I can never thank you enough.

As for those glittering names I have been privileged to work closely with over the years, I could start at the beginning of the alphabet and work through ... but there just isn't the space, so I will limit myself here to those who have not only been an inspiration but generously given me their time: Azzedine Alaïa, Manolo Blahnik, Christopher Bailey, Roberto Cavalli, Dolce & Gabbana, Roland Mouret, Valentino and Matthew Williamson. And behind each one of them there are a dozen others who make it happen. A real heartfelt thank you to you all.

FINALLY, MY FAMILY: Louise, my chief high-street scout for this book – hard work, I know, but fun, you'll have to admit. Mostly I'd like to thank you for your honesty. I might not always have taken it well (I am your big sister after all) but I appreciate it, and please never stop. I love you. Jackie, Tony and my brother Christian: it's not been easy over the past few years. Thanks for giving me strength and just being there. I love you all.

MY BOYS: Brooklyn, Romeo and Cruz – it's amazing how rips and splodges and the need to turn things inside out can open up a whole range of fashion possibilities. I love you all so much, Mummy. xxx

DAVID: Your love and support means everything to me. I never thought it was possible but I can honestly say that I love you now more than ever. You complete me, you make me who I am. xx

TO MY FANS: You will never know how much you mean to me. I am so grateful for your loyalty and support. Thank you.

PICTURE SOURCES

Picture of Victoria Beckham on p.92. Courtesy of David Beckham.
Victoria Beckham in red Roland Mouret dress on p.118. Used by kind
permission of Roland Mouret and Richard Young/Rex Features.
Victoria Beckham in yellow Roberto Cavalli dress on p.174 © Rex
Features; in red Robert Cavalli dress on p.174. Used by kind permisson
of Ben Cooke; in Roberto Cavalli Ming Vase dress on p.175 © Kevin
Mazur/Wireimage.com.
Original sketches on pp.174/175 by Robert Cavalli.
Picture of Victoria Beckham on p.180 © Sipa Press/Rex Features.
Pictures of Victoria Beckham on pp.189/190. Used by kind permission
of Tony and Jackie Adams.
Manolo Blahnik sketch on pp.192/193. Courtesy of Manolo Blahnik.
Victoria Beckham wearing brown poncho on p.281 © Matthew Pover/
matrixphotos.com.
Victoria Beckham wearing blue poncho on p.281 © bigpicturesphoto.com.
Artwork on p.355 © Ruben Toledo, 2001.
Pictures of Victoria Beckham on pp.356/357. Used by kind permission of
Charlotte Martin.
Pictures of Victoria Beckham on p.158, p.333, p.343. Used by kind
permission of Ben Cooke.
Pictures of Victoria Beckham on p.ii and p.380. Used by kind
permission of David Beckham, Ellen Von Unwerth, Ben Cooke,
Charlotte Martin and Andre J. at Patricia Field.
Inside cover © Mapesbury Locations Limited.

TEXT SOURCES

A special thank you to Christopher Bailey, Manolo Blahnik, Roberto
Cavalli, Roland Mouret, Valentino and Matthew Williamson for
providing quotes for the book.

Every effort has been made to contact the copyright holders and we
apologize for any unintentional omission. We would be pleased to insert
the appropriate acknowledgement in any subsequent edition.